Radical
Endurance

Also by Andrea Gilats

Published by the University of Minnesota Press

After Effects: A Memoir of Complicated Grief

Radical Endurance

GROWING OLD IN AN AGE OF LONGEVITY

Andrea Gilats

UNIVERSITY OF MINNESOTA PRESS
MINNEAPOLIS • LONDON

Published by the University of Minnesota Press
111 Third Avenue South, Suite 290
Minneapolis, MN 55401–2520
http://www.upress.umn.edu

ISBN 978-1-5179-1806-4 (pb)

A Cataloging-in-Publication record for this book is available from the Library of Congress.

Printed in the United States of America on acid-free paper

The University of Minnesota is an equal-opportunity educator and employer.

32 31 30 29 28 27 26 25 24 10 9 8 7 6 5 4 3 2 1

For my parents

Lee Ward Gilats (1919–2004)
and David Gilats (1916–2009)

and for my grandparents

Reva Vinarsky Ward (1900–2001)
and Boris Ward (1894–1986)

Rose Latts Gilats Rose (1890–1980)
and Sam Gilats (1886–1924)

and for my great-grandmother

Risia Beevna Vinarskaia (1868–1941)

Old age is a time to contemplate and understand the contradictions and find a way to live in harmony with one's spirit and conscience. Ultimately, this might be impossible, but having experience, being able to reflect on the past and grow through it, being able to have a second childhood and grow up again on a conscious level, and being able to put it into paint, music, words, and gestures seems to be part of the art of aging. There is no need to resolve everything. Death will take care of that.

HERBERT KOHL, *Painting Chinese: A Lifelong Teacher Gains the Wisdom of Youth*

Contents

Introduction

THE PAGES OF OUR LIVES

IN MARCH 2020, JUST AS A WORRISOME OUTBREAK OF a novel coronavirus was exploding into a global pandemic, I was completing work on my first memoir, *After Effects: A Memoir of Complicated Grief.* It told my story of living with and through prolonged grief disorder, a debilitating condition that swallowed my life for more than a decade after I lost my husband, Tom Dayton, to cancer in 1998.

In that memoir I wrote about the healing effects of leaving my longtime job and starting a new kind of work at the University of Minnesota, where I had worked for thirty-four years. My new work focused on creating educational programs for people approaching retirement, including helping participants prepare for the health and well-being challenges that accompany aging, as well as helping them prepare for a life in which they would now need to fill time that used to be spent working, a change that for many people raises questions about identity and purpose. To do this work, I had to familiarize myself with current thinking about what experts were calling "the new old age," a project I willingly undertook to the best of my grief-limited abilities.

Coincidentally or not, ten years later and eight years after my own retirement, I woke up one ordinary morning shocked by a sudden leap of consciousness. I found myself bursting with an obsessive need to come to terms with my seventy-fifth birthday, the milestone at which I would enter old age. Sadly, because my work with pre-retirees had focused on people in their sixties, it had failed to prepare me for what lay ahead. Seventy-five was not the new sixty-five—that much I knew.

I returned to some of the texts I had read a decade earlier. These included philosophical arguments for living a "young" life in old age, sociological and psychological writings on the aging of America's baby boomers, and self-help advice written for people approaching later life. I also began reading more recent texts about aging. I discovered that apart from a few outstanding exceptions like *Being Mortal* by Atul Gawande and *Elderhood* by Louise Aronson, recent general interest texts still characterized later life as a peak, an apogee during which there is no reason why we shouldn't continue living the kind of merry life a physically fit, financially secure, socially connected person might live.

Well and good, but I can't live that kind of life. It doesn't fit the person I have become. To my deep disappointment, much of what I read didn't reflect my own lived experience of aging or those of my family members and friends. This omission lit in my mind the notion of an essay-like effort (where essay means to try, to attempt) that might help illuminate my muddled, pandemic-infused passage into old age, thereby helping to ease the way for others. I think of these attempts as stories, where according to the distinguished writer and critic Vivian Gornick in *The Situation and the Story,* story is defined not as plot (that is

the "situation" part) but as "the emotional experience that preoccupies the writer."

As these ideas simmered in my mind, I recognized that I wanted to write about more than my recent journey into elderhood. Rather than limiting my literary voice to recollections, I also wanted to speak authentically and honestly from the perspective of the old woman I am now. We are not, I am learning, merely fossilized versions of our earlier selves; if we were, I would have thicker hair, fewer wrinkles, and a lot less wisdom. Thankfully, most of us can—with a little luck, good health habits, and supportive relationships—continue to adapt, renew, and even reinvent ourselves throughout our later lives. Because optimism is so critical to healthy longevity, I have tried my best to hew to this frame of mind throughout *Radical Endurance,* even when exigencies, prejudices, and uncertainties begged me to interrupt myself or give up.

Nobel literature laureate Isaac Bashevis Singer reminds us that the pages of our lives can only be turned forward, never back. Only now, as advancing age has granted me the time and psychic space for sustained rumination, have I been able to recognize that certain memorable, consciousness-changing experiences from my past, along with the courageous people who made them possible, affected me so deeply that I was literally transformed from those points forward.

Together with more recent truths that I can no longer ignore or deny, these transformations have helped me understand that aging, as biologists rightly insist on reminding us, begins at birth and continues through a lifetime. It is marvelous what we can see when we open our older eyes to our younger selves. Suddenly, events and experiences that

I once thought of as squirreled-away trash—or treasures—of my past have come alive with new, relevant meaning. As educator Herbert Kohl says, reconsidering our pasts in old age gives us the chance to "grow up again on a conscious level." Indeed, as our lives lengthen, our pasts become the durable, supportive shoulders on which we can stand as we live through old age.

Most spectacularly, reaching old age in an age of longevity means that we now have futures, and for a good number of us they will be long, almost as long as middle age. It is only fitting, then, that in some of this book's stories I have tried to look ahead. By nature we are dynamic beings, and I am unwilling to surrender my remaining years to the ageist myth that I will inevitably suffer an extended period of impairment, decline, and decrepitude before dying. Nor do I feel able to put myself on the front lines of a decisive war against ageism. But in order to be honest with myself, I have to acknowledge—and as a writer give language to—the fact that I will live out my remaining years in a profoundly ageist society.

Ageism, including age discrimination, is thoroughly embedded in today's citified, urbanized American society, a shameful waste product of the twentieth century's longevity revolution. I am sorry to say that few people who grow old in this dominant culture escape ageism's tentacles, so it is important that we speak not only to describe but to resist. As we make ourselves heard, and as we constitute an ever greater share of our society's population, I hope that we will savor the sweetness of justice during the last years of our precious lives.

Finally, a story about entering old age during the first few years of the coronavirus pandemic must, of course,

also be a story about how that global scourge affected the lives of old people. Thankfully I am one who has, at least so far, lived to tell about it, and I have felt with all my heart an urgent moral obligation to do so. Writing *Radical Endurance* has helped me fulfill that vital duty. Growing old is not a story of loss and heartbreak, but it is made so when it occurs at the same time as a highly contagious, incurable virus has shown an ambitious preference for those of us with "old" immune systems.

Old age, I am discovering, is not necessarily a time of life characterized by simplification, simplicity, and retreat. I am beginning to see that it is actually a time of contradiction and unprecedented complexity. In these ways it is like the rest of life: interesting, unpredictable, and at times unbearably hard. But there is one difference. Old age is our final time of life as we know it. Until I began writing *Radical Endurance,* I had no idea how curious I would become about what comes after. Now I am steadfastly hoping that whenever I enter whatever comes after, I will embrace everlastingly everyone I have ever loved, including those who live after me. I know that I will become dust, but I hope, as physicist Carl Sagan suggested, it will be cosmic dust.

Throughout my reading life, I have been buoyed by the life stories of my fellow humans. In each of us there is something for all of us. If we are alive now, chances are still excellent that if we are not already old, we are going to grow old, an achievement I never counted on until it happened to me. No matter your age now, I hope that you will find nourishment for your soul in the true stories offered here and that they will help light your way into the rest of your life.

Part I

~~

Truths

A Leap of
Consciousness

THE DATE WAS MAY 12, 2020, A TUESDAY. THAT PLEAS-
ant morning I awoke feeling rested. I inhaled my daily
emphysema medication, hopped out of bed, did my duty
in the bathroom, rinsed my mouth, washed my hands,
walked into the kitchen, and put on the coffee. I surveyed
my Mississippi River neighborhood from my dining room
window: hardly a ripple. I felt exhilarated in the way that
a Minnesotan feels exhilarated by that extravaganza called
spring; I felt relaxed in the way that a retiree with an ade-
quate pension feels relaxed. I had gotten plenty of sleep; I
felt safe in my home. I was a fortunate woman. It would be
a peaceful day.

 Breakfast was the usual: orange juice with a side of pills
and a half-cup of All-Bran Buds generously spiked with
blueberries. I turned on MSNBC and ate while watching
seven or eight minutes of pharmaceutical commercials and
seven or eight minutes of interviews with medical experts
about the exploding coronavirus pandemic. With break-
fast out of the way, I poured my coffee and went to my
computer, where I spent an hour browsing the morning
newspapers: the *New York Times* and the *Washington Post,*
the *St. Paul Pioneer Press* and the *Minneapolis Star Tribune,*

3

and *MinnPost,* our state's nonprofit digital news room. Keeping up with the events of the day is essential during a pandemic, especially if you live in a country in which the current president is a malevolent madman and his sycophants are made of soaked toast.

A few days earlier, on Friday, May 8, 2020, I had had a televisit with Dr. S. D., my longtime internist, to complete my annual Medicare wellness assessment and review my medical needs in light of the pandemic. Insofar as a visit with one's doctor can be a romp, this one was nothing short of jolly, and why not? My medications were working, which meant that both my emphysema and my Crohn's disease were stable, as was my blood pressure. I was comfortably maintaining my daily exercise regimen of a half-hour of midday yoga and a twenty-minute evening walk. I had no new complaints or symptoms, partly because I was in isolation at home, an incarceration that still felt like a pleasure to this introverted writer. I was also pleased as punch that during my televisit I passed my annual Medicare memory test with flying colors. I am proud to say that I believe I remembered the three words from the 2019 assessment right up until I took the 2020 test. Those words may have been *village, baby,* and *table,* but as I write, it is possible that I am conflating the two years.

In deference to the coronavirus threat, Dr. S. D. and I discussed whether and how long to postpone my periodic examinations, screening procedures, and blood tests. I had a plethora of them upcoming and overdue, ranging from my annual eye, dental, and physical examinations to a DEXA scan to monitor my osteoporosis, a Reclast infusion to treat my osteoporosis, a colonoscopy, a mammogram, and an MRI of my head to assess whether my brain

aneurysms, which had been surgically treated four years earlier, were stable. Without hesitation, Dr. S. D. recommended that I postpone all these until later in the year, when with a little luck and widespread hygienic compliance the worst of the pandemic might be over. In three months, she promised, we would visit again to reassess the situation. She was obviously delighted with the state of my health and ended our visit by exclaiming, "You're doing great! I have *zero* concerns about you!"

Such reassurance from one's doctor! My spirit soared.

Four days later, on that aforementioned May Tuesday, having had my fill of the news, I decided to visit my online health chart to review Dr. S. D.'s notes from our visit. I wanted to clarify whether I was supposed to schedule an appointment for three months hence. I logged in, found my chart, opened the doctor's progress notes, and read the first sentence: "Andrea Gilats is a seventy-four-year-old female who presents at that age." What? Instantly, I reacted to what the sentence could have said but did not: "Andrea Gilats is a seventy-four-year-old female who presents at a much younger age." I felt bemused and slightly hurt. I had never thought of myself as the picture of pink-cheeked vitality, but I had always thought of myself as "presenting" younger than my chronological age. In fact, I believe that my own mother had actually told me as much when I was middle-aged.

She presents at that age. I felt a think coming on. Then, in the split second it takes for puzzlement to become rumination, a shock wave of emotion shot through me. Imagine that in an instant of inattention you walk half a step too far on the slippery rock floor at the head of Niagara Falls, and at the moment the edge betrays you you are swept 167 feet

downward by the fury of the great waterfall. Miraculously, you land alive, but you are forever altered. In a tumble down Niagara Falls, in a stumble down an invisible rabbit hole, in what I can only call an astonishing leap of consciousness, I saw that I was about to descend from older woman to old woman. A self-protective myth was about to give way to reality. In only nine more Tuesdays, I would no longer be a seventy-four-year-old woman who presents at that age. I would be a seventy-five-year-old woman, and heaven only knew at what age I would present then.

Almost immediately, my initial shock was replaced by dread, that compressed, frozen feeling wedged somewhere between high anxiety and deadly fright. I remember abruptly rising to my feet, stunned. In that rush of altered consciousness, I had been struck by the imminence of my own death. Being older means that you will face death after a nebulous, extended future, but being old means that you will die pretty soon. Most of my life was over, and what was left would surely be a downhill slide, the pitch as yet unknown. *Most of my life was over.* It was that apprehension that undid me. I heard myself repeating, "My horizon is shortening, my horizon is shortening." I have never been a good financial planner, but embarrassingly, those were the uninspiring words that came to me in that flash. The mortal fact was that I was running out of time.

With my leap of consciousness had come a new urgency. Suddenly and surprisingly, I was certain there was more I needed to do. I once heard a story, which might have been a legend, about the French artist Henri Matisse, who at eighty-four and confined to what would ultimately be his deathbed, invented a new, do-it-in-bed art form for himself: the iconic painted cutouts that became a touchstone of

his artistic legacy. The story has it that in the artist's final days, when he could no longer summon the strength to take scissors to paper, he lamented his impending death. "What a pity," he is said to have said. "Just when I was starting to get it right." He may or may not have actually spoken those words, but I have always believed that the story is true. It really does take a lifetime to get it right.

Well used or not, I knew that it was time, that most treasured and squandered of all commodities, that I most wanted in old age. Wait. Have I spoken too soon? Actually, it was health that I most wanted, since health is the currency needed to buy time. In my roiling mind, I remembered an image from a decades-old movie. I can no longer recall whether it was Dustin Hoffman as Louis Dega in *Papillon* or Burt Lancaster as Robert Stroud in *Birdman of Alcatraz*, but the image was of a man who was intent on keeping himself physically fit so that he could increase his chances of surviving in the barbaric hellhole to which he had been indefinitely sentenced. Against all odds, he found weights to lift, space to stretch, and the means to preserve his endurance while confined to a stingy cell. He did not let his confinement get the best of him.

I was indignant! I was belligerent! I swore to myself that on July 15, 2020, my first day as an old woman, I would treat myself to a challenging yoga practice, including sun salutations, warrior poses, and balances in order to prove beyond all doubt that these exercises, which had become second nature over my thirteen years of yoga practice, were still safely within my capabilities. I had heard the word *frailty* used to describe an alarming medical condition in which weight loss, fatigue, weakness, and depletion of spirit overtake unassuming old people, and I wanted to squelch that

prognosis pronto. I hoped that if I could maintain enough physical fitness to preserve my independence, I would feel less afraid to face what I imagined, rightly or wrongly, would be the most consequential era of my life.

For the first time, there would be no second chances; after mistakes or misfortune, there would be no more opportunities to try to get it right. I had spent my entire life trying to get it right, whatever "it" happened to be, but now I was face to face with elemental vagaries. For what would I strive? Toward what would I work? Who would I become? The life I had lived over my lifetime was coming to what felt like a screeching end. But once my mind settled down, I began to understand that in its place a new way of living would have to emerge, one in which striving and working would no longer define me. I felt all at once the terror of finality and a faint sense of relief, of movement toward peace of mind.

A Birthday

ON JULY 15, 2020, I CELEBRATED MY SEVENTY-FIFTH birthday online over Zoom with my siblings. Congratulations! I have officially entered the age of invisibility; I am now a member of the mushrooming, if mythic, cohort of people who, dull people absurdly believe, have outlived their usefulness. Like Kazuo Ishiguro's dear Klara, who was cruelly relegated to senescence in a futuristic junk heap, I remind myself that in spite of my continuing humanity, putting me out to pasture or sorting me out of society is a normative, acceptable way that my contemporary workaday culture treats old people. My whirring old mind whizzes through my life course, and I find myself returning to a 1970 film that blasted all naivety from me, forcing me to accept the lifelong possibility that I could, along with millions of others like me, be selected out of existence.

Let me recollect the final scene from *The Garden of the Finzi-Continis,* an excruciatingly beautiful film from 1970. Set in the late 1930s and early 1940s in Ferrara, Italy, the film tells the story of a wealthy, assimilated Jewish family with high enough status in its community to feel insulated from Mussolini's brutal anti-Semitism. The family

comprises Mr. and Mrs. Finzi-Contini; their young adult son, Alberto; their young adult daughter, Micol; and a tiny, ancient grandmother. Over the course of the film, Alberto's poor health fails him and he dies, leaving Micol, her parents, and her grandmother.

By 1943, the Nazis have become entrenched in Ferrara. The city's Jews are being systematically taken from their homes to holding places and from those to Nazi concentration camps. One random afternoon the Finzi-Continis are removed from their palatial home without ceremony and with only the clothes they are wearing. They are brought to a large school building, where, along with about twenty of their neighbors, they are led by a trench-coated henchman down a long hallway of classrooms, Micol and her grandmother following behind her parents. At intervals, the henchman ushers some of the captives into a classroom. When he feels the room is full, he abruptly stops the rest of the group from entering and leads the remaining captives to the next classroom. It is a sorting process based solely on his perception of each classroom's capacity.

As Micol's parents enter a nearly full classroom, the henchman once again stops the group, and Micol, her grandmother, and the people behind them are led into the next classroom along the hallway. In an arbitrary, casual instant, the family members have been separated. As the distance between them lengthens, Micol and her parents look at one another in quizzical disbelief. Wordlessly in these fraught seconds, they ask each other what is happening. Then they enter their respective classrooms, and moments later the film ends. As you watch that moment of separation, as you fix your eyes on the eyes of the Finzi-Continis, you know that they will never see each

other again. You cry for them, and you cry for yourself and for your own family. You know that if not for time and place, it would have been you and yours. You also know, newly, that now that you are old and less strong, such cruelty becomes easier to administer if your society permits or surrenders.

There was a time not so long ago when I claimed a rightful space in the world, when my softening voice was still audible. When was that? Where did I go? Are my past selves lost to the passage of time? Have they aged into the scars, rough patches, and liver spots that speckle my skin? I am not sure. I am not clear yet. Still, against alarming evidence, I have begun to hope that old age might hold a last chance to find clarity, to arrive at end-stage peace.

Our society's dominant culture, from its physicians and research scientists to its sociologists and marketers, has long parsed our adult lives into stages that delineate how we should spend our time, what kinds of health issues we are likely to confront, from whence we should derive meaning and value, and how we should perceive ourselves. These experts usually divide our lives into five stages: childhood, adolescence, young adulthood, middle age, and old age, categories created before people began living what psychologist Laura Carstensen calls "extra long lives." Today, gerontologists further divide later life into three oxymoronic categories: young-old (ages sixty-five through seventy-four), middle-old (seventy-five through eighty-four), and old-old (eighty-five and older). Regrettably, too many of us have gotten used to contextualizing ourselves according to these kinds of categories, an act that I believe reduces our individual humanity and diverse life paths to mealy descriptors that have little specific meaning.

From our vantage points in the twenty-first century, it is easy to think that attempts to segment the white, European human lifespan into discrete stages began with psychologists like Abraham Maslow, whose five-stage hierarchy of human needs helped transform developmental psychology in 1943. But Maslow had nothing on Shakespeare, who in 1623 in the famous "All the world's a stage" speech from *As You Like It,* identified seven ages of life, beginning with the mewling and puking infant and continuing with the whining schoolboy, the sighing lover, the justice in fair round belly, and the bespectacled pantaloon wearer, and concluding with second childhood, in which our player is "sans teeth, sans eyes, sans taste, sans everything." What makes Shakespeare's descriptions so eerily timely is that in the early seventeenth century, life expectancy was only thirty-nine years. But because infant and childhood mortality accounted for that low average, people who made it to adulthood did sometimes ascend to old age, and some of them fell into dementia, the "second childhood" that today's older Americans fear more than any other disorder.

Even though Maslow was describing needs rather than developmental or biological phases, growth was the necessary prerequisite to enter succeeding stages. But as Shakespeare made clear, the human life course is not necessarily a ladder to heaven. Some of the time I still feel like a corpus of my younger selves, but when I examine the particular paths my life has taken, I feel, as Bob Dylan did, that I was older then than now. I know that I must have grown as my life unfurled, but my expedition has not been a series of stepping stones, a scout-like project in which one earns a badge that marks the close of one stage and confers eligibility to go on to the next. Life, as thousands

before me have said, is a river that flows in and through its environments but preserves enough of its integrity to run its route until it reaches its vanishing point.

The Mississippi River, which is my downtown St. Paul backyard, begins as a trickle from Lake Itasca in northern Minnesota, comes into itself as it emerges from the state's northern forests, and flows 2,300 miles through ten states before emptying into the Gulf of Mexico. Yet like the courses of most of our lives, the great river wanders to and fro even as it bisects the country. Periodic floods have rerouted its waters, forming bends and curls that sometimes cause the river to flow east to west or west to east, as it does in the Twin Cities. These idiosyncratic bends and loops are called meanders.

If receding water or erosion causes a rise in a meander's floodplain, it can close, cutting itself off from the river and creating a new pond or lake. That newborn is called an abandoned meander. As the Mississippi flows, it takes on water from its 250 tributaries, and by the time it reaches the Gulf of Mexico it is filled with the waters of the Missouri, Illinois, Ohio, and Arkansas rivers. But even at its mouth, even at its widest and broadest, even at its most cacophonous, it still holds some of its original water, that northernmost trickle.

The Mississippi River symbolizes all that I have been and all that I carry with me as I enter old age. I feel certain that I still hold my source, the primal parts of me that were gifts from my ancestors, and that throughout the ebb and flow of my life I have never lost or discarded. Like the Mississippi, I have also meandered; I have felt myself drowning in floods of my own tears; I have been penetrated by the people, places, and pursuits to which my currents have

led me; dejected, I have abandoned more than my share of them, and sometimes they have abandoned me.

That is why I resist parsing the river of my past into sociological life stages. If I were to do so, it would only be for the sake of my reader, the person with whom I seek a wholly honest, empathetic connection. In that spirit I might call my stages girlhood, young womanhood, marriage (the long period of my life that I spent with my husband), and grief (the long period of my life that I spent grieving his untimely death). I might also call them childhood, teenaged, young adult, middle-aged adult, and older adult. I still mourn the fact that having begun working in my father's grocery store at the age of nine, I have spent too much of my life trying to earn enough money to feel financially stable, if not financially secure. Still, even these two sets of stages, chosen and named by me from the comfort of old age, feel stilted and inadequate as I attempt to characterize the flow of three-quarters of a century.

We are human! I cannot bring myself to feel like Klara must have felt. For me, for now, old age feels like the future because as I write almost all of it lies ahead. Partially, tentatively, I would like to define the old-age stage of my life as an inevitable widening and the terminal opportunity to cleanse myself of unfulfilled desires, pay the last of my bills to humanity, and finally allow myself to be known, both to myself and others. How long, I want and do not want to know, will that widening last? How wide can I become before I am no longer me, an ongoing person? How wide will my river grow before I empty into infinity? To what length will it grow before I am composed entirely of my past?

A Right of Passage

BY THE TIME I ACTUALLY TURNED SEVENTY-FIVE, I was already getting used to the idea that my horizon had shortened, but as in most acts of excessive dissection, I found that the longer I ruminated over this fact, the longer my imagined horizon became. I even began toying with the idea of setting an aspirational longevity goal, something that would fly in the face of the promise I made when I retired from the University of Minnesota eight years earlier: never again would I subject myself to the kind of stress caused by thirty-four years of having to meet someone else's goals. I would dream, I would aspire, I would act, but not for the purpose of reaching imposed, subjective ends.

I wondered if setting a longevity goal might inspire me to live in a way that would lengthen both my lifespan and my health span, the latter defined as the length of time that I could still enjoy reasonably good health and be able to live entirely, or nearly so, without assistance. Though I feel a little arrogant as I think back on it, I finally decided to set my aspirational goal at ninety years old, making my horizon fifteen years. Why such a fancy? Perhaps I thought, and perhaps I still think, that optimism in old age can be

a self-fulfilling prophecy. After all, a study reported in the *Proceedings of the National Academy of Science* in 2019 found that "optimism is specifically related to [an] 11 to 15 percent longer lifespan, on average, and to greater odds of achieving 'exceptional longevity,' that is, living to the age of 85 or beyond." As luck would have it, only days after planting that aspirational longevity goal in my anxious mind, I was presented with an urgent opportunity to learn just how short or long my horizon might be.

It was August, a month past my birthday and time for my annual mammogram. Though I have had annual mammograms for twenty-five years, I always fear them because I feel intensely anxious while awaiting the results. During the day or two following the procedure, I keep an ear tuned to my phone in case the dreaded call comes, and after that I continue to feel on edge until the all-clear email arrives. Twice in the past two decades I have been sent for ultrasound examinations of my right breast, but both were in response to something my doctors felt rather than something seen on a mammogram. Neither exam showed an irregularity, but each helped me feel luckier than I felt before I was tested. I cannot help but compare the sensation to the high one feels when an excruciating toothache, perhaps caused by an infected wisdom tooth, is relieved by a good dentist.

I recently read that seventy-five marks the age at which some health experts suggest that women who are at average risk of breast cancer may no longer benefit from mammograms. I turned to Google, that indiscriminate portal of sources, and learned that the American Cancer Society says that mammogram screenings "should continue as long as a woman is in good health and is expected to

live at least ten more years." On the other hand, the U.S. Preventive Services Task Force, which offers health care providers, governmental entities, and members of the public guidance on whether or not to undergo a variety of procedures and tests, says that because of insufficient evidence it cannot determine the balance of benefits and harms associated with mammography in women seventy-five and older.

The buffet of mammogram pros and cons that experts lay on this table includes the pro-mammogram arguments that breast cancer becomes more common as women age and that old women can and do develop breast cancers that if treated can extend longevity. But there may be a price: old women who undergo mammogram screenings have a 10 percent rate of false alarms, causing them to endure unnecessary tests and needless anxiety. Still, diagnosing breast cancer in its early stages usually means simpler and more effective treatments. The flip side of that coin is that the number of such cancers is small, and breast cancers in old women tend to be indolent. In other words, they would have no ill effect on health no matter how much longer the affected women lived.

My maternal grandmother, Reva Vinarsky Ward (who, purely as a point of interest, stood just over four and half feet tall), was diagnosed with a breast tumor at ninety-one years old and died ten years later of natural causes. Why in heaven's name she was subjected to a mammogram at such an advanced age, I will never understand. There is more: in a leap from the ridiculous to the dangerous, her male doctor recommended surgery, a suggestion that thanks to empathetic, rational thinking by her daughter and granddaughters was never taken. Our old bodies

behave differently from our young and middle-aged ones, and I am only now discovering how crucial these differences are as we make choices about our health care. If we believe that we have reached an age where preventive examinations, tests, and procedures may not benefit us, especially when submitting to those measures might be emotionally draining, painful, or humiliating, I believe that we have a perfect right to discontinue them. In her breathtakingly honest 2018 book, *Natural Causes: An Epidemic of Wellness, the Certainty of Dying, and Killing Ourselves to Live Longer,* the late journalist, political activist, and feminist health advocate Barbara Ehrenreich says:

> I gradually came to realize that I was *old enough to die,* by which I am not suggesting that each of us bears an expiration date. There is of course no fixed age at which a person ceases to be worthy of further medical investment, whether aimed at prevention or cure.
>
> Once I realized I was old enough to die, I decided that I was also old enough not to incur any more suffering, annoyance, or boredom in the pursuit of a longer life. . . . As for medical care: I will seek help for an urgent problem, but I am no longer interested in looking for problems that are undetectable to me.

I did not have a mammogram during the inaugural year of the coronavirus pandemic, but in 2021, after being vaccinated against Covid, I decided, albeit halfheartedly, to have one. Since then, I have opened myself more deeply to Ehrenreich's practices because I steadfastly admire her honesty and the hard-won wisdom from which it springs. For example, several years ago, Dr. S. D. asked if I would like a free CT scan of my lungs because I am a former smoker. The idea was to catch something in its

asymptomatic early stages. Rather than being diagnostic, it was precautionary. Rather than being preventive, it was—how best to characterize this?—informational, like a baseline mammogram.

It took me no time to answer in the negative. I did not want to know if I had a lung tumor then, and I do not want to know now unless absolutely necessary. What if I had had that scan and been diagnosed with an untreatable cancer? How would it have felt to live with that diagnosis knowing that I was helpless against it, as my late husband did? My remaining time on Earth would have been a death watch, whether for a few months or a few years. Living with such knowledge is also a death knell to optimism: it crushes well-being and kills the spirit even as the body continues to function. As it turns out, in old age, ignorance can sometimes be bliss.

Before I quit smoking, I was so afraid of having a chest X-ray or CT scan of my lungs that when I did need to visit a doctor, I scrupulously hid the fact that I smoked, including lying on questionnaires. This meant that for the first sixty-one years of my life, I never underwent an X-ray or lung scan. That run ended in 2006, when what turned out to be an emphysema exacerbation landed me in the emergency room of United Hospital, St. Paul's largest. There I suffered through a botched CT scan, which was followed by a successful PET scan that revealed emphysema but no tumors. I have not had an X-ray or scan of my lungs since and never will again, unless I am convinced that there is a compelling reason why an image of my lungs would be of consequential benefit to me.

Courageously, in *Natural Causes* Barbara Ehrenreich also discusses several deeply sexist, grossly humiliating

medical tests and procedures that until women became physicians in great enough numbers usually involved a dominant male physician and a submissive female patient. First among these was of course the pelvic examination. Because of my own deep, unyielding discomfort, I have never undergone a pelvic examination by a male physician. I would have sooner died. In fact, I was so afraid of invasive examinations and uncomfortable tests that I did not have regular physical exams until I was almost fifty years old.

My doctor-free life came to an end one morning in the spring of 1995 when I awakened feeling so dizzy that I could not sit up. Never before and never since has my head whirled so violently for so long without letting up. In an amazing coincidence of true love, Tom awoke the same morning with his left ankle so swollen that he could not step into his work boots. Though each step burned, he could still walk, so he took charge. After feeding me some Advil, he called my insurance provider's clinic, told them my tale of dizzy woe, and made an appointment for me at two o'clock that afternoon. After that, he called his healthcare clinic, which was then known simply as the "industrial clinic." Come right away, he was told, so he got dressed and off he went in his moccasins.

When he returned an hour and a half later, I was still in bed, unable to move my head. Thankfully, he had received a steroid injection to calm the swelling caused by a mild sprain, and he was already feeling better. He gave me more Advil, took me to the bathroom, held my head as I emptied my bowels, steadied me as I brushed my teeth, and delivered me back into bed, where I rested for another hour or so. When it was time to leave for my doctor's

appointment, he dressed me, bundled me into my jacket, walked me to the car, and secured my seat belt around me.

At the clinic a female doctor with an Eastern European accent listened to my heart and took my blood pressure: 210/110. Heaven help me! With a dangerous bang, I had arrived in middle age. Luckily, by the time I entered the doctor's office my headache was subsiding somewhat, which allowed me to open my awareness to the enormous fish I would now have to fry. There and then I was given medication to reduce my blood pressure, along with two prescriptions for hypertension medications that I would take for the rest of my life. I had avoided the common symptoms of hypertension for months, even years, by attributing my frequent headaches, heart palpitations, and relentless anxiety to work-related stress. Now all of a sudden I knew that stress alone could not account for the turmoil inside my body.

Within two weeks I was free of all these discomforts, but out of that scare had come new obligations. Just in time for my fiftieth birthday, I now had a duty to see my female doctor every three months in order to monitor my blood pressure, thereby averting a stroke, and at her insistent recommendation to undergo the gynecological examinations that would help me avoid a cornucopia of women's cancers as I aged. In one afternoon I became educated. I am neither ashamed nor proud of my ignorance; I offer my lesson here because it is one of the most salient truths about my journey into old age: that it is a voyage that begins sooner and lasts longer than I could have imagined.

If by the grace of my grandmother's genes I should be lucky enough to live past ninety, my final years may not be healthy, happy, or meaningful. They may be years when I

might wish for death rather than endure the life I might be living. As I write, I feel an intensifying passion for life, but I am not afraid to die, especially if I reach a point where my life is depleted of meaning. Health crises, needless losses, and a want of love notwithstanding, I cannot live without meaning. I dearly need the protein of thought, of creative occupation, of engagement with my fellow humans. I need the iron of health to meet those needs, and I need time, whether earned or gifted, to understand once and for all how I can help ease the world.

A Life Alone

BECAUSE MY SEVENTY-FIVE-YEAR-OLD MIND STILL insisted on operating within the ontological confines of the middle-aged woman I had been for more than two decades, I failed to recognize the first manifestations of old age for what they were. Cursory research tells me that the biological journey from older to old is gradual, that environmental conditions and state of mind can hurry or slow it, and that various parts of our bodies age in different ways and at different rates. It is the appearance, the outward presentation, of old age that sneaks up on us. One confounding morning we look in the mirror, and, suddenly, as though it should be a surprise, our grandmother's face is looking back at us.

The medical community actually has a name for this: *apparent old age.* Had I put the chronological together with the apparent, I think I would have suspected that I was leaping from older to old in a hurry, but as rotten luck would have it, it took a tangible crisis of aging to help me appreciate that connection. I had weathered my July birthday, but since the advent of the autumn cooldown around the middle of October I had been losing too much hair. Every day, after combing my hair, the entire surface of my

bathroom sink would be strewn with hairs, like seaweed on a lake bottom. I was also finding hairs on my desk, my pillow, the bathroom floor under my towel rack, my yoga mat, my sofa, and, disgustingly, on the kitchen counter. Like the anguished Gregory Peck in *Spellbound,* any barely discernible dark line on any surface was deservedly suspect. By early December, after about six weeks of unabated hair shedding, I had reached a point where I dreaded washing and combing my hair.

Every day I spent long minutes peering into the mirror, inspecting my scalp as closely as my nearsightedness permitted. I was certain I could see a nickel-sized bare spot, shiny and smooth, on the topmost area of my skull, indisputable evidence that my crown was balding. When I ran my palms along the sides of my head, it felt as though I had no hair at all. In a concurrent blow to my ego, my hair was also turning white at an alarming pace, especially at my crown and temples. Against my pale scalp those fine white hairs were rendered invisible. Even my (dyed) brown hairs seemed wan and washed out. By the middle of December, when I finally went to see Dr. S. D. about my problem, I had also begun to notice that each individual hair was becoming smaller in diameter. I was terrified that I would soon be bald, and I had become irrationally preoccupied with that fear.

While my middle-aged, rational self must have understood that hair loss is not a literal death sentence, my old woman self nonetheless feared that I was descending into debility. I would no longer be comfortable interacting with people, I would no longer want to be out and about in my community, I would no longer feel attractive, and I would certainly no longer feel young. Most dreadfully, whatever

it was that had me yearning for more time on Earth would no longer be possible unless, like my maternal grandmother before me, I were to don a wig that would render my concealed bald head glaringly obvious to anyone I encountered. It never occurred to me that even though my hair was thinning, it was possible that I was not going bald.

My panic consumed me. I forgot to feel grateful for the good health I was enjoying, and I forgot to put empathy first, a quality that had always been part of my nature. Though I could not see it at the time, I had misplaced my sense of perspective. Where had it gone? Why had a reasonable, emotionally stable woman like me become senselessly obsessed with a nonpathological condition that affects half of American women older than sixty-five? Why did I react so tortuously when I should have felt so lucky? After all, I was enjoying a relaxed, free-to-be-me life. What could have led me to blow such a common condition so enormously out of proportion?

Here is a possibility. As I approached my seventy-fifth birthday, I was also approaching the twenty-second anniversary of my husband's passing, an event that left me facing a long future alone. I struggled with prolonged grief disorder for more than a decade, but eventually I found my way into a genuinely satisfying life in which I feel real joy when I sit up in bed each morning. Whether by resignation, reconciliation, or simple preference, I have been lucky enough to find richness in a singleton's life.

Still, after enough time, love not given—love held in suspense—conspires to produce a life that in spite of friends, sisters and brothers, passions, vocations, and religious congregations, turns insidiously inward into itself, like a confused snake attempting to squeeze back into its

shed skin. The result is a self that is cramped, twisted, and unfree, a person out of proportion, a life out of balance. Every pale mole becomes skin cancer, every thunderstorm a tornado, every sneeze the onset of Covid, every new wrinkle a calling card from the Grim Reaper, every day an occasion for too much self-centered rumination.

Love not given forgets itself. Instead of facing life's inevitable vicissitudes with a longtime life partner who loves and supports you, even to the point of kissing your bald spot, you face each challenge alone. There is no one to temper you when you begin to foolishly "awfulize" a benign situation; there is no one to reassure you when you begin to feel that you are no longer lovable. That is why I felt like a bald woman even though I still had a perfectly average head of hair.

As my pandemic homestay lengthened, I found myself sinking ever more deeply into acquiescence; I could feel myself surrendering to stoicism. I admitted to myself that restoring the head of hair I had lived with all my life was as much a fantasy as opening my front door and finding Tom there. After a shocking leap of consciousness that had thrust me into old age before I knew what was coming, after a fit of bravado in defense of my physical fitness, after buying and returning a box of women's minoxidil, I saw the dazzling truth: no matter the state of my hair, I would face the last years of my life alone.

But in a deeply disturbing paradox, I also realized that I would be living as one woman among a pathetic scattering of my peers, a diaspora of aged singletons. Our spouses may die before us; our children, if we have any, will be long gone into their own, sometimes geographically distant lives; our once trusted friends and associates will gradually

fall away as our years in retirement lengthen; and now we would be made to serve an indefinite sentence of forced isolation courtesy of a deadly pandemic.

According to a recent *Merck Manual* study, I am one of about 44 percent of American women who were living alone by the time they reached seventy-five years old. I am also one of 30 percent of American women age sixty-five and older who are widows. This same study found that 60 percent of Americans aged seventy-five and older reported feeling lonely, and the same number reported feeling socially isolated. Tragically, this reflected the state of older Americans before Covid killed three-quarters of a million old people and forced those of us who survived into long-term social sequestration, turning the everyday isolation we had been used to into prison-like solitary confinement.

Though I had lived alone for twenty-two years, only during the early months of my pandemic-enforced isolation did I begin to feel the malaise of loneliness. I tried to reassure myself that I was still wholly me, but I missed my pre-pandemic life. I knew of course that there had been too many people who had been forced to endure much worse for much longer, but those cooped-up summer days of 2020 proved unexpectedly difficult. Even though made unwillingly, my choice to live alone had been an act of personal agency. An externally imposed isolation, I discovered, is a sentence.

In my pre-pandemic life I also spent much of my time alone, but I did so mostly out of choice. My now-past lifestyle afforded social connection (lunch or coffee with friends, dinner out with my siblings, family gatherings for birthdays and holidays), cultural engagement (visiting

museums, attending concerts and plays), time in nature (outdoor walks along the Mississippi River, traveling in greater Minnesota, traveling in the western United States), and forays into the hubbub of the community in which I live (enriching a shopping errand at the Mall of America by savoring a bento box lunch and walking the entire perimeter of the Mall, an afternoon of bingo at Mystic Lake Casino, several annual visits to the Minnesota State Fair). A humble list, yes, but efficacious too. However ordinary, these are the ways in which good health, full mobility, cognitive soundness, and a few extra dollars allowed me to keep loneliness at bay.

I long to live that life again. I sometimes feel hopeless because I am afraid it will never return, and sometimes I forget for a moment that it is gone. Just as one can be angry at God for taking one's beloved partner in the prime of his life, I am angry at the pandemic because it has stolen the ordered life I had made in widowhood. There is more. I am also afraid that if and when the circumstances that enabled my pre-pandemic life return, I may be changed in ways that prevent me from living it. Prerequisites like good health, mobility, mental acuity, and financial resources may no longer be available to me. I resent the pandemic for robbing me of my independent life just when it was most precious to me.

I resent myself for becoming smaller in spirit, suddenly intolerant, overly paranoid, shamefully petty, and hatefully selfish. But these resentments pale in comparison to the anger I feel at the incompetent, cruel United States federal government that failed to control this killer when it had the chance. I grieve with each person who has lost loved ones to Covid. All my anger at the federal government, all

my resentment of the pandemic, all my sorrow at so much death: all are manifestations of grief.

Some experts view loneliness as a symptom of grief and vice versa, but the two are distinct in that we do not have to be grieving the loss of a loved one in order to feel the weight of loneliness. In contrast to grief, loneliness can be formless; it can be diffuse. It can be, as the late John Prine sang, a matter of staring blankly out the back door screen. Rather than the torment of unfulfilled longing, loneliness is a pall. It can feel unreachable, like emptiness, or it can feel heavy and cold, like wet wool. It does not stab; it aches. It does not pierce; it settles on the skin. It is more chronic than acute; it can feel like the news repeating itself in a never-ending loop.

Sometimes we live through loneliness: our outlook or circumstances change, and we recover our sense of well-being. But in old age, loneliness can kill, and that is what scares me. Researchers at the National Institute on Aging say that while social isolation and loneliness are separate states of being, they are not mutually exclusive; behavioral scientists at the Institute have been asking whether "social isolation and loneliness are two independent processes affecting health differently, or whether loneliness provides a pathway for social isolation to [negatively] affect health." The late John Cacioppo, former director of the Center for Cognitive and Social Neuroscience at the University of Chicago, defines social isolation as an objective state evidenced by physical separation from other people (such as living alone), and loneliness as a subjective state evidenced by the "distressed feeling of being alone or separated."

A fact and a feeling, but when it comes to mortality,

feeling seems to trump fact. Cacioppo believes that "loneliness automatically triggers a set of related behavioral and biological processes that contribute to the association between loneliness and premature death in people of all ages." But before killing us, loneliness can make us sick. It is also associated with the buildup of plaque in the arteries, which can lead to strokes; it can promote the growth and spread of cancer cells; and it can increase the inflammation in the brain that leads to Alzheimer's disease.

I need not rely on experts to tell me that loneliness can induce the kind of apathy that conspires to prevent us from acting in ways that will ease our loneliness. But in a time of forced social isolation, what are the elixirs for a household of one old woman? Since March 2020, when the coronavirus pandemic began in earnest in the United States, I have taken to turning on the television in the morning and leaving it on at low volume all day. The subdued hum of cable news personalities' voices delivers the so-called white noise that helps me focus on my writing, an enterprise of faith that keeps me in close, truth-seeking company with myself. But most pleasurably, it harkens a sensation of refuge that I felt as a little girl lying in bed at night being lulled into dreamland as I listened to the muffled voices of my parents in the kitchen. Other voices, other rooms, long ago, but always present.

Part II

Transformations

A Belated Tenderness

ON ONE HAND, THERE IS MY MIND, AND ON THE other, there is my body. But on the third hand, there is my heart, which on the day my husband died shattered into so many incongruent pieces that, like Humpty Dumpty, it proved beyond reassembly. Can we ever fully repair ourselves after a significant loss? I doubt it, nor would we want to do so. Unlike redundant organs like kidneys and matched sets like eyes, our hearts remain our only emotional home even when they are no longer whole. Still, a heart that has been badly broken, whether from the loss of a spouse, the loss of a child, or the indescribable tragedy of never having been loved in the first place, is weakened and vulnerable. It is a heart that may or may not hold out over a long life.

Now that I am old, it is becoming harder for me to remember my life before I lost Tom, but I continue to feel certain that the two decades we spent together were the happiest of my life. For more than a decade before we committed to our relationship, I longed for love, and now, almost two and a half decades after Tom's death, I still long for love. The difference is that as I have aged, I

have become emotionally, physically, and spiritually more fragile than the secure, stable woman who was widowed in midlife. I have never completely recovered my resilience, but I have finally accepted that it is irretrievable in its remembered form. To my surprise, I have begun to regard this as a gift, a blessing. As I enter old age, I feel a belated tenderness, an emotional vulnerability that I now realize had been buried as soundly as Tom's coffin during the years I suffered from prolonged grief.

Sometime fairly recently—perhaps four or five years ago, after I retired from teaching yoga—I experienced, gradually and without thinking, a profound spiritual transformation. I no longer yearned to see Tom. I no longer dreamed that in an understandable miracle he returned to me. I have continued to dream about him once or twice a year, but these dreams have been more perfunctory; they linger as passing reveries in which he had never died and our life together had somehow continued apace. But now, even when I try to focus deeply, I can no longer conjure his body beside me, living here with me in a place in which he has never lived and, most disconcerting, seeing him as an old man in his middle seventies.

In my dreams of him we are both younger, probably in our forties. But if I imagine opening the door of my condominium to him, I can no longer see the handsome man who died at fifty-two. I can no longer deny that I am now almost twenty-five years older than he, and I cannot pretend that it is possible to turn the pages of my life ever more backward until we reunite on the same page. In some profound way he has gone, the victim of an ever-lengthening, relentless passage of time. I remember him vividly and poignantly, I think of him every day, I hold

sacred our undying love. But now the years have over-taken us, and only his spirit remains with me.

My peel is thin, and on the backs of my hands it is actually transparent, due mostly to my steady diet of steroid medications over the past fifteen years. More telling is this: underneath my blotches and bruises, I am newly raw. I cry easily and frequently when I am alone and not at all when I am among people, but that is only one aspect of what I now feel is an age-bestowed, hard-earned depth of tenderness. It is one thing to feel a few silent tears well up as I watch the reunion of Smithy and Paula in the 1942 film *Random Harvest* on Turner Classic Movies, but I have noticed lately that those reserved, barely visible trickles seem to be a thing of the past. Now as I once again watch Smithy cathartically recognizing his beloved Paula after years of shell shock–induced amnesia, I unabashedly bawl the jumbo tears of a baby left alone in the dark.

Part of this acquired peculiarity is that now that my eyes have opened, I cannot seem to control the faucets in them. And why try? These are the good cries that I have stifled throughout a lifetime of bucking up, and now I am making up for lost time. At home there is no one to hear me, no one to assume that my tears are caused by permanent grief or physical pain or mental depression. I am moved, so I cry. I am not sad, I am not in pain, I am simply moved. I feel, so I cry. I listen to music, and I cry. I look at a late Rembrandt self-portrait, and I cry. I read my nephew's beautiful Facebook posts, and I cry. I no longer consider whether crying is an appropriate response to an experience, a thought, or an occasion: I just cry. Crying does me good. It warms my heart. It keeps me human.

My thin peel; my past, future, and chronic illnesses; my

advancing age; and the repeated if easily dismissed pecks at my cognition now leave me with an intensifying feeling of vulnerability, something that also brings tears to my eyes. Some medical experts use the word *frailty* to describe an observable, age-related condition that can lead to poor health outcomes like hospitalizations, permanent disabilities, and death. They describe it as a set of phenotypes: low grip strength, low energy, slowed walking speed, unintentional weight loss, and reduced physical activity. Other experts prefer to use a *frailty index* to define this condition, believing that it is a more sensitive predictor of adverse health outcomes. Commonly called the FI, the index asks diagnosing physicians to check all applicable risk factors from a list of accumulated "deficits," including disabilities, diseases, physical and cognitive impairments, psychological and social susceptibilities, falls, urinary incontinence, and other woeful conditions.

Because they exist in a universe that is so far removed from the soul, neither of these definitions seems fair or adequate or respectful or holistic, so I have decided to try to create a definition of age-dependent vulnerability that honestly characterizes how I perceive my health but at the same time grants me wholeness. I have no use for the ill-chosen word *frailty*. I prefer the gentler, more humane descriptor *vulnerability*. I am more than my illnesses, losses, and phenotypes, and I cannot trust any analysis that ignores these simple truths.

For me, age-dependent vulnerability means a slow, painless relaxing of hardiness; a gradual change of mind in which the material aspects of life seem less important; an acceptance of my biological aging, including the processes that have made my hair fall out and wrinkled my skin; and

a discernible self-thinning, a permeability that refutes my earlier acceptance of the opacity of the veil between life and death. I have come to feel that age-dependent vulnerability is not a descent. It is a kind of preparation, even a form of education, that will continue as my days unfold. It is a transformation that requires no sacrifice, and it invites me, at long last, to be at peace.

That is not all. No matter how much longer I live, I am now ready to accept that the world will not be repaired or healed by the time I die. I accept that this state is not my failure or that of my peers but, rather, our defining human nature. The world, and all of us in it, will always be in need of repair and restoration, no matter our achievements, efforts, or intentions. I have always thought that the two most magnificent attributes of being human were our universal instinct to do for others when it appears that no immediate, individual benefit will accrue to us, and our choice to act in ways that may not benefit our kind until after we are dead.

A Right to Choose

KNOWING THAT I WILL LIVE OUT MY FUTURE IN A perpetually wounded world, I have to ask: Will that world be rendered more beautiful, more complete by virtue of its scars? That is how it appears to me from the calm of my later life perch, but I also feel a palpable shudder of uncertainty. As political winds blow increasingly hotter and colder, can we continue to hope that a country like ours can still move inexorably toward greater justice, greater peace, and greater enlightenment for all of us and our progeny? Can we continue to take moral progress for granted as a permanent cornerstone of our society? In this newly felt state of uncertainty, I think of my unborn daughter.

Her name would have been Rose, after my paternal grandmother. As I write during a surprise November snowstorm in 2021, her forty-first birthday would have been about two months from now, somewhere around the new year. By now she would have been the mother of my grandchildren. Her father would have died when she was eighteen, too young to lose a parent. She would have been brought up right: her father would have doted on her, and she would have leaned on him. Her mother would have protected her from bad influences, instilled in her a love

of learning, and encouraged her to follow her heart. She would have grown up in a family who never had quite enough money but who would have tried to give her every chance to thrive. Born of a Jewish mother, she would have been Jewish; her parents would have put aside enough money for a nice Bat Mitzvah on her thirteenth birthday. She would have gone to college, perhaps at the University of Minnesota, perhaps out of state. She would have turned out well, making her deceased father proud.

She was conceived in the late winter or early spring of 1979, about eight months after Tom and I began living together but before we were married. I had demurred when he proposed marriage because I was still not sure I wanted to make that commitment. Knowing what I know now but did not know then, I shake my head. It was such a cowardly hesitation. I was topsy-turvy in love with him! I vividly remember daydreaming about him at work, and I could not wait to go home to him each evening.

That was my heart, but when I became pregnant my head ruled. At the time Tom had been divorced from his second wife for less than a year, and we both felt that we were still getting to know each other. Our financial future was also far from certain. I had recently started a job in Continuing Education in the Arts at the University of Minnesota, and I was earning a junior secretary's pay. We were getting by, and nothing more. But the superseding truth was that I could not imagine myself as a mother or Tom as a father. At that tender time I did not trust either of us to be worthy parents. We were newly in love, we were happy as we were, and we concluded that it was simply too early in our relationship to start a family.

And I was afraid. Knowing that birth control pills posed

a danger to women who smoked, I had avoided taking them. By some inexplicable grace I had been lucky up to that point. I was trying to use what was then called the rhythm method of birth control, but because my menstrual cycle was imprecise, I could only guess at when I might be ovulating. Supposedly one's temperature rose during ovulation, but I never bothered to take my temperature, and at any rate I do not believe we owned a thermometer.

There was also pregnancy itself. Even in the liberated 1970s, women were counseled not to smoke during pregnancy. Smoking could cause preterm births, low birth weight, and even birth defects. I was hardheaded about the child I was carrying. I admitted to myself that I was not willing to give up smoking. At the same time I was not willing to risk the health of our baby by smoking during pregnancy. One fear was a rock, the other a hard place. With Tom's understanding, agreement, and support, I decided to have an abortion. Fortunately, by summer of 1979, abortion had been legal for more than six years.

If I close my eyes and turn off the television, I can transport myself back to January 22, 1973, when I lived alone in one-fourth of Alan Beck's fourplex at 1664 Selby Avenue in St. Paul. It was a Monday; it may have been late afternoon. I was sitting in the living room when I heard the news flash on National Public Radio. The U.S. Supreme Court had ruled in favor of Jane Roe in *Roe v. Wade*. Abortion would now be legal nationwide. As soon as the words registered in my mind, I broke out crying. I admit that some of my tears flowed from uncontained joy at my own sexual liberation, but overwhelmingly they were the products of unbridled emotion that poured forth in gratitude

for the colossal leap toward full human rights for American women. It was as though the cork had finally popped on a premier bottle of champagne, unleashing a geyser of bubbly ambrosia into the air. "This changes everything!" I brayed to no one in particular.

The unimpeachable beauty of the ruling was that it did not take a secular stance about abortion itself. It merely held that a woman had a legal right to choose whether to have an abortion or not in accordance with her beliefs. For all of us who can no longer imagine a unified Supreme Court, it is important to remind ourselves that the decision in *Roe v. Wade* was a lopsided seven to two. Seven justices ruled in favor of plaintiff Norma McCorvey (Jane Roe) and two ruled in favor of the defendant, Dallas County District Attorney Henry Wade. The ruling, which struck down a ban on abortions in Texas, was based on a constitutional right to privacy protected under the Due Process Clause of the Fourteenth Amendment. According to the ruling a woman has a fundamental right to choose to have an abortion as long as the procedure takes place before the fetus achieves what is called "viability," the ability to live outside the womb, which is usually defined as twenty-four to twenty-eight weeks after conception.

"Someday, abortion will be a humane medical service, not a felony." These are the undated, pre-*Roe* words of Jane E. Hodgson, M.D., writing in the Mayo Clinic alumni magazine. Dr. Hodgson was not only a hero to the world, she was also a prime catalyst in making abortion legal and safe in the United States. She was born in northwestern Minnesota's Red River Valley, in the city of Crookston, in 1915. After high school she traveled south to earn a degree

in chemistry from Carleton College in Northfield, Minnesota, and took her medical training in obstetrics and gynecology at the University of Minnesota.

In 1947, Dr. Hodgson opened a private practice in St. Paul, her professional home until 1972, and during the 1960s she worked for Project Hope in Tanzania, Peru, Grenada, Ecuador, Nicaragua, Egypt, and China. These experiences not only broadened her perspective on women's health, they allowed her to recognize common threads that ran through her patients' diverse lives. She observed that "a woman's place in society was directly related to the availability of abortion services, contraception, and family planning services. In countries where it was all illegal, women were much worse off as far as their overall rights, healthcare, and poverty levels."

Jane Hodgson devoted her life to obtaining and assuring reproductive rights for women. In April 1970, she became the first physician ever convicted of performing an illegal abortion in a hospital when she did a dilation and curettage for a twenty-three-year-old mother of three who had contracted rubella early in her fourth pregnancy. Rubella, then called German measles, can cause birth defects in children whose mothers contract the disease in pregnancy. Dr. Hodgson had advised her patient of this, and the patient had prudently decided to have an abortion. But Minnesota law outlawed abortion except when the pregnancy threatened the life of the mother. Dr. Hodgson petitioned in federal court to declare the law unconstitutional, but when the court failed to rule by the time her patient reached her twelfth week of pregnancy, Dr. Hodgson admitted her to St. Paul Ramsey Hospital and performed the abortion.

A few hours after the surgery Dr. Hodgson was arrested in her office and charged with committing an illegal abortion. She pled guilty and was sentenced to thirty days in jail and a year of probation. Needless to say, her medical license was also revoked. Following *Roe v. Wade,* she appealed her conviction to the Minnesota Supreme Court, where it was overturned, and she resumed her work as a practicing obstetrician and gynecologist. Called a "human rights hero" by the American Bar Association, Jane Hodgson spent most of the rest of her long life advocating for women's health, helping local communities establish women's health clinics, and taking care of patients, including performing legal abortions. She was especially committed to bringing safe reproductive healthcare to women throughout Minnesota, including cofounding the Duluth Women's Health Center in 1981. Blessed with abundant vigor and an abiding sense of purpose, she continued her work until she was eighty-eight years old, passing on in 2006 at the age of ninety-one.

In June 1979, when I had my abortion, Dr. Hodgson was working at Planned Parenthood's St. Paul clinic, located in a former Perkins Pancake House on Ford Parkway, the site of daily anti-abortion pickets for at least two decades. The building was situated across the street from the public library that I visited almost every day as a child and from its adjoining Hillcrest field, where my older brother played pickup softball on summer Sundays. I believe it was mid-morning when Tom and I arrived for my appointment with Dr. Hodgson. We took side-by-side seats in the waiting room, and when my turn came I followed a friendly nurse into an examination room while Tom waited. I remember almost nothing of the events that immediately followed because I was bursting with anticipation at the prospect of

meeting one of my greatest heroes. The awkward truth is that I was so preoccupied with the fact that Dr. Hodgson would be performing my abortion that I temporarily forgot why I was there.

I distinctly remember lying on the examination table when Dr. Hodgson entered the room. She smiled. She greeted me, told me what she would be doing during the procedure, and set about her brief preparations. I put my heels in the stirrups and she began. At that point I began gushing: "I just want to tell you, Dr. Hodgson, what an honor it is to have you do my abortion. I admire you with all my heart. Your work has meant the world to me and millions of other women, and I hope that you're okay after all you've been through. I love you."

Grinning, Dr. Hodgson gently thanked me as she worked, and within what seemed no longer than ten minutes it was over. I do not remember having any pain at all, mostly because I had probably been given a local anesthetic, but partly, I am sure, because I knew that I was in the best of hands. Tom and I drove home, and because we had both taken the day off from our jobs, we spent the afternoon relaxing in front of the television. I napped on and off, and Tom made dinner, which must have been Hamburger Helper. I bled, I think, for several days, and sometime soon after that, my menstrual periods resumed. Time passed, our relationship deepened, and eventually we decided that we would not try to have children. Other than my lifelong reverence for Dr. Hodgson, I rarely if ever thought about the fact that I had had an abortion, and as long as Tom was alive, I never had second thoughts or regrets about my reproductive decisions. Without much consideration, I easily put them behind me.

Now that I am old, I wonder if that was a uniquely youthful, nearsighted way of thinking. Menopause, which for me began a few months after Tom's death, made these decisions permanent; for other women it may have been childbirth that resolved any misgivings about motherhood. After Tom died, I sometimes wondered whether my own grief would have been eased if I had been able to comfort and care for our grieving daughter. I also wonder how seeing him in her would have affected me. Several weeks after Tom died, his grown son from his first marriage paid me a visit, and as I talked with him, it was all I could do to keep from breaking down. His facial features and expressions, his gestures and movements, the timbre of his voice, all so like his father's, felt like bullets to my heart. My grief would not allow me to accept the blessing of biology: that human beings reproduce and thereby continue themselves even after their deaths.

Today I have neither the fortitude nor the appetite to doubt that I made the right choice at the time, but as the arc of my lifespan bends downward, my longtime certainty seems to be giving way to complexity and contradiction, conditions that beg our acceptance as we try to make peace with ourselves. Very little, we learn, is wholly one way or another, and some decisions become permanent transformations no matter how we regarded them when they were made. Resignation and reconciliation mix readily with regret when reconsideration is no longer possible. As I find myself increasingly separated from all to which I have belonged during my life, I feel twinges of envy for my peers who are now enjoying the pleasures of grandparenthood. I have four great-nieces (one of whom identifies as nonbinary) whom I love, but I am not part of their

day-to-day lives. Even so, I take quiet joy from simply observing them from a distance, watching their characters take shape, learning how they choose to place themselves in their worlds, and seeing their individual personalities bloom forth.

Author's note: With the exception of its first paragraph, this chapter was written before the *Dobbs* case came before the Supreme Court. On June 24, 2022, *Dobbs v. Jackson Women's Health Organization* overturned *Roe v. Wade,* leaving each state to decide for itself whether abortion should be legal. I decided to let this story stand as I originally wrote it rather than amending it to include the reversal of rights wrought by *Dobbs.* It is profoundly important to remember that following *Roe* abortion was legal in every state. This story now stands as hope that it will be so again.

Living like Joan Baez

HOW LONG DO OUR MEMORIES REMAIN ALIVE WITHIN us? We speak of recollection as though it is possible to access even our most ordinary memories throughout our lifetimes, but now that I am old, I know with poignant certainty that this is far from the truth. As I write, I am forced to fill in important blanks with speculative, indefinite language in order to keep myself honest. It is excruciatingly frustrating to me that I can no longer recall so much of my past, especially my childhood, adolescence, and young adulthood. I rationalize this by supposing that the life events I have forgotten must not have been important when they happened, but this too is a far cry from the truth.

I believe that we forget because over our lifetimes our minds become crowded, with more recent events pushing aside less recent ones, and, eventually, as our experience heap grows higher, we unconsciously obliterate memories that have sunk to the bottom of the pile, whether through attrition, self-neglect, inattention, or trauma. Still, alongside all that I have forgotten, and as resistance against allowing some of my most transformative memories to slip out from under me, stand a few extraordinary experiences

that, though heartbreakingly diminished by time, remain hallowed in my heart, alive in my values, and embedded in my actions.

Here is one.

When Joan Baez's self-titled first album was released in October 1960, I was fifteen years old, just four years younger than Joan when she recorded it. It had been a banner autumn: I had shed my thick glasses in favor of a contact lens in my right eye (my left eye was too near-sighted to benefit from a corrective lens); I had matriculated to St. Paul's Central High School, the largest, most diverse in the city; and I had met my first boyfriend, a budding guitarist whose family had recently moved to our neighborhood from Milwaukee. By then I was a seasoned artist and frequent writer, but most memorably I was devoted to music.

I no longer remember whether I had seen Joan on *The Ed Sullivan Show* or heard a song from her album on the radio, but I bought that debut album immediately after hearing her sing. I also bought every album she recorded for the next thirty years. It was not just the thrush-like purity of her angelic voice that transfixed me; it was the loveliness and meaning of the songs she sang. From "Silver Dagger" (*"All men are false, says my mother"*) to "All My Trials" (*"Hush little baby, now don't you cry. You know your mama was born to die"*), and in later albums, labor songs like "Joe Hill" (*"Where working men defend their rights, it's there you'll find Joe Hill"*) and now-classic Bob Dylan antiwar songs like "With God on Our Side" (*"The words fill my head and fall to the floor / that if God is on our side, he'll stop the next war"*).

Along with my leftist father, who with many of his

friends was a fellow traveler during the last years of the Great Depression, it was Joan Baez who politicized me as I grew from girlhood to womanhood. Nourished by her for decades, I stood fast within the political values she imparted to me, both through her songs and her political actions. It was that congruence that affirmed the authenticity of her voice and amplified its reach beyond anything I had ever experienced. To be made aware of injustice, to understand injustice, to witness injustice, even through books or films, was not enough. If one were aware, if one understood, if one witnessed, one was compelled to act. There is no justification for standing by while human suffering proceeds apace, whether through prejudicial poverty, institutional denial of human rights, mass murder in imperialistic, ideological fighting wars, or racial genocide.

These are some of the ways in which one woman's glorious voice penetrated my heart and elevated my consciousness, and why on the morning of June 21, 1972, my sister Nan and I settled into our seats on a Greyhound bus bound for Washington, D.C., where having answered a public call from Joan Baez we would join two thousand other women and children to create a human ring around the U.S. Capitol in order to protest the Vietnam War. Said Joan a week earlier to the *New York Times*:

> This is an attempt . . . in the hope that women and children can have some kind of creative, dignified, nonviolent—obviously—and civilized effect. Ring Around the Congress is what it's called, and it's pretty symbolic, and we—just the women and children—will make a literal circle around the Capitol—to say that Congress should cut off funds for the war. At a certain point in the day

anybody who wants to—and who hopefully will have written ahead—will go in and talk to their Congress people. Not, you know, to have long discussions about whether the boys should be there, but just to say, "Look, we're women, we're kids, and we just can't stand it [any] more."

We rode the overused, undercleaned bus all day and all night, passing through towns whose green highway signs, though still clear to me in form, are now devoid of lettering, like dolls without eyes. Their names, sad to say, will balance in perpetuity on the tip of my tongue. After what must have felt like an interminable night, the sun came up, and we arrived in Washington at what must have been about eight o'clock in the morning. We had a few hours of free time before assembling at the Capitol, so we headed to the bus depot's cafeteria for some breakfast, seating ourselves at one end of a long, empty table. Soon after we arrived, a man and a woman came and sat at the other end of our table. Possibly in their forties and looking unkempt and discouraged, they immediately made their presence known to the entire cafeteria. As soon as they sat down, the man began growling loudly and angrily at his companion, who kept trying to ignore him. To our naive ears they sounded drunk; only afterward did we realize that they must have been high on drugs.

As their words grew more heated, so too did the man's physical threats, and before we knew it, he began lunging at his companion from across the table, extending his long arms and fingers to encircle her neck. In a flash he had pinned her to the grimy vinyl floor and was brutally strangling her as he shouted sexist obscenities inches from her face. Her cries were a mind-curdling mixture of scratchy

screams and gasping coughs as she flailed her arms and kicked her legs over and over again, ultimately revealing her undergarments as her dress rode up to her waist. Shocked, Nan and I quickly rose from our seats, but we remained frozen in place as the murder attempt unfolded before our eyes. Finally in what had to be the nick of time, a security guard or policeman arrived and subdued the man, helped the woman up, and escorted them from the cafeteria. Where they went we will never know.

As I relive the horrible scene in my mind, it rolls in slow motion, leaving me with the impression that it must have lasted several minutes. But the plain fact is that it probably lasted only two or three minutes, otherwise the woman would have surely met her death. That she walked away from the scene still amazes me. That she had to live on after the attack is an object lesson in the supercilious nature of torture. What I remember, or imagine I remember, about him: the extraordinary length of his arms and fingers, the hate in his eyes, the piss in his voice. What I remember, or imagine I remember, about her: her black-penciled eyebrows, the fear in her eyes, her garnet lips, her chalky face. What I remember, or imagine I remember, about them as a couple: their dejection, their disrespect for each other, the feeling that their personhood, their human character, had somehow been excised from them, taking with it their divine entitlement to dignity.

Sickened by what we had witnessed, I doubt that Nan and I actually ate breakfast, but in due course we arrived at the Capitol, where we began making our way through the crowd to find Joan Baez. Though surrounded by photographers and fellow demonstrators, she was surprisingly approachable, and I remember as though it were yesterday

standing immediately to her left as she sang "Amazing Grace" into a small round microphone. Dressed in a white shirt and denim overalls, she looked and sounded just as I imagined she would: pure. When she finished singing, Nan encouraged me to approach her. I must have tapped her on the shoulder, and she turned to face me. "I love you!" I blurted, and she embraced me with all her might. I hugged her tightly, overcome with love, and after we separated, I asked for her autograph, which she gave me on a small scrap of paper torn from a poster publicizing the demonstration.

After the songs and speeches we formed our ring around the Capitol by holding hands with the two people on either side of us, enlarging the circle as more people entered it, and as far as I can remember ultimately closing it to create an unbroken human ring. It was a spectacular gesture. I held Nan's left hand with my right one; then in an astonished glance, I realized that the hand I held with my left belonged to Candace Bergen, who stood nearly six feet tall and looked like a golden goddess in her camel's hair blazer, flowing honey hair, and impossibly delicate facial features. There I was, chubby and disheveled, with bitten nails and a crooked tooth, and smelling from an overnight bus trip. But I had just hugged Joan Baez and I was now holding hands with Candace Bergen. I was in heaven.

Dutifully, Nan and I trotted off to visit former vice president and recently reelected U.S. Senator Hubert H. Humphrey, who in spite of his politically calamitous waffling on the Vietnam War still held the hearts of progressive Minnesotans, a term that in 1972 described most of the state's citizens. Alas, the Happy Warrior was not in his office when we arrived, so we spoke with an aide. On that

June day the war was raging. Peace seemed no closer than it had when Richard Nixon took office in January 1969, promising to gradually put the South Vietnamese in charge of the fighting so that America could "honorably" extricate itself. Called "Vietnamization," the policy, like the others that preceded it, failed completely. By 1972, it felt like the war would last forever.

It did not. While Nan and I were busy protesting, "peace" talks among the United States, South Vietnam, North Vietnam, and the Vietcong were underway in Paris. Pursuant to agreements finally reached there in early 1973, the United States withdrew its remaining combat troops without pretext. In return the North Vietnamese released what they claimed were the last of the American prisoners of war held there. Over the following months, the war became one of attrition between north and south, with the iron-willed, China-supported North Vietnamese and Vietcong soldiers outmanning and outlasting South Vietnam's war-weary troops, bringing about the exact end that American politicians and generals had predicted for so long: the triumph of communism. Finally in April 1975, the nation of Vietnam, which by virtue of a 1954 treaty had been split into north and south at the seventeenth parallel, were violently reunited when North Vietnamese forces stormed Saigon, South Vietnam's capital city.

The Vietnam War, which was the first of several senseless wars fought by the American military during my long adulthood, left almost four million people dead, including about fifty-eight thousand Americans. Many of them were "fighting age": young people conscripted or otherwise convinced to fight a war whose outcome had been clear from the start but which, in the name of thwarting "the

spread of communism," had been prolonged by American ideological arrogance, an act that in its cruelty was equal to beating the same dead horse for twenty years.

With our senatorial visit completed, Nan and I returned to the Greyhound bus depot, boarded the bus that would take us home, rode through the night, and arrived in St. Paul the following afternoon. In one long day, we had witnessed an attempted murder at shockingly close range, we had embraced heroic Joan Baez, and we had helped make an important objection to the evils of the Vietnam War. We had seen the worst in us alongside the best in us, and it was this juxtaposition, as much the events themselves, that rendered the day forever unforgettable. All it might take is one jolting encounter with hatred and madness at a big-city bus depot to lose one's innocence about the violence that so-called civilized people can wreak upon one another when they have been debased by an inhumane society. At the same time, we were washed of the sin we had witnessed when I received the love that poured forth from my most deeply admired hero as she returned the awkward expression of adoration I had offered so artlessly.

Though seemingly contradictory, it is possible to treasure an experience you would not want to relive, partly because its specificity and complexity render it beyond reenactment, but also because I am no longer intrepid. I no longer feel the inner impetus toward front-line activism that allowed me to answer Joan Baez's call without hesitation or trepidation. As I have aged, I have lost my innocent fearlessness. Nonetheless, after fifty years the desire to act remains unchanged within me. It is just that the switch that powers it into action no longer works. Today the thought

of riding a bus to and from Washington, D.C., makes me cringe with discomfort, and I would probably collapse in fatigue if I had to walk the perimeter of the U.S. Capitol.

Though I will always cherish this extraordinary experience, the task of preserving it in language has been messy, frustrating, and at times actually nauseating. I also feel bound to admit that I have relied heavily on Nan's recollections to render our story in its fullness. In particular, I have no memory at all of visiting Senator Humphrey's office, returning to the bus depot after the demonstration, or riding home on the Greyhound bus. This, I now understand, is the price I have paid for not writing about our trip fifty years ago, when it was still fresh in my young mind, the mind that I thoughtlessly assumed would remember forever everything I ever did.

An Inner Life

WHAT IS LEFT AFTER ONE'S ABILITY TO ACT IN THE world has been indefinitely curtailed by the doggedness of a viral devil? What is left after one's family and social life has been reduced to online confabs? What is left for old widows and other aging singletons who have been forced to fend for themselves within the confines of their own walls? If the forces that connect us to one another no longer exist, what, after all, is left to keep us human? Only connect! And if, as E. M. Forster warned, we do not, what is left to keep us from simply giving out and dying? Short of death, what is left to keep us generous, empathetic, and considerate? What is left to keep us whole?

An inner life. A life of the mind. An intellectual life. A creative life. A life of the imagination.

These are the flames, lit purely by thought, that enable us to live in opulence even when we are starved for human contact. They, and they alone, remain after everything else is lost. I have come to believe that no matter how brutally beaten down and left to die, the life of the mind can still be rekindled. Reports from the Holocaust suggest that it was our innate ability to think ourselves into survival that helped save death camp prisoners during World War II.

In *Man's Search for Meaning,* Viktor Frankl even goes so far as to say that "in some ways, suffering ceases to be suffering at the moment it finds a meaning, such as the meaning of a sacrifice." While in Auschwitz, Frankl experienced an intensification of his inner life, in which thought, especially concentrated contemplation of his beloved wife (even though he did not know whether she was alive or dead), transported him away from "the emptiness, desolation and spiritual poverty of his existence." Of those who suffered with him, he says:

> Under the influence of a world which no longer recognized the value of human life and human dignity, which had robbed man of his will and made him an object to be exterminated . . . under this influence the personal ego finally suffered a loss of values. If the man in the concentration camp did not struggle against this in a last effort to save his self-respect, he lost the feeling of being an individual, a being with a mind, with inner freedom and personal value. He thought of himself then as only a part of an enormous mass of people; his existence descended to the level of animal life.

<p style="text-align:center">* * *</p>

I cannot remember a time when I have not had an active inner life. That internal fecundity could explain why I became introverted in childhood and have remained so all my life. I am sure that I was making art by the time I was two or three years old, and I am sure that my child's imagination was also roaring by then. But it was at age six when I learned to read that I gave birth to myself. I read therefore I thought; I thought therefore I was. I read and thought, therefore I could make meaning, and, instantly, without forethought, I became dependent on meaning

to keep me alive. Several years before dementia stole his mind, my father told me that as soon as I learned to read I became a different person. He said that before I started reading I was a fun-loving child who ran around the neighborhood playing with my fellow baby boomers, but once I started reading, he noticed that I became silent and sedentary. He even asked my mother if I was sick.

Thought is profound and magnificent. It is eminently satisfying as an end unto itself, it is supremely efficacious because we must think in order to survive, and it is equipped with infinitely capable wings. Through it we can leave our fearful, injured bodies behind, at least for a while, and settle down with a true love on a sun-washed piazza in a seaside village where mutual understanding wafts mildly through the breeze and all is always well. Because thinking is in our nature, we take it for granted. Just as we are given eyes to see and ears to hear and mouths to taste and speak, we are given minds to think. Only disease or death can destroy them. At least that is what I would have believed, if I had thought about it, until May 21, 1992.

In 1992, the United States of America was actively commemorating the passing of five hundred years since the ships known as the *Niña,* the *Pinta,* and the *Santa María* arrived at Guanahani, an island in the Bahamas that was home to the Lucayan people, whom Christopher Columbus promptly enslaved. Though Columbus never set foot on what is now U.S. soil, at some point during the five centuries since his landing, the myth that he had discovered America took hold and persisted: his landing day, October 12, has been celebrated by Italian Americans since 1792.

During the year leading up to the quincentennial, educational institutions, community organizations, and tribal

nations throughout the continent were developing curricula and sponsoring programs that would interrogate and ultimately dispatch the myth that Christopher Columbus had discovered the land that became the United States of America. In an action that several U.S. cities would soon imitate, the city of Berkeley, California, declared October 12 Indigenous People's Day. It was an exciting time for cultural workers like me. Earlier that year, the University of Minnesota had allocated funding for my department to hire a "diversity coordinator" to create programming that would promote what eventually came to be called, euphemistically or not, "cultural competence," the individual capacity to understand, communicate, and interact authentically across cultural and racial divides.

To fill our newly created position we hired Carolyn Bordeaux, an educator and women's studies scholar. Carolyn, of Sicangu Lakota heritage, had been born on the Rosebud reservation in South Dakota, but as the daughter of a civil engineer she had grown up in California and spent her high school years in Pakistan. She created a morning-long educational program featuring two renowned Native American educators, Carolyn's cousin Lionel Bordeaux, president of Sinte Gleska University, located in Mission, South Dakota, on the Rosebud Lakota reservation; and David Beaulieu, one of North America's most renowned educational policy leaders. An enrolled member of the White Earth band of Ojibwe and a former commissioner of human rights for the state of Minnesota, Dr. Beaulieu has been a pioneering leader in Native American education.

We promoted Carolyn's program to the university's staff and faculty, and to no one's surprise the event drew

an eager crowd of more than fifty colleagues. As we seated ourselves at small tables of six people to drink our coffee and eat our blueberry muffins and whole strawberries, it was easy to strike up conversations with our tablemates. In the first of three life-changing lessons that day I had an unexpectedly memorable conversation with a young African American man who had come to the University of Minnesota the previous fall as the resident counselor for one of the Minneapolis campus's residence halls, either Comstock or Centennial. I no longer remember his name, so I will call him Anthony. Dedicated and thoughtful, Anthony had chosen the university after refusing a similar job offer at South Dakota State University.

Laughing wryly, he told me about his interview with SDSU's housing director. It seems that this man had without being asked assured Anthony that he would encounter no racism on that school's campus. "We don't hate Negroes here, we only hate Indians," he declared. With a broad grin and a shake of his head, Anthony exclaimed that he could not exit that interview fast enough! He understood immediately that this man was the worst kind of racist. "He wore it like a badge," said Anthony. Then he said something that I will never forget: "Haters hate broadly." His meaning was this: people who hate Native Americans also hate African Americans and any other people who are different from them.

Haters hate broadly. I have spoken and written that sentence to myself and others countless times since my conversation with Anthony so many years ago. To this day I have never heard such precise words express such an obvious truth, and yet people like the SDSU housing director not only continue to be tolerated but receive

acceptance and respect in all facets of life, including the most influential ranks of government, education, industry, and jurisprudence. Fortunately for Anthony, he was able to secure a position that promised less overt racism, but not everyone has that option, and if you have been a target often enough, covert racism becomes as plain to you as the overt variety. So it was that a small conversational story told by a big-hearted, strong-minded young colleague held for me a lesson so indelible that I could not render a truthful portrait of my ontology without recounting it.

Our program that May day began on the heels of Anthony's story. After a fine speech by President Bordeaux our attention turned to David Beaulieu, who gave one of the most unforgettable speeches I have ever heard. As I lift my fingers to write about it, I feel struck once more by the fact that I could have been so ignorant of history that it never occurred to me to apply the lessons of the Holocaust, which had been drummed into me as a child, to the genocide of our continent's Indigenous people, an unabashed attempt at extermination carried out over five centuries on the soil we now call ours. David began by telling a small story of his own, about a job he had as a student:

> I worked in the museum and collections section of the state historical society. I worked there summers and then part time when I became a student at the University. I was asked to stay late once, and to go up to the third floor vault and pick out a black box with a certain number on it. I did. I went up there, I got the box, I brought it downstairs to the photography section where there were two men waiting to take a picture of what was in there. I opened the box and inside was the skull, the tanned scalp, and the arm bones of Little Crow, the leader of the Sioux

war in Minnesota. I was somewhat astonished to realize that such a historical personage was in this box at the state historical society. I asked some questions and found out that one of the men there represented Little Crow's grandson and had come from Flandreau, South Dakota, to take a picture of the remains because he was unable to secure the burial of Little Crow when he first discovered his grandfather on public display at the state capitol and wanted to bury him, but because he was refused that, the state saying that they owned the remains, had this guy come up and take pictures every so often to prove that his grandfather's remains were still there and that they weren't damaged, etc.

Little Crow was shot to death by a white farmer on July 3, 1863, near Hutchinson in south central Minnesota. Afterward his body was dragged through the streets of that town and ritually mutilated by the town's white settlers. Finally, the tortured corpse was dumped in a pit to decompose. At that point an enterprising army lieutenant cut off Little Crow's skull, scalp, and wrist bones to keep as trophies, in the same way that some Minnesotans might display the stuffed head of a buck deer in their homes. In 1896, Little Crow's remains were donated to the Minnesota Historical Society, where they were archived until 1971, when they were returned to his heirs, who gave Little Crow a proper burial among his ancestors.

What remains after a Native American father, deprived through brutal racist imperialism of the land that fed his family, is shot in cold blood while picking raspberries in a low thicket with his little boy? What remains after millions of Holocaust victims, having been stripped naked, are gassed to death while packed like vertical sardines in

an execution chamber disguised as a communal shower? What remains after thirty-three thousand Jews, one of whom was my great-grandmother, are marched into a Ukrainian ravine called Babi Yar, slaughtered like penned cattle, and covered over with the same earth that once provided their livelihood? Only bones, and even those are not free from human abuse, as I learned by listening in rapt shock to the story of Little Crow's afterlife.

Remarkably, the third and grandest lesson of May 21, 1992, came not from young Anthony's story or David's story but from a history lesson that David offered as the essence of his speech. To begin, he asked if we knew about the seven stolen rights of American Indians. The vast majority of us shook our heads in the negative. He then told us about a man whom most of us had never heard of: Arthur Caswell Parker, the longtime director of the Rochester Museum of Arts and Sciences in New York and the inaugural president of the Society for American Archaeology. Born in 1881 on the Seneca nation's Cattaraugus reservation in western New York, Parker was Seneca on his father's side. As a small child growing up among his Seneca family, he had the benefit of tribal knowledge imparted by his grandfather and great-uncle, both revered community leaders.

On advice from his grandfather, Parker began studying for the ministry after high school. He apprenticed as an archaeologist while doing so, and it was that work that led to his career. He also became an abiding activist for Native American social and political justice, and together with Dr. Charles Eastman, a Native American of Santee Dakota descent, founded the Society of American Indians in 1911. In 1916, Parker published what was to become an article

for the ages in the *American Journal of Sociology*. In "The Social Elements of the Indian Problem," Parker argued that "there is little real understanding of the blight that has fallen upon the red race in the United States." To explain, he discussed seven rights that the United States stole from Native Americans. David read them to us directly from Parker's article:

> The people of the United States through their governmental agencies, and through the aggression of their citizens have: (1) robbed the American Indian of freedom of action; (2) robbed the American Indian of economic independence; (3) robbed the American Indian of social organization; (4) robbed a race of men—the American Indian—of an intellectual life; (5) robbed the American Indian of moral standards and of racial ideals; (6) robbed the American Indian of a good name among the peoples of the earth; (7) robbed the American Indian of a definite civic status.

The words landed on my head like an atomic bomb. After I heard them I was never the same. Then and there my mind began racing. Of all that had been stolen, from a way of life to a right to human agency, what could it mean to be robbed of an intellectual life? To be robbed of the capacity to think? The idea seemed at once incomprehensible and all too real given our country's treatment of Black slaves at the same time as it was attempting to exterminate North America's Indigenous people. When everything else is lost, do our minds remain our last sanctuary? Are they our safest haven? Until that day in 1992, I must have believed that the human mind was a hallowed place where freedom reigned no matter how shackled or degraded our situation. Without ever questioning my right to my own mind, I must

have assumed that an intellectual life is a permanent birthright that exists beyond the reach of any external force. It never occurred to me that it could be stolen or otherwise beaten out of me.

Later I located Parker's article and read for myself exactly what he meant by an intellectual life:

> In his native state the Indian had things to think about, things and forces vital to his existence. Unless he thought, he could not live. . . . All men must have a thought nucleus. Rationally associated concepts become the basis of intellectual activity. When thought springs from activity and leaps to action, interest and desire are created, and the man finds in thoughts things that keep him alert. . . . Human beings have a primary right to an intellectual life, but civilization has swept down upon groups of Indians and, by destroying their relationship to nature, blighted or banished their intellectual life, and left a group of people mentally confused.

Without a life of the mind, we are for all intents and purposes dead. What is perpetrated on the body also destroys the mind, and what tortures the mind ultimately degrades the body. I am sure this has always been so. No matter the nature of the hatred (racism, manifest destiny, anti-Semitism) or its execution (enslavement of Africans by Europeans, attempted extermination of Native Americans by European imperialists, genocide of European Jews by the Nazis), haters have leveraged these double-helixed truths as their stock and trade. Arthur C. Parker gave actionable meaning to my restless, diffuse empathy, enabling me to act on behalf of it from that point forward in my life.

Part III

Growing Old

An Encore

THREE YEARS BEFORE I RETIRED FROM THE UNIVER-
sity of Minnesota, I accidentally, against all logic, and
without preparation, training, education, or inclination,
became an "expert" in the burgeoning interdisciplinary
field then called healthy aging. Before I could think, before
I could worm my way out of it, before I could make myself
sick with anxiety over it, my dean and I began working
under the auspices of the university's vice president for
human resources to create a seminar series designed to
motivate reticent older faculty members to take the plunge
into retirement.

The fortunes of our project were significantly enhanced
when we were joined by a community-based family physi-
cian who, with support from a foundation-funded middle-
career fellowship, was working toward solutions to the
growing problem of late-career burnout among physi-
cians. Though his work centered on dissuading experi-
enced physicians from retiring, and ours centered on per-
suading the university's longest-serving faculty members
to do the opposite, both efforts centered on helping these
professionals direct their time and energy in new ways,

whether within one's primary career as a physician or beyond one's primary career in the academy.

Because our budding series looked at retirement planning as more than financial planning, it broke new ground. The stable, well-off academics we were hoping to serve were not much worried about their financial futures, but to a person they were frightened to death of giving up their jobs. What would they do with themselves? How would they fill all that newly freed time? How would they occupy their minds? Worse, who would they be without their life-long career identities? What would become of their worldly status? How would their lives continue to matter? To what and whom would they belong? For these entrenched academics, retirement represented a loss that went far beyond their duly anticipated loss of earnings. It represented a profound, irrecoverable loss of selfhood. They could see no life path beyond their careers, and because of that, they viewed retirement as a living death that in our age of radical longevity could well last two or three decades.

To these people, most of whom had enjoyed advantages and privileges afforded to few earthlings, our seminar series, which we called Encore Transitions: Preparing for Post-Career Life, was transformative because it enabled them to embrace transition as an optimistic, clarifying time of life. With guidance from physicians, financial planners, civic leaders, psychologists, artists, and writers, and with collegial support from their peers, participants could find language for expressing and overcoming their fears, they could plot their next "decade at a glance"; they could learn to value lifestyle modifications over genetic inheritance when considering their health outlooks; and they could even learn what *having enough* means when it

comes to money. The result was that participants could actually picture themselves in a life after retirement, a life in which every eventuality was not yet clear but on which they could count in the same way as they had counted on going to work at the university each day.

This not only calmed them down, it whetted their appetites for a life of greater control over their time, which meant more time with grandchildren, more time for long-postponed vacation travel, more time for helping those in need, more time for hobbies that had languished for decades in the musty corners of their lives, and more time to slow down and regain their sanity.

As psychosociological theories of aging then held, our post-career years would arguably be the best of our lives. Biologically, we would be relatively young for at least another decade; functionally, we would be healthy for even longer; and emotionally, the greatest barriers of our lives would have long ago been overcome, thereby granting us sustained peace of mind. Just in case, however, our holistic program also included an inspiring session with a psychiatrist specializing in resilience, allowing participants to consider the effects of setbacks and losses as they aged.

For many of our participants, this shining scenario actually came true, at least in part and for an unknown length of time. More than half decided to retire during the year after they participated in Encore Transitions, and an additional number committed to retirement dates in the year or two after that. Indeed, much of what I later came to regard as overly optimistic, shamefully elitist happy talk proved valuable to our audience. Encore Transitions was a principled, credible educational effort conceived within a framework that at the time made sense on paper and

in conference rooms, and was delivered in a format that showcased esteemed scholars from the academy alongside respected experts from the Twin Cities community. Our popular program was a perfect example of an urban public university seizing a unique moment in American history, the moment when seventy-eight million baby boomers would begin turning sixty-five years old.

* * *

But for me there was a fundamental problem. As the program's director and co-architect, I had come to Encore Transitions with too little knowledge of the subject at hand: an amount deficient enough so that wise educators would characterize it as a dangerous thing. It takes time, study, and independent thought to develop a critical perspective in one's field of endeavor, in this case healthy aging. Having worked in the arts for most of my career, I lacked that. I did not even know how to swim, let alone serve as lead lifeguard.

To guide me, I had only the popular thinking of the day, proffered by intelligent, learned white men who had come of age in their fields of psychiatry, sociology, government, and geriatrics and were now offering their thinking to a society that was on the brink of what psychologist–entrepreneur Ken Dychtwald famously called "the age wave." That cursory knowledge certainly did not qualify me to lead a university-sponsored adult education program; it just made me a well-informed amateur with experience designing and delivering lifelong learning programs.

Thanks to me, Encore Transitions pitched what for some participants was destined to become a false narrative, because it promoted a Pollyannaish view of retirement

life. What we deemphasized or left out entirely was the possibility that one's expectations for a satisfying elderhood could suddenly go up in smoke if just one precarious advantage toppled, whether health, money, or spousal or family support. Moreover, the older one got, the greater the odds of this metaphorical fire igniting. Therein lay the far less palatable but equally likely truth. I see it so clearly now, but I was blind to it then.

Then, sometime around my sixty-fifth birthday, I was behaving, to my current regret and long abhorrence, as what I would call a naive experientialist, a person who believes that one can become an expert at something simply by virtue of having experienced whatever the something was. I had seen this behavior for years in people who had participated in an arts workshop at the Split Rock Arts Program and upon completing it had decided that they were qualified to teach the workshop they had just taken.

In my defense, my false claim to expertise was not entirely due to my advancing age or the fact that I was in the midst of training to become a yoga teacher. Nor was it due to the fact that a directive to create a lifelong learning program for pre-retirees had been dropped in my lap by the university administration. It started because I happened to have read the right books. In 1991, Peter Laslett, a British historian who studied societal structures, published the now-classic book *A Fresh Map of Life: The Emergence of the Third Age,* in which he described an ever-lengthening time of life after one's parenting and working years but before "true" old age, that dreaded period of decrepitude preceding death. He framed the Third Age as a developmental era rather than a reactive or passive one, in which we are still fully capable of hitting our stride and forming

new perspectives and tastes. During the Third Age, Laslett suggested, "the apogee of personal life is achieved."

In 1999, venerable social entrepreneur Marc Freedman published *Prime Time: How Baby Boomers Will Revolution-ize Retirement and Transform America.* In this landmark book he predicted that the traditional notion of retire-ment as endless leisure will be turned on its head as baby boomers, that huge cohort who years ago had begun ruling the American roost, reach retirement age. In Freedman's vision, meaningful postcareer work, including volunteer work, as well as lifelong learning and service would soon supplant the Del Webb lifestyle of daily golf and patio coffee klatches.

According to Freedman and kindred experts, purpose in living, including active civic engagement, leads to lon-ger, healthier, more satisfying lives. Freedman broke new ground by coining the term *encore career* to denote a flex-ible career of purposeful work after one's primary career, a lifestyle choice that has since been promoted by human development professionals and financial planners. The bottom line? Without the longevity revolution and without the Third Age, the retirement revolution Freedman pro-posed would be unimaginable.

It would also be unimaginable if all of America's highly educated, well-fixed former hippies became fuzzy-headed in old age. Until the middle of the twentieth century, the minds and brains of healthy old people had barely been studied by psychologists and physicians, and the field of gerontology was just emerging. The fact that most studies of old people focused on dementia patients gave scientists and the public the impression that some degree of senility was inevitable as we aged. But thanks to what pioneering gerontologist

Robert Butler called "the longevity revolution," everyone from neuroscientists to psychiatrists to adult grandchildren began to observe that this was plainly not the case. Dementia, as well as other conditions that were seen as foregone elements of aging, was not a normal mental state; it was a disorder, a disease. The brain, scientists were discovering, was a malleable, growing organ that was capable of functioning effectively for the whole of even the longest lives.

Then, in 2005, renowned psychiatrist and gerontologist Gene Cohen published *The Mature Mind: The Positive Power of the Aging Brain,* in which he synthesized observations from his vast experience as a clinician with his studied interpretations of the young millennium's most influential brain research to prove that the human mind, which is after all the brain's expression, could adapt and expand throughout one's life. Cohen took inspiration from Albert Einstein, who elevated thinking to a starry art by marrying it to actions in the universe. "All that is valuable in human society," Einstein said, "depends upon the opportunity for development accorded the individual." Gene Cohen used that insight to prove that lifelong mental development is no less certain than breath itself. Cohen conceived of a human condition he called "developmental intelligence":

> Developmental intelligence is defined as the maturing of cognition, emotional intelligence, judgment, social skills, life experience, and consciousness, and their integration and synergy. With aging, each of these individual components of developmental intelligence continues to mature, as does the process of integrating each with the others. This is why many older adults continue functioning at very high intellectual levels and display the age-dependent quality of wisdom.

It bears repeating: there is no wisdom without maturity. That is why it grieves me to report that this precociously wise man died of prostate cancer in 2009 at the age of sixty-five. Thank you, Gene Cohen, not only for *The Mature Mind* but also for *The Creative Age,* another of your books that I love. Thank you for believing that human creativity is inherent and lasts a lifetime. Thank you for knowing that using our creativity boosts our immune systems. Thank you for telling us that our vocabularies keep expanding all the way into our eighties, and thank you for helping us understand that stimulating our minds allows us to heal from mood and sleep disorders, even in old age.

My own life, which had been an immobilized train wreck for more than a decade as I lived with prolonged grief disorder after my husband's death, seemed finally to be unfolding in precisely the ways that Peter Laslett, Marc Freedman, and Gene Cohen prophesized. Demographically and situationally, I perfectly fit the audience for whom Encore Transitions was intended. These coincidences rendered me receptive, and I bought in. I was a naive cheerleader for the idea of an encore life, and that enthusiasm made me a congenial program host. Most of the content I presented to participants came from Butler, Laslett, Freedman, and Cohen, all of whom shielded me from flaunting my ignorance. Even so, during the several years I worked with Encore Transitions, I always felt out of my depth and away from my home country, a stranger in an unexpectedly bourgeois land.

Now more than a decade later I can see with regret that Encore Transitions was as noteworthy for the people it omitted as it was for the people it served. To begin, the major popular texts on the "new" aging saw the world

through the white, male, upper middle class eyes that defined their authors' lives and thinking. These experts were the very people who by coincidence not just of their labor but of their inheritance and the societal norms that supported them stood, seemingly by default, at the center of Western influence. When it came to how we might shape our post-work lives, these were the men to whom we were supposed to look to show us the way. Women who had careers outside the home were grudgingly given admittance to the club, but they mostly functioned as bit players in the phenomenon that came to be called "two-retirement households." As groundbreaking life course sociologist Phyllis Moen pointed out, even career women most often followed in their husbands' retirement footsteps.

There is more. The minute you begin to include in the encore universe people who have not had the advantages of advanced education, long-term marriages, good health, or stable ample incomes, the illusory notion of a crowning Third Age is blown to bits. Not many of us have had all four of those advantages. In fact, studies continue to show that for many of us retirement comes sooner than we had planned because of a late-career layoff, an unforeseen illness or disability, or a need to care for dependent parents, spouses, or grandchildren. When you are trying to keep body and soul together without the income stream that had kept your head above water, and when you have loved ones who need your time and energy and care, the idea of an encore career is inconceivable, as is the idea that after a lifetime of work you would crave more work.

If you belong to a race or culture against which our dominant healthcare system has discriminated for your

entire lifetime, you have undoubtedly experienced uncon-
scionable disparities in care, resulting in outcomes that
may shorten your life. If your skills in the English language
do not approach those of the healthcare professionals
with whom you must deal, you are used to being misun-
derstood, also something that could shorten your life. If
you are confined to a wheelchair or otherwise disabled, it
may be almost impossible for you to fully participate in the
often touted, ableist pleasures of life after work. If none of
these disadvantages applies to you, then imagine yourself
gradually forgetting how to live independently and how to
speak about your fears. The passage into an active, fulfill-
ing Third Age is a privilege that should be a right, but so
far we have not had the will to make it so.

The uncomfortable truth is that even for those of us who
are still whole in mind and body, Peter Laslett's notion of
a Third Age is fundamentally biased. It challenges us to
demonstrate that because we may still be physically and
cognitively fit, we can live a "young" life, one that draws its
rewards from the unrestricted time and renewed energy
created by the long-awaited release from the pressures
and obligations that defined our middle years. It asks us
to prove through our lifestyle that we remain free of the
indicators and impediments of advancing age, while at
the same time displaying the self-awareness, wisdom, and
calm that only age can bring. In short, we are asked to
spend a decade or more pretending that we are not yet old
enough to be treated as old even though it is increasingly
obvious that we are getting observably closer to ripe old
age with every passing day.

Inevitably, and without preview or orientation or the
click of a stopwatch, the glory days of the Third Age come

to an end. One day, either because of a precipitating event or a relaxation of attitude, we cross a perceptual threshold into what Laslett calls the Fourth Age, a deeply ageist classification because it assumes that an era of illness, frailty, and disability is the inevitable prelude to death. We might still be relatively young when this happens, and we might still be having a pretty good time.

Take me. At seventy years old, I was teaching yoga, painting, writing, and finally having some success at putting the grief of my past into the past. Then one invincible day while standing in the shower, I suffered the headache of a lifetime, and—voila!—I had to undergo a life-saving craniotomy to treat two persnickety brain aneurysms. I came through the ordeal with my mind intact, but I never regained my pre-surgery blaze. I got tired more quickly, I needed more sleep, my yoga classes drained and pained me, and within a year after surgery I had quit teaching. Farewell to my encore career, farewell to busyness for its own sake, farewell to solo driving trips, goodbye to the apogee of life.

A Well Being

BEFORE I SUFFERED THE HEADACHE OF A LIFETIME, before I underwent brain surgery, before I slid from the apogee of life, I fell hard for the notion of a crowning Third Age because it happened to insinuate itself into my consciousness at just the right time. I was in my early sixties and nearing retirement, a word, by the way, then denounced as a no-no by some Third Age acolytes. I was finally beginning to heal from prolonged grief disorder after my husband's death; I was enjoying at long last a new job within my university; and organically, without conscious intention I had made what would become a lifelong commitment to the practice of yoga.

Because my teacher Maren was perceptive, sensitive, and kind, I learned yoga using approaches that respected my physical limitations while allowing me to safely and comfortably practice a cornucopia of interesting, invigorating, and progressively more challenging poses, whether standing up, sitting down, or lying on my back in a physical openness I had not felt since Tom's death. All that rapture would have been enough, but there was also an underlying, life-saving gift. In a coincidence of consciousness, my yoga learning journey was unfolding at the same time as I began

experiencing some of the inevitable physical changes that herald the transition from middle to old age. This concurrence helped me realize that my prolonged chronic grief had led me to disassociate my inner thinking self from my physicality. To paraphrase Lyle Lovett, I lived in my own mind. But yoga, that colossus of wellness, enabled me to reunite my mind and body, and that reunification inspired me to make a holistic commitment to my own health, a pledge that has sustained me ever since.

If not for the ethereal elephant that filled the room in every class I took, my yoga life would have been sublime. But unfailingly, throughout my three years of twice-weekly classes, I stuck out like a hoary sore thumb because I was anywhere from ten to forty years older than my classmates. I am not exaggerating. What seemed to come naturally to them sometimes required groan-provoking effort from me, and all too often I declined to try poses that simply felt too dangerous for my osteoporotic bones. My classmates, on the other hand, still possessed the balance skills that allow children to roller-skate confidently on the cracked, heaving sidewalks that I skimmed during my own childhood. It took about two years, but eventually I came to understand that the source of my nagging feeling of alienation was not my age or physical limitations: it was the prevailing yoga culture—how yoga was taught and marketed.

* * *

When I came to yoga in early 2008, there were classes for the young and lithe and the buffed and toned. There were chair- and wheelchair-based classes for people who were not mobile; these were usually offered in community centers, senior centers, assisted living facilities, and nursing

homes. But there were no classes designed for Third Agers like me—people who were alert and mobile, people whose lifestyles had become more sedentary as they passed through middle age and settled into retirement, and most saliently, people who could never in a million years imagine contorting themselves in an expensive, athletic yoga class wearing halter tops and skin-tight tights or macho-guy cycling gear.

Worse, there were no yoga instructor training programs that prepared students to teach what I came to call age-appropriate, body-sensitive approaches. As I continued to deepen my yoga practice, this dearth, arising as it did from ageist thoughtlessness, tore at me. I missed not having peers as classmates, and I deeply believed that if taught appropriately yoga might hold the same health benefits for them as it did for me. My university work in the field of healthy aging had inspired me to study more deeply the benefits of intentional movement in middle and old age, and that had led me to a passionate interest in health, well-being, and wellness for those of us who were progressing from middle age into later life.

Bingo! Just as Marc Freedman had urged, I had landed on an encore career! Using state-mandated senior citizen discounts, I would take training at my nearby vocational college to become a certified yoga instructor, and I would open a yoga teaching practice dedicated to the health and well-being of people in the second half of life. I would serve people who could not afford to take classes at yoga studios and, more to the point, who could not imagine themselves in such alien settings. In what struck me at the time as a stroke of genius, I would call my teaching practice Third Age Yoga. I would teach my classes exclusively in

community-based nonprofit settings, and I would charge eight dollars per person per class, which I would split with the sponsoring venue.

All this I did in blithe spirit for eight years until I was felled by that aforementioned headache of a lifetime. No matter. Though I can no longer teach, my personal yoga practice remains a source of profound delight, lifting and challenging me even on the laziest of my days. One of the most exquisite endowments of yoga is that it is infinitely adaptable, allowing us to reap its benefits throughout our lives. This makes it a uniquely efficacious tool for preserving and enhancing our health and well-being even if we live into our nineties. These days I usually practice yoga for about twenty minutes each afternoon. On days when I must keep appointments or attend meetings, I may practice for only ten or fifteen minutes. But I always obey my first commandment regarding intentional physical movement: anything, no matter how brief or gentle, is better than nothing.

Along with wisdom received from my friend Bill, the physician with whom I co-developed Encore Transitions at the University of Minnesota, it was my yoga education as well as the lessons I learned as a teacher that ultimately awakened me to the idea that I, as the possessor of my being, could define for myself what constitutes health in later life. After a process of elimination, here is the three-pronged definition I decided on: first, aging is not in itself a disease; second, in an age of longevity health can no longer be defined as the absence of disease; and third, I have the power to preserve and improve my health during old age.

Girded by these (informed) beliefs, I could look more critically at the ingrained assumption that old age is a

time of gradual dissipation or sudden decline. Add to this falsehood a medical system that remains entrenched and invested in a disease-centered model of care, and it is easy to understand why in old age we often become passive bystanders as our health futures play out, even when we are cared for by good doctors. But this need not be a matter of fate. Once we reach our sixties, our genetic inheritance no longer holds sway over our health prognoses. Rather, it is our habits of living and outlook on life that exert greater influence over our health futures. Most experts agree that in old age our genes account for only about 30 percent of our health outcomes while our lifestyles account for about 70 percent.

After half a century of harming my body through unhealthy habits and suffocating my soul through unhealthy self-conceptions, I had been born again. For too many years I had believed that my incurable chronic conditions—hypertension, emphysema, Crohn's disease, and osteoporosis—would keep me from achieving good health no matter how assiduous my wellness habits. But I was gloriously wrong. With the help of ever more effective treatments for my diseases, I could now, even in old age, plow a path toward a longer health span and a longer life. To live a long life free of disease is extremely rare in our dominant society; after all, even a touch of arthritis could take us out of the running. If the absence of disease were the criterion for good health, few of us would qualify no matter how long we lived or how advantaged our lives.

World-changing scientific discoveries; advanced medical and civil interventions; determined progress in eliminating disparities in healthcare due to racial, cultural, and sex-based biases; good nutrition and hygiene; and regular,

frequent movement are critical reasons why a woman like me, who lives with chronic diseases that not so long ago usually led to an early death, can now live well during a long old age.

For the first half of the twentieth century medical experts continued to define health as being able-bodied and free of disease. Luckily, you could still qualify if you fought off the flu or recovered from an appendectomy, or if you wore hearing aids or eyeglasses. My left eye is so nearsighted that I cannot use it, and over my lifetime some ophthalmologists have pronounced this a disability. (Others have not.) At my most recent appointment, my current ophthalmologist told me, "Your eyes are healthy." The fact that I could not see out of one of them did not faze him. In the end a narrow, nearsighted definition of health could not hold in light of the twentieth century's remarkable expansion of longevity. A broader, more realistic characterization of health had to emerge.

By the time I began my work in the field of healthy aging, researchers had learned that in old age, health, as it had long been defined, did not influence longevity as much as well-being, a subjective state of existence hallmarked by an abiding feeling that our lives are satisfying and meaningful, that challenges can be weathered, that optimism feels more natural than pessimism, and that we have it within us to create our own happiness. In a timely sea change after World War II, the newly formed World Health Organization officially brought together what had long been separate definitions of well-being and health: the amended preamble to its 1946 constitution defines health as "a state of complete physical, mental and social well-being and not merely the absence of disease or infirmity."

This, I believe, was what doctors would have ordered had they known.

But here is the catch. Health is not a fixed state of being; it cannot be taken for granted, especially in old age. Maintaining and improving our health require awareness, attention, and effort. Happily, it is that vulnerability that ultimately gave rise to today's concept of wellness. If health refers to our state of being, wellness refers to our habits of living: it is the ongoing pursuit of health. Wellness need not be an occupation, but like our personal habits of hygiene it is something that I believe most of us can easily build into our everyday lives. For me wellness means practicing yoga for a few minutes most days, taking a short indoor or outdoor walk most days, connecting with friends and family often enough so that I do not slump into loneliness, and, perhaps most essential, engrossing myself in activities that refresh my creativity, allow me to expand my mind, and content me.

But Goody Two Shoes I am not. Alongside my diligent efforts at a healthy lifestyle, I feel ethically bound to confess that I have no intention of giving up a glass of wine with dinner, sporadically consuming a share-size bag of almond M&Ms all by myself, or, while vacationing in Las Vegas each year, drowning in delight as I commune with my all-time favorite slot machine, Whales of Cash. At these times I do feel a bit like a whale, but I am only human, and though it may seem counterintuitive, my measured indulgences help keep me contented and healthy.

Because I am old, I cannot assume that I will be able to maintain my current lifestyle for the rest of my life. But I have come to accept that possibility, and that acceptance has helped me find peace of mind. The fact that my health

may deteriorate is no reason not to try to preserve it now. To embrace a sense of personal agency about our health is a gift of sustenance to our aging selves. My longtime mentor, educator and architect Gerald Allan, believes that creativity is like a muscle: it must be used regularly in order to remain in good working order. The same is true about personal agency, the ability to direct our own lives. We must try, if we can, to live in a way that enhances our well-being, no matter our age.

Living like Herb Kohl

IF YOU LIVE LONG ENOUGH, EVERYTHING IS LOST. Heartbreakingly, even our most precious memories become fragmented shards of our pasts. They are rarely intact, and they are increasingly susceptible to loss as our histories lengthen. Still, unlike dreams, they almost always register as true, even when partly forgotten or misremembered. Dreams, including those that resemble memories, are never quite right. Always in them something is not as it should be or not as it was. Some are treasures in that they actually do approximate once-loved realities, some are welcome lessons or revelations or reminders, some are nightmares, and lots of others are flotsam. Now as I feel my sense of self being altered by age, am I really supposed to believe that memories and dreams can suffice as reasons for living? If after entering old age I am made mostly of memories and dreams, who am I? What is my claim to life? To whom and what do I belong?

Even in a society like ours, which overemphasizes the separateness of the individual, I believe selfhood is crucially defined by our communities of belonging, including for most of us the ones into which we are born. As our lives unfold, we join and are ultimately separated from

community after community until, finally, by the time we reach old age we no longer belong to anything or anyone. I liken this state of being to the kindly fan who approaches the aged former teenage idol, now stricken with ultimately fatal Alzheimer's disease, and asks, "Didn't you used to be Bobby Vee?" The truth is that more and more these days I have come to think of myself as the woman who used to be Andy Gilats, a person once valued, a person who was a part of things, a person who was missed when not present, a person who belonged.

Ironically, and perhaps foolishly, I left some of my former communities voluntarily, but somehow over time whatever needs I had for security, stability, and structure overtook my desire to live in a way that I hoped would lead to artistic bliss and justice for all. I belonged to a workplace community at the University of Minnesota for more than thirty years, and though it was populated by different people at different times, it became an essential part of my identity.

What was it about that community that so deeply defined me during those decades? Was it the fact that I was given the chance to do meaningful work that enriched people's lives? Was it the tolerance, good humor, compassion, and commitment of the people with whom I worked? Was it the opportunity, after years of what I can only call selfless service, to wield influence in that community? Was it the honorable intentions of the institution itself as it made efforts toward greater inclusivity and allowed me to do the same? Was it the creative and intellectual education my work afforded me? Was it the long tenure of my belonging? After three decades, had I had enough of my university community? Did I rejoice when I left it? Yes to each of these questions.

But here after everything is the conundrum of old age: I still feel that I belong to that community even though it has long forgotten me. I would not want to step backwards in order to rejoin it, but I continue to miss it even though it does not miss me. I have noticed that when I am asked, people are surprised to hear that I do not miss the meaty work I did. Rather, I miss the recurring change, whether slow enough to appear nonexistent or sudden enough to feel like a pail of ice water thrown to the face. I miss the ebb and flow of human relationships that most of us watch so closely in our work communities. Who is in? Who is out? What about that closely observed person who reputedly collects a hefty paycheck but no one seems to know what he or she actually does? How are decision-makers carrying out their obligations? Are they meeting in small groups in small rooms to decide the fate of the hundreds of employees and thousands of students under their aegis? How is power balanced and shared? Are promises and pledges being kept? How is equity achieved?

I have been away from my work community for a decade, time enough, one would think, to recover from whatever fatigue accompanied me into my post-university life. Still, to this day whenever I think about the real work I did, the useful enterprise of designing, developing, and directing lifelong learning programs, I feel worn out. In fact, I feel utterly drained. I want to stretch out on the sofa and close my eyes to the afternoon sun.

Why should I feel this way after so long? Why do these frightful memories persist? Was it those harrowing drives to and from Duluth, the ones during which my car was literally enveloped in fog, that so depleted me? Was it the stressful snowstorms through which I drove in order

to attend unimportant meetings required by insensitive superiors? Was it the humiliation of having to compromise my values in order to preserve funding for the programs to which I routinely, over more than twenty years, surrendered my health and well-being? I feel like an old boulder as I sink into my desk chair.

* * *

I think this insistent, heavy fatigue might be a symptom of grief. For more than thirty years I created and led innovative, memorable programs that had deep personal meaning for the people they served, but these programs are all dead now; they no longer exist. For some, the time to meet their maker came naturally and expectedly; others' lives were cut short by short-sightedness. Death without trial, death without curative intervention, death without consideration. Death by memo, death in the strikethrough of a line on a budget, death by layoff or consolidation, death by retrenchment, death by pandemic lockdown. Death without eulogy or funeral, death without goodbye.

I have now outlived all my programmatic children, the offspring of the work of my life. But I am not a victim and I am not an innocent bystander. The hidden underbelly of my grief is that eventually I became weary of parenting what my colleagues used to call my brainchildren. I loved my brainchildren, but as my retirement horizon grew shorter, I no longer felt able to nurture them. For a rucksack of reasons, especially my overpowering physical and psychological exhaustion, I had lost the inner determination needed to help them succeed. This I am relieved to admit, but I also claim the right to grieve their loss.

What does the demise of my programs say about the

value of my work? Nothing, really. The passing of my pro-
grams has mostly to do with the passage of time and my
own passing into retirement. What remains, I hope, is the
impact of those programs on the people who participated
in them. Some, meaning thousands, of those people's lives
were profoundly enriched through their participation, and
I believe that for some of them, that effect lasted a life-
time. The value of my work does not at its heart belong
to me. It exists as an echo of the timeless, cosmic value
of democratic education, including the communities that
make those opportunities possible. I was and will remain
an educator.

We are led to believe that the day after our retirement
party we are supposed to dive with gusto into whatever we
are supposed to do next, even if that means a cold plunge
into the deep end of an unfamiliar pool. Our exit should be
a clean one, after which we are supposed to leave our long
working lives behind. Specifically, we are allowed to have
a casual interest in how the people and products of our
former life are faring, but too much interest is considered
unhealthy. It indicates that we are having trouble moving
forward, that we are dwelling too much on a part of our
lives from which we must disengage so that we can enjoy
good mental health in our golden years. We must avoid,
at all costs, spending our days staring out the backdoor
screen even if the world has now decided that we are no
longer fit for anything else.

What a load of antiquated bull! We continue to be
everything we were, and thankfully our changes in outlook
and attitude are most often gradual. Within the loose con-
fines of our nature, the self is psychologically infinite and
so allows nothing to be permanently lost except through

the insidious chemistry of dementia. We forget without intention and we forget on purpose, but even what is forgotten is never actually lost; it is just forgotten. What is the harm in remembering when remembering no longer brings pain? What is the harm in continuing to be fond of something that is beyond redux or reconstitution? I am blessed by my previous affiliations, and though they now belong to the past, they nonetheless remain alive within me and my generational peers. The difference is that they no longer frustrate or deplete me.

I am grateful that, at least for now, my past lives on to gird me, but where if anywhere will it lead me? What will I find in my future? If I have years left to me, can I still be my own agent? Just as I created educational programs in the arts during my career, can I create another kind of future? When I began teaching yoga after retiring from the university, I thought that was a pretty good vocation for a sixty-five-year-old. Then eight years later, after surviving brain surgery, my body ordered me to retire from that vocation. The pesky questions raised their heads again. What will my future bring? And will I have a say in it?

* * *

Each time these questions have visited me, itching to be answered but resisting the same old solutions, I have found guidance in one of my most precious books, *Painting Chinese: A Lifelong Teacher Gains the Wisdom of Youth,* by Herbert Kohl. Though I have never met him, I know that Herb Kohl has led an exemplary life of conviction, courage, boundless creativity, and unwavering fidelity to the cause of social justice. As an intellectually gifted, curious young man, he studied mathematics and philosophy, but instead

of a career in the academy he chose a master's degree in education and became one of the greatest teachers of his era.

He began his career by teaching for six years in a store-front school in Harlem that was funded by the National Institute of Education. His landmark 1967 memoir *36 Children* grew from that experience. It became a classic text in the fields of progressive public education and arts-infused public education, but that was only the beginning. In 1967, Kohl also founded Teachers and Writers Collaborative, an organization that I have loved and respected for much of my adult life. The collaborative sprung from Kohl's belief that writing should be integral to learning, so that no matter how we spend our lives we carry within us the ability to communicate ideas and information, create stories from our imaginations and experiences, and explain ourselves and our worlds to others. Significantly, it was one of the first organizations in the country to send working writers into public schools as teachers of their art. Teachers and Writers Collaborative continues to thrive today with an expanded mission that includes visual and performing arts as well as lifelong learning for older adults.

Herb Kohl went on to publish more than forty books, including *The View from the Oak,* cowritten with his wife, Judith Kohl, which won a 1978 National Book Award in children's literature. But to my elation some of the most consequential efforts of Kohl's interesting life came after all those books. *Painting Chinese* was published in 2007, as Kohl was turning seventy years old, and as I was transitioning to part-time work in the field of lifelong learning geared toward older adults. In the book he reflects on what it was like to age out of his previous lifestyle:

One of my problems with becoming older was a stubborn refusal to accept the inevitable slowing down that comes with age. I continued to work twelve hours a day, even though occasionally I almost passed out from exhaustion. . . . In the past, I was somehow able to complete things, but increasingly I couldn't keep up with myself. I needed to learn to live and learn and create at a slower pace and with less ambition.

He began this new learning after what could be called a "last hurrah":

For the five years before I turned seventy, I created and directed a teacher education program at the University of San Francisco based on the idea of integrating issues of social justice throughout the curriculum, hoping to bring idealistic young people into public school teaching and to fortify them with the skills and stamina to make their dreams practical realities. I succeeded in recruiting thirty students to the program each year, most of them students of color, and had a wonderful time with them.

The program ended bitterly in the fourth year when the university cut it after the funding I had raised ran out. I had put an enormous energy into developing and teaching in the program and during my last year there felt worn down physically and emotionally, not from the teaching, but from constant harassment by the administration.

During the despondent days that followed the demise of his program, Kohl began strolling the streets near the university. These were random ambles during which he could people-watch over a cup of tea, enjoy the comings and goings of the neighborhood's street life, and window-shop as he walked. His favorite haunt was Clement Street, a bustling commercial hub serving San Franciscans of Chinese

heritage. One mundane morning Kohl happened by a storefront featuring a sign that said Joseph Fine Art School. He saw that the school offered classes in painting, an art form that had always interested him and in which he had dabbled from time to time over the years.

His curiosity was piqued: if ever there were a time to try something new, this was it. He entered the empty school and asked the attendant if he could speak to Joseph Fine. It turned out that Joseph Fine was actually Joseph Zhuoqing Yan, and his fine art school specialized in Chinese brush painting and related arts. Now Kohl was even more interested. "Stumbling upon that school on Clement reminded me of the times I'd promised myself to take painting lessons one day," he writes. "I decided to enroll in a class whatever the school was like and turn casual painting into an integral part of my new life. It would also bind me in a specific way to the Clement world I was beginning to create as a way of providing some transition to my indefinite future."

Little did he know that his fellow students would be Chinese children between the ages of four and seven years old. To Kohl's utter delight, Joseph and his co-teacher and wife, Janny, along with his fellow students, treated him with the same respect they accorded each other and accepted him without reservation or prejudice as one of their classmates. That is how Herb Kohl came to spend three years learning to paint Chinese at the Joseph Fine Art School. Near the end of *Painting Chinese,* he writes:

> Painting Chinese enriched my political, educational, and personal life. It kept me from despair at losing my program at the University of San Francisco and not knowing what I might do next. It opened me up to moving back to

my home . . . and writing instead of trying to be involved in educational struggles full-time. And it confirmed my belief that being on the side of the positive at a historical moment when the negative was ascendant, however painful and frustrating, was the only way I could live.

It is the only way I can live, too. In fact, I have come to believe that "being on the side of the positive" is the only way any of us can live a committed, personally meaningful, peaceful life in old age, no matter which way the winds of time blow. I have a habit of jotting crude thoughts on sticky notes as I work at the computer, awkward reminders of what I might try writing about later in this book. Each morning I scan them, crumple a few that have become too embarrassing to consider, and toss those little offenders into the waste basket next to my desk chair.

But I always keep a few that I think might have potential. Now, as I take my stand on behalf of optimism, I offer this sticky note: "I am happy except when I go into a funk." Thanks to heroes like Herb Kohl, my benign funks are few and far between, they last no longer than a few hours and sometimes only a few minutes, and when I emerge from them, I always feel happier than I felt before. Tested but not scarred.

A Life Review

WHAT REMAINS AFTER YOU ARE NO LONGER OBLI-gated to serve any particular person or institution? What remains when you no longer need to sell your time for money? What remains when there are no more luncheons, meetings, seminars, or ancillary medical appointments? When there is nothing more to shop for? When there are no more interruptions? What remains after the flotsam and jetsam of your unruly life have been cleared away? What remains after the dusting is done? After your universe has contracted? When your idea of selfhood no longer applies? After you no longer matter? What remains when everything you had avoided or feared has come to pass and there is nothing more to turn you against yourself?

Freedom. Freedom to remember, after a lifetime, what your dreams were and to chase them, if only in your mind. Freedom to do as you please with your days, even when that amounts to nothing. Freedom to take a vacation knowing that when you return home, you will not have to return to your job because your job is over. Freedom to awaken naturally in the morning rather than be shocked out of sleep by the rude blare of an alarm clock. Freedom to stay home when it snows, and freedom to stay home

for as long as necessary when there is a once-in-a-century coronavirus pandemic. Freedom to read novels and poems and memoirs and histories and social commentaries all day or all evening until your eyes naturally close. Freedom to knit shawls and blankets and vests all day. Freedom to paint abstractions all day or make drawings of Attacus atlas moths with your new set of colored pencils.

There are other types of freedom, too, some of which put me in mind of Franklin Roosevelt's four freedoms: freedom of speech, freedom of worship, freedom from want, freedom from fear. To these I add: freedom from artificial, cruel competition, the kind that fuels too many workplaces. Freedom from self-destructive ambition, the kind that snags that regrettable, self-sacrificial job promotion. Freedom from compromises made for the sake of assuaging others' egos. Freedom from feeling forced to say or do things that are unethical or immoral so that you can hang on to your job. Freedom from remaining silent in the face of everyday, garden-variety injustices. Freedom to take a walk along the Mississippi River, turn your pockets inside out, and empty them of sins, as my grandfather did each year during Rosh Hashanah.

Above all, freedom to think, and through thought to plant the seeds from which authentic actions can grow. But thinking takes time, unscheduled, unfettered, unmonitored time, because that is how germination works in us. We are not quick-sprouting radishes: our thoughts may come and go, they may evolve, they may replace themselves. But time by itself is not enough. Thinking also requires inner space, the fertile, receptive earth of the mind, uncluttered by unethical or immoral distractions. If we can empty our minds of a lifetime of restrictions and impositions, the act

of thinking can lead to ideas and memories and stories and opinions that beg to be written. In a talk given to students in the middle 1960s, the venerable activist, story writer, journalist, and poet Grace Paley said, "Some people have to live first and write later." She could have been talking about me. I am old now; I have the time and inner space, and I am happily writing down my ideas and memories and stories and opinions. I am writing all day. I am writing like the dickens.

With age I have acquired greater scope. I no longer feel that my ideas and memories and experiences would have no meaning to others. Now I feel that having lived for more than three-quarters of a century I am an interesting woman whose years have given her substantive, meaty matters to share, matters that younger women cannot yet write about from firsthand experience. Rather than my mind going to seed, I find that I am a better thinker now. I think more slowly, but quickness is no advantage when you are trying to write truthfully and liltingly. Now that I am old I have more trouble finding the right words and spelling them correctly, but after a lifetime of learning I have many more words at my disposal, words that I can now call on to make meaning.

Meaning has no meaning without expression, and now that I am old writing has become my easiest, most natural mode for sharing my thoughts and feelings. It is spectacularly efficacious: it can be shared in multiple forms; it can be revised, expanded on, and criticized; it can be translated into an array of languages and mediums; and it can enrich the lives of readers who might especially value the voice of an old woman because they themselves are old or because they will, providence allowing, grow old.

We must not forget that half of writing is reading. Written works, like many worthy pursuits, cannot be completed by an author. They can only be completed by a reader. When you read what I have written, meaning flows between us, and eventually, I hope, among countless others. By thinking about and remarking on what you have read, you yourself become an author and purveyor, and the flow of meaning continues, creating an ever-widening river of shared empathy.

Though writing did not become my primary occupation until I was almost seventy years old, I have been composing stories, essays, and what I wantonly called poems ever since I learned to print. Even though my childhood memories have been reduced to a disjointed reel of fleeting images seen through a View-Master, I remember one of my earliest essays quite vividly. As an eight-year-old I had just finished writing a story about myself for a school assignment. I remember feeling so delighted with it that I could not wait to read it to my mother, who was my only willing listener. She was pregnant with my younger brother at the time, a fact that is critical to understanding why I was so anxious to share my story with her. I remember nothing of the story as a whole, but I can still visualize one particular paragraph on a page printed in my own tender hand. I recounted for my reader the moment when my mother told me she was going to have a baby. Having just broken the news, she asked me whether I would like a girl or a boy. "Yes," I said.

Ha ha ha! What a knee-slapper! It was probably the first (and perhaps only) joke I ever wrote, and it tickled me to pieces. I had no ego then, so I took no pride in my cleverness. I was just so amused by the joke itself that I felt

compelled to share it. That dual urge to create and share, along with the inclination toward reciprocity, is one of the most attractive impulses we humans possess, and it was that attraction that set me on a lifelong path of making and sharing. Three-quarters of a century and a multitude of common vicissitudes have not yet gotten the best of me. The urge to give my gifts, humble as they may be, along with the desire to receive the gifts of others, is as strong within me now as when I was eight years old.

* * *

I was a passionate artist as a child. When I try to conjure my child self, it seems that I was always painting or drawing or designing original fashions for my paper dolls. I do not remember myself as a writer, although Mr. Gore, my sixth grade teacher, stated on my report card that "we have appreciated her many contributions to the class, especially her creative writing." I am sure that Mr. Gore's kind words flew past me. At the time I was preoccupied with painting portraits, reading Nancy Drew mysteries, and listening to Buddy Holly.

But by the time I entered high school, painting had been relegated to an occasional hobby in my busy life. I was college bound, so there was no room for art in my academic schedule. I had the unfortunate luck of starting high school during the space race, when the nation's public schools focused their curricula on mathematics and physical sciences, thereby giving short shrift to liberal and fine arts. Along with numbers, the written word was considered the coin of the realm if one wanted to get anywhere in life, so I wrote. Truth be told, my high school writing assignments were the only tolerable tasks in my

prodigiously uninteresting curriculum. I can still feel the profound restlessness I suffered as I sat through chemistry, a class I completed without ever memorizing the periodic table of elements, and trigonometry, a class in which I can still visualize my seat assignment but cannot tell you what trigonometry is without consulting Google.

As an adult I studied art. I rarely wrote for pleasure or healing or to follow a creative calling. Eventually, I lost track of myself as a writer. My position at the University of Minnesota required me to write endlessly, however, and for more than thirty years I wrote proposals, program catalogs, reports, letters to writers and artists around the world, policy statements, evaluations, articles for journals and magazines, slide show and web content, planning documents, and footnotes. Graduate school also required endless writing, and I wrote book reviews, travel journals, cultural criticism, presentations, research summaries, abstracts, and a dissertation titled "American Indian Lives, Lands, and Cultures: The Story of an Intercultural Educational Travel Program."

When Tom and I bought a first-generation Apple computer in 1985, I was astounded at the miracle of being able to write at the speed of thought. The keys yielded to the gentlest pressure, allowing my fingers to fly. There was no return bar to push after each typewritten line, and the delete function allowed me to correct and edit as I wrote, creating a perpetually clean document. Eureka! I soon realized I could now write a book, so I did.

In 1986, I wrote a novella called *Rock and Roll Girl,* titled after the recently released John Fogarty song "Rock and Roll Girls." The book told the story of a music-obsessed girl named Andy Sue. (Any resemblance to my own

childhood nickname was nothing more than an expedient way of creating a character that would justify the book's title.) The gist of the plot was that Andy Sue met and fell hopelessly in love with a boy named Bobby Burke. (The use of Tom's mother's maiden name was nothing more than an expedient way of creating a tall, blond Norwegian/Irish character). Unfortunately, the story concluded with Bobby sailing away to join the Navy, leaving Andy Sue to adopt a chaste life as an abstract expressionist painter.

Because I felt that my creative spirit had been compromised by my art education, I avoided writing classes, even though the Split Rock Arts Program offered a tempting array. Finally in the summer of 2006, my last as the program's director, I took a poetry workshop taught by Kentucky poet Frank X. Walker, the founder of the Affrilachian poetry movement, which acknowledged "the union of the Appalachian identity and the region's African American culture and history."

The workshop focused on writing about our ancestors, so most participants wrote about their family histories. But for me it offered a chance to write about the Native American beadwork artists whose glorious creations I had been collecting for more than a decade. My poem was inspired by the many conversations I had with these artists while visiting their communities, conversations that remain profoundly meaningful to me. Here in a stanza from a poem I wrote during that workshop are the names of some of the artists whose work I collected:

> We have names that fly.
> Call me Rosella Birdtail.
> I am Rosella's first cousin.
> Call me Cindy Eagle.

Cindy calls me the best beader on the rez.
I am Sylvia High Hawk.
My daughter is Doree Plume.
My aunt makes silver dollar medallions.
Her name is Birdie Real Bird.
My other niece is Sherry Red Owl
Over in the village at the mission school.
I like to bead with my friend
Irma White Butterfly.
She is not a bird.

Precious though they are, my encounters with these artists have morphed over time into incomplete fragments, snatches of stories, and vague, filmy scenes that feel paradoxically like I am seeing them through a cataract. I still hold out hope that I can honor them in my future writing, but at the same time I must also concede that this inextricable loss of clarity leaves me empty, despondent.

By the time I wrote "We Have Names," I was sixty-one years old and I had already begun my inner journey from overworked program administrator to pensioner. I was a year away from the start of a five-year phased retirement, and I was giving more of my creative energy to painting and writing and less to my job, something that I discovered made no difference to anyone. Painting and writing were peacefully coexisting in my widow's life; I was doing what I wanted in the same way that an awakened two-year-old expresses her presence in the world.

After spending twenty-two years steering the University of Minnesota's Split Rock Arts Program, I was finally able to free myself of decades of self-deprecation that had kept me from acknowledging my own need for self-expression, for making and sharing what came from my

own creative spirit. Without knowing it I was rescuing my identity as a writer.

When I finally left my university work at the age of sixty-seven, I reclaimed my human right to an intellectual and creative life of my own making. Even though I could not have put it into words at the time, once I reached that point I knew that for the rest of my life I would try to serve my fellow humans through my writing. I would no longer write as an occasional avocation done in addition to my "real" work; I was now entering my seventies, and I knew finally that writing had become my real work. I promised myself that it would never be anything less: I would have faith in the value of my voice to others, and I would try, on my own behalf, to have it heard.

* * *

I think now of that overused adage: write what you know. Generally attributed to Mark Twain, I understand this advice to mean that writers should write about their experiences, their families, their geographies, their vocations and avocations, their loves and losses, their influences and lessons, and the further array of elements that comprise their lives. This approach would hold true, Twain must have assumed, whether you are attempting a factual or fictional rendering, or a rendering that blurs those thin, often translucent lines. Truth is truth, whether clothed in fiction or undressed in nonfiction.

Because my own life is the fount of my writing, I wonder if my access to the truth is gradually lessening as advancing age forces me to peer further and further back in time in order to retrieve my past. How can I claim authority

for what I can no longer recall? How much of my "true subject" will I lose as I recede from the apogee of my life?

I am profoundly disheartened at how little I remember of my life, especially the flavorful details that might bring my past to bear on my writing. I realize now that my memories of my life prior to Tom's death are much dimmer than my memories of that year and the following years. It is as though those memories exist behind a veil, and except for my uncannily vivid memories of childhood traumas, the further back in time I travel, the more opaque the veil becomes. I have convinced myself that this arbitrary, partial way in which my memory now seems to operate is an expected feature of a long life, not a failure caused by a diseased, disabled mind or a mind permanently scarred by prolonged grief.

That is why I hope to allow my memory, my assumptions, and my imagination to coalesce as I try to come to terms with the character and worth of the life I have lived up to now and may (or may not) live in the future. Only through this kind of accommodation can I help ease the way for others who must face their pasts and futures as they reach old age. In *Just as I Thought,* Grace Paley advises this: "No matter what you feel about what you're doing, if that is really what you're looking for, if that is really what you're trying to understand, if that is really what you're stupid about, if that's what you're dumb about and you're trying to understand it, stay with it, no matter what, and you'll at least live your own truth or be hung for it." Luckily, we are soulful wholes who are greater than the sum of our parts. What is left at the threshold of old age may be arbitrary and partial, but what we discover there is the

courage to write about our lives without fear or shame. In one way or another what has happened or might happen to me might have happened or might yet happen to you. That makes for a close, empathetic connection, one that may be immensely valuable to us later in our lives.

According to Robert Butler, the pioneering psychiatrist who coined the terms *ageism* and *gerontology,* old age is a time when we find ourselves preoccupied with self-reflection. Prompted by extensive reminiscing about our pasts, this rekindled desire to make sense of our lives seems to come unbidden to the forefront of our minds and persists there until we die. And why not? It is only human to want to understand ourselves, even long after the soul searching of youth or the reconsiderations of middle age. Butler calls this kind of active reflection "life review."

Until Butler wrote his landmark 1964 article "The Life Review: An Interpretation of Reminiscence in the Aged," it was considered emotionally unhealthy to dwell on (or in) one's past during one's last years. But as he clarifies, that was mostly because behavioral scientists were only studying old people who were suffering from disease, including dementia. Healthy old people, that large majority who were doing just fine, apparently did not interest researchers. By the way, that is also how aging itself came to be seen by the medical establishment as a disease, when in fact it is simply one more stage of life. After dispensing with that myth, Butler defines life review as follows:

> The life review is conceived of as a naturally-occurring universal mental process characterized by the progressive return to consciousness of past experiences, and particularly, the resurgence of unresolved conflicts; simultaneously, and normally, these revived experiences and

conflicts are surveyed and reintegrated. It is assumed that this process is prompted by the realization of approaching dissolution and death, and by the inability to maintain one's sense of personal invulnerability. Although the process is initiated internally by the perception of approaching death, it is further shaped by contemporaneous experiences and its nature and outcome are affected by the lifelong unfolding of character.

He then goes on to say that "the process may not be completed prior to death," affirming once again that however long our lives many of us will die before we have finished living. I hope to be one of those.

Writing is generative: it involves creating something new even when one's raw material is wrested from an indistinct past. To live a satisfying life in a time of reminiscence, we must continue creating ourselves. By doing so we can use our pasts to fortify our futures. I hope to continue my writing practice until my ability to do so is reduced, like a December maple, to bones. If my memory no longer serves me, I hope to call on my imagination, which seems, at least so far, reliably persistent. I once knew a respected fiction writer who said that he only writes about his own experiences, whether or not they actually happened to him. He had a beer or two under his belt at the time, but his words come back to me with renewed resonance as I am forced to humble myself in the face of my changing realities.

Even after caveats, confessions, and full losses, it is still through memory that we might retrieve, at least partially and in sensually incomplete ways, some of what has been forfeited to time. Perhaps this is because, as Vladimir Nabokov remarks in *Speak, Memory*, "one is always

at home in one's past." Spurred by recollection, we might resuscitate our pasts if we can meet them with a clear, brave mind. But many memories, especially those in our distant pasts, stubbornly refuse our mental pleas for clarity and appear in our mind's eye as wan facsimiles of the experiences we actually had. That feels especially true if the experience in question was a profoundly sensual one, involving sound, touch, taste, wide-eyed wonder, or even smell, like the aroma of boiling water as it saturates broken-up bits of matzo in preparation for frying *matzo brei*. Even when my recollection is reduced to a wistful whiff, I delight in memories like this.

I may not remember my past as clearly as when it was nearer to my present, but as an old woman I am better equipped to compensate for that because my long past has awarded me more mistakes to learn from, a broader array of experiences from which to gain perspective, a longer acquaintance with my fellow humans through which to practice empathy, more forms of education though which to expand my knowledge, more trials from which to gain wisdom, more losses that have tempered my ability to survive, and more time on Earth to figure things out or let them lie. After more than seventy-five years, I am learning to my delight that not only are we not diminished in old age, we are replete with wisdom, the fruit that ripens only with age.

Warnings
and Salutations

ON ONE HAND, THERE IS MY BODY, AND ON THE OTHER, there is my mind. I know that what happens to my brain affects my mind, and what happens to my mind affects my body. It is that particular cause and effect that now frightens me more than an alarming physiological diagnosis. I have only recently learned that one of the earliest signs of dementia, including Alzheimer's disease, is a change in one's gait. One's strides become shorter, one's pace slows, and one begins to teeter, creating the need to support oneself while walking, perhaps with a cane, perhaps with a walker, perhaps by pressing one's palms against door frames and walls on the way to and from the bathroom in the pitch dark of night.

Over the past year I have noticed that every so often, perhaps once every three or four weeks, I feel oddly tipsy when coming to a stop after taking some steps. I find myself having to balance on my heels or toes in order to halt myself, and having done that I have to consciously plant my feet. Lately, when I walk to and from the bathroom during the night, I am aware that I am not walking a straight line. Instead, I seem to be making wide semicircles

as I bob and weave my way back to bed and, seconds later, back to sleep. In my optimistic moments I wonder whether I will be heir to some low-level chronic gait disorder, and in my apprehensive moments I wonder whether I am heir to something worse. When at ninety-two the last vestiges of my father's unfailingly quick mind had finally left him, he stopped walking and spent the last year of his life in bed. At the time his family thought he was apathetic and tired out, but it is also likely that because of dementia he had forgotten how to ambulate.

On one hand, there is my gait. On the other, there is my handwriting, which was always even and nicely formed, but has over the past two or three years become less fluid, less attractive, and less legible. I used to be able to write without thinking: my hand was the faithful servant of my mind. Now, except when I am dashing off Post-it notes to myself, I must think about each letter as I write it. Writing my signature has become especially difficult, partly, I think, because I feel the intense anxiety that accompanies an attempt to do something you have done all your life but no longer feel sure you can do. According to sources on Google, this could be a sign of approaching Alzheimer's, it could indicate a tremor caused by steroid medications, it could reflect an acquired fear of handwriting, or it could simply be caused by a pen with a mind of its own.

Rather than worrying over what I have now learned is a common phenomenon in old age, I have decided to enjoy the chance to visualize each letter and the sequence to which it belongs, and to accept without fear the need to pause or even start over if I am not satisfied with the legibility of my handwriting. As a coping strategy, this approach has been reasonably effective, but it has taken the joy out

of writing a heartfelt message on a birthday card. As I was researching the deterioration of my handwriting, trying my best to find a pathologically indifferent reason for it, I ran across an unusual article on the National Institute of Health's PubMed website about age-related deterioration in handwriting legibility. To prove how common this impediment is, the authors claim that a significant number of wills signed by old people have been contested in court because the maker's signature looked like a forgery. To my personal chagrin, my own signature now looks eerily like my father's.

On one hand, I am still able to safely walk anywhere I want without assistance, the primary prerequisite to living independently. On the other hand, my handwriting has also become shaky, like my mother's in the year or two before her death. Whether this means that I will follow in her footsteps, only time will tell. I prefer to think of it as an understandable coincidence caused by the fact that I take some of the same steroid medications as she did. But is this merely one more rationalization in a larger fiction I am trying to tell myself about the nature of my future? On one hand there is this; on the other, that.

But metaphorically there are never just two hands. There is always a third and for me, at least for now, that hand is a blank-out I recently experienced while driving to pick up my groceries. I remember arriving at the supermarket, but I could not remember how I got there. This was not just the partial inattention that can occur while driving a familiar route: it was an eyes-open faint that had my entire body quaking with fear as I drove home. The unwelcome bottom line is that for each positive health prospect in my life, I now have several negative prospects,

a situation that could, if I let it, make a pessimist out of this recently minted optimist.

While I must be hardheaded in assessing my odds for a healthy future, I must also be honest about my feelings, and for any number of persuasive reasons I feel that my overall health is considerably better than it was when I was a tender sixty-five-year-old celebrating my Medicare matriculation. I was diagnosed with hypertension when I was fifty; I have suffered from Crohn's disease since early adulthood but was not diagnosed until I was sixty; I was diagnosed with emphysema in my middle fifties; I was diagnosed with osteoporosis at fifty-four. This is the incomplete history of my body's disorders. I know that over the past decade my high blood pressure, osteoporosis, Crohn's disease, and emphysema have not miraculously reversed course or healed themselves, but these days I am much better able to manage them than I was ten years ago.

If all this sounds too good to be true, that is because it probably is. I am not the picture of vitality, as is apparent from my list of chronic diseases. The truth is that my physical health is unusually fragile: one fall, one emphysema exacerbation, one stroke, one ruptured brain aneurysm, or one insidious case of long Covid could permanently disable me, thereby ruining my hope for an independent future, or kill me, thereby ruining my hope for any future at all. Should I survive the near term, I will almost certainly age beyond any hope I might harbor for improving my health. No matter the tales I have told myself, I feel for the first time in my life that my future, as well as that of my contemporaries, is a crapshoot. Tiny warning signs seem to pop up with increasing frequency, bringing with

them an unfamiliar, penetrating feeling of uncertainty, like innocuous hairline cracks in the faithful foundation of one's home. I cannot seem to shake my apprehension. What is my fate? Can I alter it?

These questions have so frustrated me that one recent afternoon, I emailed Allen, my scientist brother-in-law, and asked him, "Does our pace of aging accelerate as we get older? Or do we age at about the same rate throughout our lives?" Lo and behold, my questions were answered by Laura Niedernhofer, a renowned biologist and DNA researcher who directs the University of Minnesota's Institute on the Biology of Aging and Metabolism. The institute's mission is to "identify aspects of the biology of aging that might be targeted therapeutically to keep the elderly healthier." In answer to my questions, Dr. Niedernhofer was kind enough to offer Allen six points on which scientists who work in the field of biological aging might readily agree:

▶ Aging is highly heterogeneous, so the answer to your question is likely unique to a person, their genetics, and environment.

▶ Aging starts at birth (or earlier, depending on in utero stressors).

▶ One measure of biologic age (a senescence marker measured in lymphocytes) increases exponentially with chronological age (between twenty and eighty years old), suggesting an acceleration of the aging process with age.

▶ Stress (e.g., cancer chemotherapy, radiation) will accelerate aging.

▶ Aging is also surely accelerated once there is onset

116

of an age-related disease, unless that disease is swiftly
and effectively managed (e.g., diabetes or COPD).
▶ Centenarians age slowly and at a more constant pace.

A necessary note: when she wrote this, Dr. Niedernhofer
did not know that I have emphysema, one of two diseases
that fall under the umbrella term COPD (chronic obstruc-
tive pulmonary disease); the other is chronic bronchitis.

If you are a cell biologist, you probably define aging as
"the gradual deterioration of functional characteristics in
living organisms," at least while you are at work. No mat-
ter how heterogeneous our bodies and environments are,
damage, decline, and deterioration mark the journeys of
our cells through our lifetimes. After enough time, some
turn rogue and create malignancies; cataracts form over
our lenses; our bones lose mass, turn brittle, and break
more easily; our immune systems naturally weaken, mak-
ing us ever more vulnerable to severe infections. *Mon dieu!*
What, then, can we hope for as we enter old age?

Gratefully, we can pin some of our—and our children's
and grandchildren's—hopes on scientists like Laura Nie-
dernhofer. After explaining that "being old is the greatest
risk factor for most chronic diseases," her laboratory's
website goes on to say that "the pillars of aging that are
considered druggable include inflammation, adaptations
to stress, autophagy [scrubbing out damaged cells in order
to regenerate newer, healthier cells], proteostasis [regula-
tion of proteins within a cell], stem cell function, metab-
olism, epigenetics, macromolecular or organelle damage,
and senescent cells [those that can no longer divide]."
Notwithstanding the fact that I do not understand all these
terms, I grasp the gist.

For me, *druggable* is the salutary word. I love reading about the history of science and medicine, so I know that explorations similar to Niedernhofer's began centuries ago and included the development of antibiotics to cure bacterial infections; steroids to reduce the inflammation that causes (in my case) emphysema and Crohn's disease; insulin (in an isolated injectable form) to treat diabetes; chemotherapies that kill cancer cells; and mRNA-based drugs to vaccinate against severe Covid. As the history of medicine proves, we humans can interrupt the ravages that time wreaks on our cells. We can—and I have no doubt that if we can remain a democratic society, we will—turn back our cellular clocks to render our bodies more reliable and better able to function as we live through old age.

There is lifespan, but in our age of radical longevity there is also, as Niedernhofer's work suggests, *health span,* a scientifically nebulous term that I choose to define as the amount of time we can remain healthy enough to live as independently as we wish, make our own decisions, and enjoy the pleasures of culture, nature, and other people. For me health span does not mean that we are free of the chronic diseases (diabetes, high blood pressure, high cho-lesterol) that scientists like Niedernhofer associate with old age, but that they are being effectively treated, as she suggests in her email to Allen.

Indeed, it is druggability that has lengthened the health spans of people like me. Now that I have a reached the time when I see my own old age in the mirror every day, I am discovering that an extended health span is much more important to me than living to be "ancient," as geriatrician Louise Aronson so perfectly calls it. The chronological point at which we become ancient varies from individual

to individual, but I keep choosing to put it at ninety years old, partly because my family history includes both nonagenarians and centenarians, and partly because I am happier when I am bright-sided. Good enough health for long enough, whether conferred by medications, genes, or lifestyle, is my hope for all of us.

The products of our society's efforts to manage longevity are ubiquitous, encompassing senior living apartments, metro mobility vans, nursing homes, meals on wheels, and even chair-based yoga classes, but these interventions are mostly designed to serve people whose health spans have already shortened. Grateful as I feel for these services and environments, I have no wish to spend my old age in their clutches. As poet Mary Oliver famously writes, I want to spend my "one wild and precious" old age doing what I want, with whom I want, where I want, for the sake of my fellow humans. And I want to walk there. And drive there. And if my back does not hurt, I would like to do a couple of downward-facing-dog poses when I get there.

Part IV

Ageism

A Right to Die

IN 1965, A MONTH AFTER MY TWENTIETH BIRTHDAY, my boyfriend jilted me, so I committed suicide. I did it in the still broad daylight of an August evening, in my bedroom in my parents' home shortly after dinner. That means I must have eaten dinner, a notion that now feels mildly nauseating to me. The boyfriend who was to blame for this ultimate act of human agency was a tall, blue-eyed blond named Tom Dayton, whom I had met earlier that summer at a party. The morning after I met him he left town to begin serving in the U.S. Navy, and during the six weeks he spent in basic training we wrote almost every day. It was no wonder that by the time he came home to St. Paul on leave, we were in love, or so I imagined. We had two dates during his leave, after which he returned to the Navy without a word of good-bye.

Three or four weeks passed. Finally, on that fateful August day, I received a Dear Jane letter from him, explaining that he could not continue our relationship because he felt bound to his longtime high school sweetheart. He apologized for leading me on. At the callow age of nineteen he must have felt guilty, but it never crossed my mind to feel even grudgingly grateful for his honesty.

I felt nothing except an uncontrollable, enveloping sensation that I could not go on. It did not occur to me that if I killed myself I would forfeit my future. Yesterday was dead and tomorrow was blind, to quote the sweet-voiced Willie Nelson, and all I had that day was the greatest disappointment of my young life. It is possible that if I had had an ambition, a vocation to which I felt called, a love of learning for its own sake, a moral obligation to my family, or any preoccupation besides teenage fantasies of romantic love, I might have changed my mind. But I had none of those saving graces. I was empty then; I had not yet come into myself.

That evening I must have poured a glass of water from the kitchen faucet, and with glass in hand I must have commandeered the family's bottle of aspirin from the bathroom medicine chest. I remember taking both into my bedroom and closing the door. Then calmly and deliberately, without hesitation, I took fourteen aspirin, one at a time. I think there were still several tablets in the bottle when I finished, but I remember thinking that fourteen should be more than enough to do the job. I lay down in bed, closed my eyes, and waited for something to happen. Only then in the stillness that awakened my consciousness did I realize that I was about to die. It took, I think, only two or three minutes for this reality to land. It landed hard. I bounded out of bed and ran, screaming and crying, to find my mother.

In tearful bursts I blurted out what I had done. I am sure Mom must have been terrified beyond all reason, but she was resourceful and quick thinking and immediately telephoned Dr. Straight, a pediatrician who lived a few houses up the street from us. The good doctor advised that

fourteen aspirin tablets were not enough to kill me; in fact, they were not even enough to sicken me. I would not need to have my stomach pumped, but I would need to drink glass after glass of water to flush all that acetylsalicylic acid through my system as quickly as possible. I complied of course, and eventually I must have fallen asleep for the night. The next morning I awoke still feeling deeply hurt, but not as low as I had felt before hatching my half-baked suicide plan. Still, this fiasco had marked me. Overnight I had developed miniscule red speckles all over my body, each smaller than a pin head. Nothing more than a reactive rash, the speckles faded within a few days.

While I have no specific memory of talking with my mother about my suicide attempt in the hours and days after it happened, I remain certain that she was acutely concerned about me. It is possible that Dr. Straight suggested that I be sent to a psychiatrist for evaluation: given the pre-feminist times, I am not sure that Mom would have come to such a decision without professional advice. Indeed, a week or so after the attempt I saw a psychiatrist, an appointment during which I felt so uncomfortable that I said almost nothing. Immediately after the consultation I took the Minnesota Multiphasic Personality Inventory, which I believe showed nothing out of the ordinary. A few weeks later I started a full-time job as an accounting clerk at a life insurance company, and over the weeks that followed the incident was gradually forgotten.

Through my botched attempt at aborting my life, I had jump-started the process of banishing Tom Dayton from my heart, an excommunication that ended in spectacular style thirteen years later when he called me out of the blue to ask my forgiveness, and only weeks thereafter, to ask for

my hand in marriage. His steadfast devotion lasted until his death twenty years later. Because I bungled suicide, I rescued a future that in a stunningly perfect irony proved that because we cannot know what our futures hold we cannot imagine the harm we cause, both to ourselves and to those we leave behind, by choosing to die before our lives are over. How, I now ask myself, would Tom Dayton have felt if in 1978, when he telephoned my mother to ask how to reach me, she had said, "I'm sorry but she died thirteen years ago."

Suicide seems to be circumstantial, and most often it appears to be a choice. To succeed at it, you need the will, the means, and the physical and mental agency to accomplish the task, whether or not you are in your right mind. There is also a fourth consideration: you must believe that suicide is a human right even though it is, on paper at least, illegal in all but nine of the United States of America. (How would the perpetrator-cum-victim of a successful suicide be punished?) Legal or not, according to a 2018 report from the Centers for Disease Control, suicide was the tenth leading cause of death for all ages of Americans and, not surprisingly, the second leading cause of death for those from ten to thirty-four years old. Even so, in that pre-pandemic year suicide among twenty-year-olds was rare: only about thirteen of every hundred thousand Americans between the ages of fifteen and twenty-four took their own lives. Still, I cannot help but wonder how many young people attempt but do not succeed at suicide. Though we do not become notable statistics, we may nonetheless share profound affinities with peers who do.

From 1999 to 2018, almost four times as many men committed suicide as women, which might help explain

why slightly more than half of all suicides in the United States were accomplished using firearms. The rate of suicide in Americans who are twenty-five years old and older reaches a peak between the ages of forty-five and fifty-four, when it climbs to almost twenty suicides per one hundred thousand people. Suicide is rarest in people who are between the ages of sixty-five and seventy-four, when the rate falls to slightly more than fifteen suicides per hundred thousand. This may be because people in this age group may have recently retired from the stress and monotony of full-time work. Perhaps they are tasting the fruits of finally having more control over how they spend their time; most likely they are healthy enough to engage in the everyday pleasures of living. Quite simply, they may be happier than they have been in years.

But beginning at age seventy-five and continuing through age eighty-five and beyond, suicide rates shoot up to nearly 19 per 100,000 Americans, largely because the rate for males jumps to a whopping 40 suicides per 100,000 even as the rate for females remains stable at 6 suicides per 100,000. Why are the oldest Americans also the most likely to kill themselves, perhaps with assistance, perhaps without? Is it possible that the oldest of the old, who may also be the most infirm of the infirm and the most down-hearted of the downhearted, have finally arrived at unambivalent clarity regarding their long lives? Have they recognized that they are truly finished with earthly life as they have known it? And are they therefore certain that they no longer need or want to live? Though the vast majority of America's oldest residents do not commit suicide, they, like some twenty-year-olds, may share essential feelings with those who do. The fact that the vast majority of old

people do not commit suicide does not necessarily mean that they prefer to go on living.

What is so terrifying about old age that people actually kill themselves to avoid or abort it? I am a novice at being old, but I believe I know the answer to this question. In contemporary American culture old age is viewed almost entirely through an ageist lens. The condition of being old is understood through and characterized by prejudice. The word *old* has become a slur because it is defined as the bleak (used up, discardable) opposite of young (full of potential, embraceable). Indeed, ageism is one of our dominant society's most pervasive prejudices: almost everyone who grows old suffers because of it, and even in old age most of us are both perpetrators and victims unless we reach a point at which dementia frees us from our acculturated biases.

I asked Google for synonyms for old. The first match from thesaurus.com listed the following "synonyms": aged, along in years, ancient, broken down, debilitated, decrepit, elderly, enfeebled, exhausted, experienced, fossil, geriatric, getting on, gray-haired, grizzled, hoary, impaired, inactive, infirm, mature, not young, olden, oldish, over the hill, past one's prime, seasoned, senile, senior, skilled, superannuated, tired, venerable, versed, veteran, and wasted. Two-thirds of these words and phrases are pejoratives that refer to both men and women; they do not include synonyms that are both sexist and ageist: biddy, crone, hag, old bag, and old bat for women; and codger, curmudgeon, goat, and in Yiddish *alte kaker* (literally meaning "old shitter") for men. This tiny survey barely scratches the surface of our country's ageist lexicon because it does not include

most of the sexual obscenities used to describe women, including, impossibly, old women.

Imagine thinking of yourself in these terms. Imagine others, from your family to our society's most influential institutions, treating you as a person who conforms to these terms. Now imagine living within these characterizations for two or three decades, during an era of life that may well last longer than young adulthood or middle age. Within such narrow parameters what is open to you? What if over your lifetime you had become, along with the rest of us, a person who mattered? Having once mattered, what if advancing age has robbed you of the opportunities to act in ways that have long defined you? What if after being told at every turn that you are no longer fit you begin acting like a person in decline even though you have always thought of yourself as healthy and able? What if you begin to feel that your future is a dense, undifferentiated fog of steadily worsening tomorrows? What if you begin to dread the thought of spending each day of the rest of your life feeling worse than you did the day before? Even if you feel well now, you have become convinced that your future decline is inevitable and unassailable, so why endure what you so deeply dread?

All too easily I can luridly imagine this kind of insidious psychological/social/physical descent. I have read both factual and fictionalized stories about people whose late lives have become ageist hells, and because of circumstances that I share with many other old women, including living alone, being childless, having chronic diseases that slowly worsen over time, and getting by on a fixed income, I cannot dismiss the possibility that my life too

could become a hell on Earth from which suicide feels like the only escape. But spending my old age watching and waiting for that hell to materialize is not an existence I can imagine inhabiting. I am still spirited (against ageist expectations), and I plan to resist that kind of passivity with as much force as I can muster. Having written these words, I hasten to add that it is easy to make such a pledge when you are still feeling a sense of agency, as I do right now. The pen, even in old age, is a power tool.

* * *

But not everyone feels as I do. Because of deeply internalized ageism, old age for some of us feels so risky, so scary, so repugnant that suicide becomes more than antidote: it becomes an action to be taken proactively in order to dam the proverbial flood gates before they open. To kill yourself preemptively, it helps to believe that suicide is an ethical choice, a human right analogous to a woman's right to choose whether or not to bring her pregnancy to term. At least that is the way groundbreaking feminist literary scholar Carolyn Heilbrun saw it, according to her protégé and friend, renowned feminist scholar of ageism Margaret Morganroth Gullette.

Though born in 1926, only six years after women's suffrage and a quarter-century before the modern feminist movement, Heilbrun nonetheless claimed that she had been a feminist since birth. She was a preeminent scholar of modern British literature, especially the Bloomsbury group; she taught at Columbia University from 1960 to 1992; she was the first woman to receive tenure in Columbia's then all-male English department; she was president of the Modern Language Association; and she wrote

fourteen Kate Fansler mystery novels under the pseud-
onym Amanda Cross.

In 1988, Heilbrun published one of the most famous
books in second-wave feminist literature, *Writing a
Woman's Life*. Far from just another tome on how to write
well, it feels for me like a holy grail, not just for women who
write but also for women who are written about. From the
book jacket:

> With subtlety and great eloquence, Carolyn Heilbrun
> shows how, throughout the centuries, those who write
> about women's lives—biographers *and* autobiographers—
> have suppressed the truth of the female experience in
> order to make the "written life" conform to society's expec-
> tations of what that life should be. . . . Heilbrun also exam-
> ines literature's silence on such vital subjects as friendship
> between women, the female physical experience, and the
> richness that often imbues a woman's later years.

It is a treasure of a book, a one-and-only-of-its-kind, and I
have turned to its pages time and time again over the years.
As much as any book in my library it has shepherded me
through middle age, especially my demanding career years.
Like Carolyn Heilbrun, I spent more than thirty years work-
ing within the academy, and though my roles were different
from hers, I nonetheless endured many of the same biases
as she did: I was a woman working in an academic setting
that for decades was majority female in its ranks but all male
in its top leadership; I worked in the arts, which were not
as critical to the university's research mission as hard and
soft sciences and professional programs; and I invested too
much of my identity in my work, especially after Tom died.
Eventually, Heilbrun's discriminatory, sexist work environ-
ment became more than she could tolerate, and without

notice she retired from Columbia at sixty-six, the same age as I was when I retired from the University of Minnesota.

Heilbrun had enjoyed, by all accounts, a happy family life: a loving, loyal husband to whom she had been married for more than fifty years, three well brought-up children, and two grandchildren. Given her prodigious brilliance, all who knew her expected that she would find new pursuits and passions after liberating herself from the pressures of academic work, and indeed, during her first few years of retirement, she wrote an acclaimed memoir, *The Last Gift of Time: Life beyond Sixty,* which was published in 1997, when she was seventy-one.

In that book Heilbrun writes in an unabashed, skin-prickling way of a recurring state of sadness, one that came and went over her lifetime: "However often apathy assaults me in these last decades, I know it to be danger-ous. I have found that detachment serves me only insofar as it encourages me, both to resist foretelling doom upon a world I cannot really know or guess at, and to leave the future to those who will inhabit it."

Her words were prophetic. After she wrote *The Last Gift of Time,* nothing seemed to hold her, to spark her, and her fear of becoming what she called a "useless person" began to mount. I strongly suspect, as did friends and col-leagues who knew her, that for Heilbrun "useless person" was probably an ageist euphemism for old or retired or both, since she may well have equated the two. In fact, she had talked for years with friends about suicide as a reason-able, rational option at any point at which life felt complete or no longer worthwhile, making it an exercise in freedom of choice rather than an act of desperation, a last resort.

Vanessa Grigoriadis, writing in the November 30, 2003,

issue of *New York Magazine,* relates how on a warm October afternoon in 2003, as Heilbrun leisurely walked in Central Park with fellow literary scholar Mary Ann Caws, she suddenly said to her longtime friend, "I feel sad."

"About what?" asked Caws.

"The universe," replied Heilbrun.

From all I have read, that was as far as the conversation went, but sometime after returning home, either later that day or the next morning, seventy-seven-year-old Carolyn Heilbrun was found dead in her apartment with a plastic bag over her head. A note lay near her. "The journey is over. Love to all." As if suffocation were not enough, this great-willed, staunchly ethical woman had taken enough sleeping pills to assure that she would rest in peace forever. She had not been ill, she had no known history of "hurting" herself, and she had not recently received bad news of any kind. She simply did not want to be a "useless person" living on "borrowed time." Most important, she wanted the decision about when her journey would end to be hers alone.

If Heilbrun had not accomplished all that she did in the academy, if she had not left the world a more opportune place for women, if she had not shown us that intellectual brilliance is every bit as venerable in a woman as it is in a man, she would have nonetheless earned our deepest admiration for writing these radical words in *Last Gift of Time*: "Women, I believe, search for fellow beings who have faced similar struggles, conveyed them in ways a reader can transform into her own life, confirmed desires the reader had hardly acknowledged—desires that now seem possible. Women catch courage from the women whose lives and writing they read, and women call the bearer of that courage friend."

There was no better friend than Carolyn Heilbrun to women like me, who were born into the baby boom on the heels of World War II, and who, like me, felt themselves on the cusp of a generational divide, pulled backward on the one hand toward the lifestyles of our mothers, lifestyles that privileged marriage and motherhood over advanced education and careers outside the home, and pushed forward on the other into the breaking world of women's liberation, social and political activism, and broadening constructions of female selfhood. It took the first quarter-century of my life to release myself from that backward pull and embrace a lifestyle better suited to the self-doubting, introverted, justice-loving artist I was. When I became a feminist, I found myself. It was feminism that allowed me not only to vastly enlarge my tent of understanding, but also to feel deep within my being the effects of sexism on women everywhere. Feminism, I firmly believe, also expands our capacity for understanding and resisting both racism and ageism.

I shake my head in disbelief as I remind myself that when Carolyn Heilbrun took her life, she was just two years older than I am as I write. Having entered old age relatively recently, I continue to imagine myself at the beginning of a journey, not approaching the end of my one and only earthly voyage. If I extract the ageism from old age, as I might suck out the venom from a rattlesnake bite, this new stage of life becomes a compelling late chance. I feel like a resistance fighter standing my ground against the vultures of persistent, encircling ageism. My leading act of resistance is to (try to) take thorough advantage of my stable physical, intellectual, and psychological health, and my following act is to (try to) refuse to spend my time brooding about how long each of them might last.

In an uncharacteristically optimistic passage about her children and grandchildren in *The Last Gift of Time,* Heilbrun quotes French Renaissance essayist Michel de Montaigne:

> Above all, now that I feel my life to be brief in time, do I seek to extend it in weight. I try to delay the velocity of its flight by the velocity with which I grasp it; and to compensate for the speed of its collapse by the zest which I throw into it. The shorter my hold on life, the deeper and fuller do I seek to render it. Others feel the sweetness of contentment and well-being; I feel it just as much as they do, but not by letting it just slip away.

Even though Heilbrun demonstrated that it is possible to rush death, I do not believe the opposite is true, and I do not think Montaigne really believed so either. You cannot rush life. Over the past several years I have welcomed this simple certainty as the first tenet of a writer's life, no matter the length of her future. Like life itself, the act of writing offers the occasional bracing flood of meaning and rightness, but as a vocation it is slow and often fitful. I do my part each day as ardently, sincerely, and patiently as I can, and after a period of gestation that I cannot predict or control, the utterance I labor toward gradually begins to show itself. Each day is only a step (or sometimes not) in the right direction, but giving way to the inherent slowness of my occupation does not mean that I am letting my life slip away. The truth is that this slower, unforced, more reciprocal relationship with my work has imparted a much deeper feeling of satisfaction than would have been possible earlier in my life.

* * *

Fifty-five years ago, after Tom Dayton jilted me, I felt that my life was finished. Twenty-four years ago, after he died, I once again felt that my life was finished. But both times the future proved me wrong. No matter when or how we leave our earthly lives, those lives will be suspended, remaining forever unfinished. Luckily, nature is an insistent optimist, so there will always be those who come after us to further what cannot be finished in a single lifetime. Unfortunately, that promise does not apply to the diarist. If a truthful account of one's old age becomes possible only after one dies, it will be too late to write it. Respecting the slowness of a persevering writing practice, and knowing that life ends without completion, how can I write an honest, fact-based accounting of my old age?

In *Writing a Woman's Life,* Carolyn Heilbrun offers a possible path:

> There are four ways to write a women's life: the woman herself may tell it in what she chooses to call an autobiography; she may tell it in what she chooses to call fiction; a biographer, woman or man, may write the woman's life in what is called a biography; or the woman may write her own life in advance of having lived it, unconsciously, and without recognizing or naming the process.

When I first read these lines, I thought Heilbrun's fourth way might refer to tradition and its offspring, predictability. If the generic woman to whom she refers follows what Heilbrun surely thought of as a traditionally gendered middle-class life course, that is, schooling followed by marriage followed by motherhood followed by grandmotherhood followed by rest followed by death, she might be able to write about her old age truthfully and in some detail before she lives it. I can also imagine that

Heilbrun's description might evoke a teenage girl writing her dreams in her diary. Some dreams (and unfortunately, some nightmares) do come true, and if we look back far enough, we come to understand that some of them actually transform us.

Author's note: Because it juxtaposes the long survival of a young woman who failed at suicide with the measured suicide of an older woman, this story reflects on suicide from the distance created by the passage of time. But immediately before my attempt and immediately before Carolyn Heilbrun's, the people around us, including those closest to us, had no notion that we were on the brink of taking our own lives. We appeared emotionally stable; our loved ones had no cause to worry about us. That is why I must stress that if you or someone you love, whether young or old or in the middle, seems to be contemplating suicide, it is best to seek help immediately, when it can do some good. The National Suicide Prevention Lifeline (988) is a reliable source of immediate help, as is the Institute on Aging's Friendship Line (888-670-1360). Experts agree that timely intervention can save a life that wants to be saved, and seeking intervention may well help us recognize that we and those we love are worth saving.

Facing Ageism

I WANT TO SHARE A SELF-REVELATORY STORY ABOUT the first full pandemic winter, the one we might remember for Operation Warp Speed, the government project that brought the first Covid-19 vaccines to market in the United States. It is a story that has haunted me because it marked the first time I admitted to myself that I was both a victim and perpetrator of ageism, sometimes simultaneously. That is the peculiar insidiousness of this particular prejudice: it turns us against our own kind, it turns us against some of the people we love most, and it turns us against ourselves.

On January 15, 2021, I observed my seventy-fifth-and-a-half birthday. Had my outlook on life been different that day, I might have regarded my half-birthday as a carrier of hope, a harbinger of a fresh perspective, or at least as a marker that half of the coldest month of the year had passed. But on that short, crisp day I did not feel psychologically spacious enough to consider whether my half-birthday had any particular significance, or for that matter, whether anything else about my shrunken, confined life was worth considering. On that day I had no appetite for looking inward. I was looking out, as though

from a prison cell, at my country as it stood in shambles, shocked by political unrest and hobbled by a deadly virus.

On January 16, 2021, the day after my half-year birthday, I observed the ten-month anniversary of my pandemic-produced social isolation. March 16, 2020, marked the last time I had entered a public place and mingled with strangers in it. The place was Whole Foods Market in St. Paul, where I bought freshly squeezed orange juice, unsalted popcorn, ready-to-heat-or-eat paleo grilled chicken breasts, blood oranges, and other foods that I then deemed essential. That final pre-lockdown outing, which took place soon after the earliest cases of Covid had been confirmed in Minnesota, was the first during which my fellow customers and I were taking care to stay at least six feet apart from one another. Face masks were not yet advised, so it was fortunate that we kept our distance.

For more than ten months I had lived without the occasional indulgences that perked up my ordinary days, whether those happened to be a trip to the Mall of America to savor a sushi bento box at Crave restaurant, a visit to the Minneapolis Institute of Art to browse its permanent collection for the umpteenth time, or every fourth Friday, as my house cleaner spruced up my home, a late lunch at Dixie's restaurant on nearby Grand Avenue, where I could relish a catfish basket as I read and took my evil red pen to whichever manuscript I happened to be working on. In the deep winter of early 2021, as my half-year birthday came and went, I found myself missing these incidental pleasures ever more urgently as ten months came closer to eleven and eleven to twelve, and from there, only heaven knew.

When you exist in isolation, time moves slowly and laboriously. There is a serene sameness to the days:

nondescript dark roadways and tree trunks, snow-white earth and rooftops, and tedious gray skies. These were the contours of the world outside my windows, a world in which the temperature did not rise above thirty-two degrees and did not drop below zero. But the pervasiveness and pace of the coronavirus pandemic cruelly belied the monotonous state of the weather. By January 26, 2021, more than one hundred million cases of Covid had been diagnosed around the world, including twenty-six million in the United States. Globally, two million people had died of the disease, including 406,000 in the United States. In Minnesota, which is home to 5.6 million people, nearly half a million cases had been diagnosed, and more than six thousand people had died of the disease. Almost three-quarters of them were seventy-five years old or older when the virus took them.

That is the backdrop against which glimmers of hope began finding their way into the American body, including mine. In December 2020, after months of anxious anticipation, two highly effective Covid vaccines were approved for emergency use by the U.S. Food and Drug Administration. Ever so slowly, ever so cautiously, the country began vaccinating its residents. In those early weeks there was not enough vaccine to go around, and the robust infrastructure needed to deliver mass vaccinations did not yet exist, so the most vulnerable Americans were inoculated first, beginning with people who were living in communal settings, especially nursing homes, where Covid was spreading like a September wildfire in the Los Angeles foothills.

The federal government had declared that people seventy-five and older, including those living independently in their communities, would be next in line to get vaccinated,

but when the new year began we were still waiting. As the blank days of January ground on, I selfishly yearned to be vaccinated immediately, even though my turn had not yet come. To my shame, there it was: the selfishness bred of confinement. Then on January 18, 2021, the heavens opened. To my shock, I received an email from Health-Partners, my health care provider. It informed me that they had begun their vaccination rollout, and that I would receive a follow-up email when it was my turn to be vaccinated. In the meantime, they asked me to confirm the accuracy of my online contact information so that I would be sure to receive my vaccination notification.

As we sing at Passover, *"Dayenu!"* That would have been enough for the time being, but less than twenty-four hours later I received another email from HealthPartners. Imagine my shock when I saw it:

SUBJECT: It's your turn to get vaccinated
Email for Andrea Gilats only—do not forward

Hi Andrea,

We're happy to share that you may now schedule a COVID-19 vaccine appointment. Vaccine is currently being offered to our patients age 75 years and above.

COVID-19 vaccines are given in two doses. You can now schedule your first dose. After your appointment, we'll help you schedule your second dose.

Yours in good health,
HealthPartners

* * *

Good Lord! I bolted up from my desk chair. I looked up at the ceiling as though I were expecting to see God. It is a miracle that I did not burst out of my body then and there.

I began pacing my condo, exuding energy as though I were an electric field unto myself. *I am going to live! I am going to live!* Over and over I repeated my oath of liberation, striding around my condo as if I had a purpose, as if I were on my way, as if I had a destination even though my route was circular. Freedom! I simply could not believe my good fortune.

Later I learned that even though HealthPartners would be offering vaccinations to all its patients aged seventy-five and older, it would not be doing so all at once. Because the federal government was rationing vaccine stocks according to each state's population of age-eligible residents, vaccinations would be administered over several weeks. But I was lucky: I had been randomly selected for the earliest set of appointments.

This was not only the first major privilege accorded me by virtue of attaining old age: it was also the most hallowed. Of all the miracles I could have wished for, my vaccination appointment on Tuesday, January 26, 2021, at one o'clock in the afternoon was by far the most miraculous. I may be old now, but I am still punctual by nature, and I marched into the Regions Hospital atrium at 12:50 p.m. with a mask on my face and a spring in my step. A cathedral-like, light-admitting space, the atrium is half a football field long. Its ceiling is two and a half stories high, and its width is twenty-five feet. Every square foot of its expansive floor space was devoted to the activities of the clinic, including waiting areas, in which chairs were spaced six feet apart.

As soon as I entered, I was approached by a staff person who gave me a screening form to complete. No, I have not had Covid. No, I have never had an allergic reaction to a vaccine. No, I am not pregnant. No, I am not nursing. No,

thank God, I am not feeling sick today. Once screened, I was directed to a nearby table, where another staff person gave me several pages of information about the vaccine itself, what to expect after my inoculation, and how to follow up with the Centers for Disease Control if I had questions.

Next stop? A nurse's station, one of six in the clinic. I sat down, removed the left sleeve of my hoodie, and before I could say hello, I was vaccinated. My final stop was a table at which still another staff person prepared a white Covid vaccination card that showed the brand name (Pfizer) of the vaccine I had received and the date of my dose. Then she made an appointment for three weeks later, same time, same place, at which I would receive my second dose, completing the required course. Two weeks after that I would begin enjoying 94 percent protection from most known strains of the Covid-19 virus.

My visit left me feeling optimistic and reassured, but more than the clinic's efficient care, more than the positive atmosphere created by its staff, more than the relief I felt at actually being there, it was my fellow patients who made the deepest impression on me. My observations were cursory, since there were patients scattered throughout the atrium, but I believe there were probably eight or ten men and women there, all seventy-five and older. Here is what struck me most. In one way or another, they all seemed infirm. Old. Tired. Docile. Slow. I expected to see people in their late seventies, but these people seemed to behave as if they were older, whatever that meant.

No matter, I thought: age alone is no reason for their lifeless appearance. I have friends who are in their early and middle eighties, and several of my former yoga students

were in their early eighties when I taught them. All were able to move purposefully, without prodding or aids. Scanning the clinic, I spotted two wheelchairs, one oxygen tank, and one walker. I also noticed that many of my fellow patients wore clothes whose colors did not coordinate, several wore white, black, or tan orthopedic-looking oxfords, and most memorably, several had uncombed or unwashed hair.

Why would I choose to see my fellow patients not as merely old but as infirm, tired, docile, slow, and even dirty? As far as I knew, they were not nursing home residents, reliant on unsympathetic others for their care and grooming. Why, as the person I profess to be, would I use such vile, ageist terms to describe people who are very likely not much older than I and not much sicker than I? *Infirm, tired, slow, docile*: these are terms that might be used to describe a sixteen-year-old mongrel or the proverbial old gray mare. They are terms from which I have indignantly distanced myself for more than a decade, and that, having just spit them out onto this page, I hate myself for using. But unfortunately, those were the exact words that came to mind that day as I observed my fellow patients. I did not think empathetically. I thought only in the ageist terms that came so easily to me.

How could I assume that my fellow vaccination patients inhabited a world in which they looked and acted "old" much sooner than I? Descending to the dirty truth, I must admit that I never actually saw them as my generational peers: in my stuffed-shirt mind, I think I perceived them as at least seven to ten years my senior. But if they appeared that much older than I, how was it possible that I was seventy-five and a half? Mind you, I took no satisfaction

from my observations; afterward, as my shame rose, I wished hard that I could have seen my fellow patients as generational peers: leading-edge baby boomers, the pioneering children of rock and roll.

It terrifies me to think that in my old age I have become a biased, self-hating snob who defines younger as better and older as the poor souls at the vaccination clinic. Only now, almost two years after the fact, has it dawned on me that most of my fellow vaccination patients probably were in fact several years older than I. According to another age-dependent method of classification, they were no longer considered "young-old" by gerontologists but had become, as they settled into their eighties, "middle-old." When seen this way, most of them looked pretty darned good and got about pretty darned well. Unlike me, they looked kind, open, relaxed, and content, the humane corollaries of infirm, tired, docile, and slow. In retrospect, I was the one who could have been seen as anxious, tense, stiff, and worn out.

Because we are so acculturated toward ageism, when we look around us, we may well be seeing our prejudices coming to life instead of what is actually before our eyes. When I was a fine arts undergraduate at the University of Minnesota, I took a course in genetics to fulfill my nonlaboratory science requirement. It was taught by the venerable Val Woodward, who in addition to his storied career as a researcher won, according to his 2014 obituary, "essentially every teaching and human rights award given by the University of Minnesota." Just as I remember the words of my friend Anthony when he said that "haters hate broadly," I will never forget Val's words during our first class: "You have to believe it to see it."

What makes me so sure that my fellow patients did not see me the way I saw them? More to the point, why would they bother to notice me at all? Other than one man who glanced at me as he walked past the nurse's station, I feel certain that none of the other patients noticed one more nondescript seventy-five-and-a-half-year-old getting her vaccination.

* * *

To prove to my sisters that I had actually received my shot, I had enlisted a staff person to photograph me at the moment of puncture. Here is how I looked: pandemic hair, long and stringy, faded brown topped with a nearly invisible white border an inch out from the scalp that looked like a threadbare white skullcap; beige-gray sweat pants topped with a sleeveless tank top of dusty drab rust, topped in turn with a zip-front hoodie of the same drab rust; six-year-old gray suede sneakers tied with fraying magenta shoelaces; milky cold lined face concealed by a white mask and shielded by thick frameless eyeglasses. Twigs for arms, forearms and upper arms equal in diameter, noticeable veins and freckles speckling colorless pale, slumping skin. Dull, ordinary, dreary, invisible even to people nearby.

I had witnessed myself not only in that revelatory snapshot but in my fellow patients. On January 26, 2021, after more than a decade of intellectual mythologizing about aging, a time had come when I was finally compelled to turn my prejudices inward. At seventy-five and a half years old, I began, in one eye-opening experience, to believe what I actually saw, and from there to seek an entirely new process of self-acceptance. First, I recognized

that I had to be honest about the state of my body. To find equanimity, I had to honor my garden-variety, age-appropriate wrinkled face (and arms and legs) rather than dooming myself to a life in which each new wrinkle, each crease of survival would render me ever more withered until finally, at some fictitious age, I would no longer be able to stand myself.

Proletarian poet and social justice activist Meridel LeSueur, who lived to be ninety-six, believed that she had earned her facial wrinkles and proudly wore them as badges of courage. Courage, resilience, and survival bestow beauty on those who endure, and that beauty shows in our faces. It shines! Now I must relearn how to love myself: how to see myself as lovable by virtue of having grown, having lived, having brought myself to a hard-won present. With all my heart, I want to embody the dignity that comes from hoeing the rocky road of life, and I want to think highly enough of myself so that I can unselfconsciously give to others.

This means that I cannot continue to live with ageist prejudices festering inside me, so I have vowed to unravel and discard them before they have a chance to harm others. The obvious: there is no room in old age for ageism, something I dearly wish that Carolyn Heilbrun had been able to feel. We, the old, must be the teachers, the ones who through our words and actions and habits of living demonstrate the distinctive beauties of advanced age. We cannot think of ourselves, as I did on that vaccination day, as exceptions to some invented ageist rule, and we cannot direct our ageist prejudices against ourselves. As I absorb this newfound awareness, I can actually feel myself sitting a little taller in my desk chair, and later this afternoon

during my daily walk I plan to focus more closely on my upright, forward-moving posture. I plan to practice meeting the world at eye level, and I will try to right myself if I find that I have lapsed into hanging my head, staring at the floor as I walk.

A Trip to the Nursing Home

THE AVERAGE NURSING HOME STAY FROM YOUR
entrance until your death is anywhere from eight to twenty-
eight months depending on your age, gender, and state of
health. Other than people who are sent to nursing homes
to recuperate from surgery or illness in short-term reha-
bilitation facilities, I could find no statistics that would tell
me how many people leave nursing homes because they
are physically and cognitively fit enough to resume living
in a private residence, either alone or with family mem-
bers. For too many of us, nursing homes are our last places
of residence, especially if we happen to be widowed, child-
less, or both; or if we have Alzheimer's, the most com-
mon cause of pre-pandemic deaths among people living in
nursing homes and their specialized neighbors, memory
care facilities.

The loathsome truth? If you end up in a nursing home
as a resident whose stay is indefinite, your odds of resum-
ing your previous life are almost zero, no matter how much
you dream or yearn or plead. The only person I have ever
known who defied these odds was my maternal grandfa-
ther, Boris Ward, affectionately known as Boo to his fam-
ily and friends. Boris Ward was the American name that

Grandpa received at Ellis Island; his name in the shtetl outside Kiev, the then-Russian city where he was born and raised, was Borah Wojewod. To escape widespread pogroms, Grandpa and Granny literally waded out of Russia in 1921, my two-year-old mother on Grandpa's back.

Though his younger son, my Uncle Hillard, affectionately known as Babe to his family and friends, says that Grandpa was sometimes impatient and careless, everyone knew that he was also clever. Unfortunately, his quickness did not extend to verbal communication. Even though he made a good living in St. Paul working at the Armour meat packing company, he never embraced the English language the way Granny did. Babe told me that when Grandpa spoke, "There were two or three different languages in every paragraph." We, his grandchildren, were used to his mix of English, Yiddish, and Russian; it was part of his charm.

For several years after his retirement, Grandpa worked part-time in a small kosher butcher shop. He also enjoyed a satisfying social life, spending time with his grandchildren and with his and Granny's large group of friends. In spite of losing his older son, my Uncle Irving, to congenital heart disease at the age of sixteen, I do think Grandpa felt that he had had a good life; his grandchildren always admired what we called his "positive attitude."

He was blessed with nearly perfect health until he was eighty-eight years old, and then one ordinary day, seemingly out of the blue, he landed in the hospital. That is how we condensed the story as the years wore on, but the truth was that Grandpa's health had actually been worsening for several weeks. By the time the ambulance bore him to the hospital on that ill-fated day in 1982, he was unable to

move. He was listless, he was suffering from severe edema, and he was not lucid. Here, his doctor observed, was an eighty-eight-year-old man showing common symptoms of dementia who seemed to have no discernible conditions that could otherwise account for his symptoms. The misdiagnosis of Alzheimer's disease was an easy one.

Uncle Babe told me that Grandpa's longtime physician, Dr. Ralph (his surname), had not been taking good care of him. If Grandpa had a complaint, which Dr. Ralph may not have fully understood, he simply wrote him a prescription and that was that. By the time the straw broke the camel's back, Grandpa was a healthy old man on too many medications whose professional caregivers had wrongly concluded that he was dying.

Thankfully, just in the nick of time, a miracle occurred. At some point, either while Grandpa was in the hospital or shortly after he had been discharged to Sholom East nursing home, St. Paul's only long-term care facility equipped with a kosher kitchen, he was seen by Laurence Savett, a renowned physician who had a special interest in geriatrics and was fluent in Yiddish. In his 2002 book *The Human Side of Medicine: Learning What It's Like to Be a Patient and What It's Like to Be a Physician,* Dr. Savett posited that "attending to the human side refines diagnosis and treatment by recognizing the uniqueness of each patient's experience." So it was with Grandpa.

Through gentle conversation amplified by my mother's prodding, Dr. Savett learned from Granny that she had been quietly adjusting Grandpa's medication doses, reckoning that if one pill was good, two were better. Rather than scolding Granny, the first thing Dr. Savett did was to discontinue all of Grandpa's medications. Within a few

days he began to feel better. Then Dr. Savett began reintroducing, one at a time, safe doses of only those medications that were actually needed. After four weeks at Sholom under Dr. Savett's care, Grandpa's health had fully returned, and holding his walker in one hand, he strode out of Sholom and rode home to the picturesque stucco house on Osceola Avenue that he shared with Granny and in which his children had grown up. His family was there to meet him, and he was all smiles as he chortled to my sister Resa, "I came out with my life!"

Two years later, he and Granny moved to an apartment across the street from the St. Paul Jewish Community Center, where Granny, a force of nature, taught English to refuseniks (Jewish immigrants from the Soviet Union). Together, Grandpa and Granny attended many social events at the center. They had outlived most of their friends, so this gathering place, where Yiddish and Russian were spoken as commonly as English, was a lifeline for them. Two years after moving, on December 28, 1986, during the afternoon of the third day of Hanukkah, Grandpa, having turned ninety-two several days earlier, lay down for a nap and never woke up.

That is the story of Grandpa's unique, even miraculous stay in a nursing home. More than thirty-four years later, in the late winter and early spring of 2020, the virus causing Covid-19 was loose and spreading rapidly in nursing homes, where residents were sharing it like a bowl of popcorn. The federal government was confused, defensive, and ineffective; nursing home operators, a niggardly group to whom regulators had always turned a blind eye, could not dispose of diseased corpses fast enough to control the viral spread or the odor of putrefaction. Attempts

to separate residents from one another were futile: there was not enough space and no resourcefulness.

To our profound shame, one out of every ten residents of nursing homes died of Covid between March 2020 and April 2021. That amounts to about 182,000 people, enough, if these deaths had been premeditated, to constitute a modest genocide. If you were old, if you were unlucky enough to live in a nursing home, or if you had no one to bring you to safety before you became infected, you died. But before that you suffered. Not only did you suffer, you suffered alone. No one dared share air with you, let alone offer a touch of comfort from under a glove. You were a pariah, and you met a pariah's death.

And us? The lucky ones who took the privilege of sheltering in our own roomy homes? We simply laid low, intent on saving our own skins. Speaking only for myself, what else could I have done? On orders from my siblings and doctors, I was on strict lockdown. All I could do was brood over the idea that people in nursing homes, having done nothing to offend society, are some of the least loved and most likely to be forgotten human beings in our country. The ongoing unmediated pandemic provided conclusive evidence of this.

Shocking as this catastrophe was, I was not surprised by it. Nor, I am sure, was anyone who provides services to a nursing home or works in one, or who has a loved one who lives or had died in one. Over several decades I had seen with my own eyes that nursing homes are holding pens, waiting rooms in which failing elders mark time until their inevitable deaths. Nursing homes have never been intended to serve as abiding homes. They are not apartments, they are not residence hotels, they are not free

spaces in which residents may do as they please when they please and come and go as they wish.

When you enter a nursing home under Medicare coverage, you become poor in an instant because your Social Security benefit is paid directly to the nursing home on your behalf. When you enter a nursing home, you lose access to your doctor unless your doctor happens to make visits to the particular facility you have entered, which leads you to give up hope that you will recover from any illness you might have. Your medical care goes from preventive and curative to mostly palliative. The goal is not to prolong your life or improve its quality, but to keep you safe and make you comfortable, whatever that might mean to the nursing home's underpaid, often poorly trained staff members.

Here is what law professor Nina Kohn, who studies the civil rights of older adults, wrote in the *Washington Post* on May 8, 2020: "Policymakers and healthcare providers have long accepted the preventable suffering of older adults in long-term care institutions. The U.S. Department of Health and Human Services found that about 20 percent of Medicare beneficiaries in skilled nursing facilities suffer avoidable harm."

I have no doubt that this percentage is low. Why? Because "avoidable harm" almost certainly does not include indignities and invasions of privacy; insults, especially those aimed at residents who suffer from dementia; misunderstandings resulting from language barriers; and "benign" neglect, such as failing to help residents to the bathroom after they no longer understand how to find and use a call button. Nor does it include leaving a resident alone in her or his room for hours on end with no

social stimulation, no variation in environment, no access to nature and the outdoors, and no exercise. The heart-breaking fact is that our oldest and most infirm citizens have been left to die of neglect ever since English settlers brought almshouses to America more than four hundred years ago. The deaths from the pandemic represented no novelty to nursing homes; it was only the scale that over-whelmed them.

"Excess deaths," defined as the number of deaths over and above the Centers for Disease Control's annual fore-casts, have become the norm in many nursing homes as administrators and staff have grown ever more compla-cent about assuring that residents and staff receive Covid boosters, keeping sick people isolated from their fellow residents, and requiring everyone under their roofs to wear face masks. These precautions are not excessive; at most, they are small inconveniences, no more uncom-fortable than wearing a seat belt in a car. Ethically, mor-ally, and from a public health perspective, it is as wrong to transmit Covid as it is to fall ill with it. For this state of affairs we all share blame.

Why am I so afraid to live in a nursing home? In this story I have enumerated some of the reasons, but at the risk of restating the obvious let me personalize my fears. First, I am afraid that I will deteriorate and die there: that once admitted, I will never leave. Second, I am afraid that I will get sick there, causing me unpalliated pain and has-tening my death. Third, I fear the trauma of having to give up the comfortable, independent life I now lead in the home that is mine and mine only. Because it represents an often harrowing diminishment of one's prior lifestyle, a transition to a nursing home is akin to being sent to

prison, except that you need not have committed a crime to receive the sentence.

Acutely and intensely I fear the losses of personal privacy and human dignity, and I fear the disrespect and thoughtless cruelties that cause them. I fear being undressed by strangers, I fear being bullied, I fear having nothing to do. I fear not being able to take my medicines on my own schedule; I fear having to eat poorly prepared food with tablemates who choke and drool as they dine. I fear not having anyone with whom I can have a stimulating conversation; I fear not having enough good books to read. I fear being treated as an imbecile or, worse, as an unwanted dog. I fear that these fears will comprise my daily life for the rest of my days.

An Ageist Disease

THE ONE DISEASE I FEAR MOST IS ALZHEIMER'S, AND I am sure that I am not the only one. Our fear of Alzheimer's, which recent research suggests may have been the third leading cause of death in the pre-pandemic United States, far outranks our fear of heart disease and cancer, the first and second leading causes of pre-pandemic deaths. Though there are several other common types of dementia that affect old people, Alzheimer's is by far the most ubiquitous. It is a progressive disease, and as I write there is no cure or treatment that can effectively control its symptoms.

Alzheimer's is named for Dr. Alois Alzheimer, a German psychiatrist who, according to the National Institute on Aging, "noticed changes in the brain of a woman who died of an unusual mental illness." Her symptoms included memory loss, language problems, and unpredictable behavior. After she died, he examined her brain and found many abnormal clumps (now called amyloid plaques) and tangled bundles of fibers (now called neurofibrillary tangles.) These features, which Dr. Alzheimer observed in 1906, remain defining pathologies of Alzheimer's.

One of the most confounding symptoms of advanced Alzheimer's is aggressive behavior, thought to be brought on by the patient's inability to communicate discomfort, pain, anger, hunger, and other physical or emotional states of distress or urgent need. That is one reason why many Alzheimer's patients eventually end up in nursing homes or memory care facilities, where they can be properly looked after.

But whether in a nursing home, memory care facility, or family home, I wonder whether it is humanly possible to compassionately, effectively care for a beloved old person who suffers from a multifarious disease that remains beyond our healing arts. My paternal grandmother, Rose Latts Gilats Rose, who died of complications from Alzheimer's at the age of eighty-nine, had a habit of pounding her fists into her thighs as she groaned in her wheelchair. In her earlier life she had been a gentle, good-natured woman who loved her grandchildren; no one would have guessed that violent self-injury was lurking in her nature. Frankly, I hope it was not. I would like to believe that such a ferocious habit was just one more macabre symptom of Alzheimer's.

Granny Rose's favorite television character was Hopalong Cassidy, but like me, she also enjoyed watching *All-Star Wrestling* from six to seven o'clock on Saturday evenings. Though it still embarrasses me to admit it, during my early teens I was seriously hooked on that show. After working the cash register at my father's grocery store all day every Saturday, I could not wait to get home so that I could watch local wrestlers pretend to maul each other, often inflicting garden-variety injuries as they went. I loved professional wrestling so much that every Saturday

during my lunch break, I would slip next door to Sansby's drug store to browse and usually buy wrestling magazines, which I would pore over between customers.

There were wholesome wrestlers like Minnesota-bred Verne Gagne, who co-owned, along with promoter Wally Karbo, the Minneapolis-based American Wrestling Association, and there were evil wrestlers like Minneapolitan Krusher Kowalski and Canadian Tiny Mills, who were billed as Murder Incorporated when they wrestled as a tag team. *All-Star Wrestling* was a promotional vehicle for the American Wrestling Association's Sunday cards, so there were never any upsets. The wholesome wrestlers always won, which made the evil wrestlers thrillingly angry.

Even today, I shudder with pleasure as I remember *All-Star Wrestling* host Marty O'Neill conducting after-match interviews with the losers. Kowalski and Mills, who both possessed outstanding tummies, towered over the diminutive, unassuming Marty, and as they shook their angry fingers at him, I was certain he would end up on the floor, the victim of an errant poke. But he was brave. He always stood his ground and kept his cool, which years later helped earn him a place in the Minnesota Broadcasting Hall of Fame.

Marty also interviewed Gagne, winner of all his matches, who conducted himself as a perfect gentleman and never spoke angrily at or about anyone. In fact, Gagne was a quintessential Minnesota athlete, having won two NCAA wrestling titles as an amateur and eleven American Wrestling Association championships as a professional. He was also an All–Big Ten football player at the University of Minnesota who was drafted by (but never played for) the Chicago Bears. He had an extraordinarily long and

storied career, and throughout his life he was loved and respected for his many acts of kindness and charity. Billy Bye, a longtime friend who met him when they both played football at the University of Minnesota, said, "Verne was a great man. It didn't make a difference to Verne whether you were Hubert Humphrey or a plumber. . . . He'd shake your hand and make you feel good to be around him."

* * *

When Verne Gagne was diagnosed with Alzheimer's, his nature changed: he became someone whose family and friends no longer recognized. By the time he was eighty-two, he was living in the memory loss section of a local nursing home. One of his fellow dementia patients was ninety-seven-year-old Helmut Gutmann, a medical doctor, enthusiastic sportsman, and classical musician who had fled Nazi Germany in 1936. Active and engaged throughout his life, Gutmann had served as a cancer researcher at the Minneapolis Veterans Administration Hospital for forty years and had played violin with the Bloomington Symphony Orchestra for twelve years. In their own dissimilar ways, both men had been model citizens who over their well-lived lives had significantly enriched their communities.

But according to numerous news reports, as neighbors in a communal living environment they were not neighborly. Their family members told journalists that they seemed to get on each other's nerves, if such an idiom could apply to two elderly men with severe dementia. On January 26, 2009, they had a serious altercation. No one knew what precipitated it, but it ended with Gagne hoisting Gutmann over his shoulder and flinging him to the

ground in a classic wrestling slam. Gutmann was immediately taken to the hospital with a broken hip, which was successfully repaired. A few days into his hospital stay he began refusing food and drink and died there on February 14, 2009. Neither man could recall the lethal incident. After Gutmann's death, Gagne went to live with his daughter, and he died seven years later at the age of eighty-nine. Though Gutmann's death was ruled a homicide by the Hennepin County medical examiner, the county prosecutor ultimately declined to press charges.

If this was murder, then we would have to conclude that the murderer was not a man but an indiscriminate, barbarous disease. No one who knew Verne Gagne thought him capable of murder; after the incident, Billy Bye told the *Minneapolis Star Tribune,* "This was not the real Verne." Even Gutmann's bereaved wife understood that. But in the moment of the attack, Alzheimer's seemed to spare certain deeply rooted parts of Gagne's being, including but doubtless not limited to his wrestling skills, which he had honed day by day and week by week over three quarters of a century. By the time he retired, he had probably thrown many hundreds, if not thousands of body slams. Without his intellect to palliate him, and no longer possessing a moral compass, Verne Gagne's still-formidable physical powers overtook him. Alzheimer's had reduced this living man to his basest instincts: all he had left was his reflexive urge to fight, though he could not have cognitively understood even that.

In Alzheimer's disease, we humans have an unchecked beast that gradually, insidiously, and permanently destroys our ability to live well in old age. In Alzheimer's disease we also have our society's fastest growing pre-Covid illness.

As I write, about six million Americans are living with diagnosed Alzheimer's, but the Alzheimer's Association expects that number to rise to thirteen million by 2050.

We have good reason to fear Alzheimer's more than any other illness associated with aging: apart from environmental interventions like memory care facilities, there seems to be nothing we can do about it. If there is such a thing as an ageist disease, Alzheimer's certainly is it. While I have always had faith in the remarkable powers of science, lately I have found myself thinking of Alzheimer's as a uniquely sinister form of science fiction: a thoughtless, random tool used by nature to cull the human population. Of all that could happen to those of us who have reached old age, Alzheimer's is outstanding in its brutality.

Where is the hope?

Recently I have been reading a number of lay-audience articles about Alzheimer's research, and they all seem to include one common observation: searches for cures, treatments, and preventive interventions have been excruciatingly slow. For more than a century these efforts have tried the patience of dedicated scientists who have nonetheless soldiered on vigorously after dead ends, detours, and affronts to their capabilities by investing agencies. If we understand that scientific discovery proceeds in small, incremental steps that spring from informed curiosity and irrepressible creativity, we can find hope. The longevity of these efforts, especially the fact that generations of scientists have made it their life's work to try to tame the Alzheimer's beast, is all the proof we need.

An October 2022 Mayo Clinic article titled "Alzheimer's Treatments: What's on the Horizon?" describes an impressive array of current scientific inquiries, including using

monoclonal antibodies to "prevent beta-amyloids from clumping into plaques or remove beta-amyloid plaques that have formed"; using a drug that was initially developed as a cancer treatment to reverse memory loss in people suffering from mild cognitive impairment; and "production blockers" that may reduce the amount of beta-amyloid formed in the brain. Simply reading about these efforts is inspiring, but nowhere in the article do the authors comment about whether any of them are likely to meet with success and, if they should, how long that might take.

Less than a year after this article appeared, in July 2023, the Food and Drug Administration fully approved lecanemab, a drug that in a clinical trial of "1,795 patients with early-stage, symptomatic Alzheimer's" slowed the progress of the disease by 27 percent by selectively targeting "the forms of amyloid protein that are thought to be the most toxic to brain cells." "Would I like the numbers to be higher? Of course," said Christopher Van Dyke, who led the trial, "but I don't think this is a small effect." Indeed, here we have an advancement that is not only a modest blessing in the near term but is also genuinely salutary because it paves the way toward more effective treatments.

I am at peace with this slow but reassuringly persistent process. I know that I may become demented in my last years, but now that I am settling into old age, that fear no longer preoccupies or overtakes me. There have been too many times in my long life when I have made myself miserable by yearning for the impossible, and equipped with those memories, I have finally decided not to waste my future on futility. In the introduction to a recent edition of German Jewish writer Lion Feuchtwanger's 1933 novel *The Oppermanns,* writer Joshua Cohen says that "there is

a famous saying in Talmud, attributed to the sage Tarfon: 'It is not your duty to finish the work, but neither are you free to neglect it.'" Tarfon was referring to the unending search to understand God, which is not so different from the search to harness Alzheimer's disease.

Another Trip
to the Nursing Home

IF I SHOULD LOSE MY MIND OR MOBILITY, THERE IS no one to take me in. I have no partner. I have no children. I have no grandchildren. I have no one on whom I would knowingly place the burden of my care. I do not expect, nor would I approve of, any of my siblings taking on my care out of a sense of duty or, frankly, for any other reason. But I am lucky. I already know that my final place of residence will be Sholom East nursing home, coincidentally located two and a half miles from the downtown St. Paul riverfront condominium that brought me back to life after my husband's death and enables me to cherish the life I now live.

Like his mother before him, my father spent the last two years of his ninety-three-year life in the hospice wing of Sholom in a comfortable bed in a sunlit private room that featured a tiny kitchenette, an always interesting view of J. R. Mac's Bar & Grill across Otto Avenue, and visits from one or more of his six children and their spouses each and every day of his stay. On the evening of his death we gathered around his bed to reminisce for more than two hours after his silent passing. His back and head supported by pillows, he reclined peacefully, as though he were listening

to us, his face growing chalkier and chalkier the longer we chatted.

My paternal grandmother, both my maternal grandparents, and my mother (while she was recuperating from a severe COPD exacerbation) had also lived at Sholom. Over the course of my life I had known dozens of relatives who had gone to live there, but I do not recall that seeing them in that reduced setting tore at my heartstrings. I think I was happy and interested to see them there. It never occurred to me that they had been laid low, that they were nearing the end of the line, that they were less somehow than the versions of themselves I had encountered at weddings, Bar and Bat Mitzvahs, funerals, and synagogue services so many years earlier. Looking back, I must have seen Sholom as a kind of second home, a place akin to Israel, where as Jews we would be assured of citizenship. Those were my filmy, middle-aged impressions of what we used to call "the home."

Then on a brightly lit spring day in 2009, as I was walking through Sholom's wide fourth floor hallway on my way to visit my father, I suddenly grew up. I noticed a thin, pale gentleman sitting in a wheelchair that was parked in the hallway, looking as if he and it had been abandoned. I was about to offer the old man a passing smile when I recognized him as our family's longtime rabbi. "My God! Rabbi Raskas!" I cried in astonishment.

Counselor, scholar, author, and erudite interlocutor Rabbi Bernard Solomon Raskas served for thirty-eight years as senior rabbi at St. Paul's Temple of Aaron, the city's largest Jewish congregation at the time. He greeted my grandfather every Saturday morning at Shabbat services, shook Grandpa's hand as he passed him during the

synagogue's annual Simchat Torah procession, and pre-
sided over Grandpa's funeral, one of the saddest occasions
I have ever experienced. On June 18, 1955, the morning
my sister Resa was born, he officiated at my older brother
Steve's Bar Mitzvah, and thirty-three years after that he
officiated at Steve's sons Judd and Kyle's B'nai Mitzvah.
He married my sister Nancy to my brother-in-law Allen,
and he presided over my mother's funeral. He published
several books, including a collection of his missives
titled *Seasons of the Mind,* and he called God "He, She,
and They."

Later in his life Rabbi Bernard Raskas often went by
Baruch, his preferred Hebrew name. But as an old man
suffering from dementia at Sholom, this revered clergy-
man was simply known as Bernie. "C'mon, Bernie, let's
get your medicine." "Time for lunch, Bernie," as aides
wheeled him to and fro. Bernie this, Bernie that. Even
his name tag said Bernie. I found myself so offended, so
infuriated, so hurt by this ignorant indignity that I could
barely keep from screaming. "Call him Rabbi!" I yelled in
my head as I passed the staff members who attended to his
creature needs.

To me it was unthinkable to call him anything but
Rabbi, and that is how I greeted him at Sholom. "Hi Rabbi,
how are you today?" In response he always smiled sweetly
up at me, sometimes nodding his head in the affirmative,
and I could see that the Rabbi Raskas I had known was still
within him, not straining, not struggling, but simply endur-
ing, thereby continuing to earn our admiration. For better
or worse, the largely non-Jewish staff had no understand-
ing of what it might mean to have St. Paul's most beloved
elder rabbi in their midst, and rightly offered Bernie no

more deference than Sholom's other wheelchair-bound dementia patients.

* * *

Heartbreakingly, Rabbi Raskas personifies what is lost when we lose our minds and mobility, the two essential qualities that allow us to taste the range of flavors, from sweet to bitter, of this life. In him one encountered a man who held holy the life that filled his mind, who traveled the world in search of spiritual connection, and who translated those loves into eloquent speech about the world itself, what it is to be a Jew, what it might mean to love one another, and what it might mean, even to nonbelievers, to love God.

I know that if I lose my mind, the loss would not be as weighty as his, but my love of life would die nonetheless. In my mind I have not only my intellectual curiosity, but my feelings, my ability to love and empathize, my will to act freely in human and natural communities, and my capacity to be moved to action by the diminishment resulting from injustice or cruelty. I have my capacity for learning, too, and as I enter old age, I have also acquired an expanding capacity for sharing what I have learned. I am old now, but I am not ready for intellectual gruel or, worse, starvation. Seeing Rabbi Raskas at Sholom that spring day, sitting all alone but looking perfectly content and comfortable, was one of the most poignant moments of my life. Such a human being! Such a servant of justice! Of empathy! There are no limits: the heart breaks and breaks and breaks.

I do not kid myself. I know that when I go to live at Sholom, I will not be able to take most of my material possessions with me. That alone may kill me. First and

foremost, what will happen to my tools? Just as the gardener needs her hoe, I need my computer, printer, desk, files, easel, paints, brushes, drawing boards, sketchbooks, canvas rolls, stretcher bars, no. 2 pencils, knitting needles and notions, yarn inventory, and *The Knitter's Companion,* my spiral-bound guide to stitches and patterns.

Now that I think of it, perhaps I could live for a while without some of my tools, but what about the sources of my edification and uplift? Just as members of the clergy need their sacred bibles, above all else I need my library of books that I have passionately collected since fourth grade, when I received for my ninth birthday a collection of short biographies titled *They All Are Jews.* Reading has kept me alive even when I did not think I could go on living. What hell could it be to live without the mind to read? What hell robs us of understanding? What hell steals our need for meaning? Is that need obliterated with the loss of our wits? Or, unthinkably, is it simply imprisoned? Is life life without one's mind?

I need my beloved collections of Native American beadwork, storytellers, and kachina dolls; I need the divine blessings I receive from my Mexican American retablos and altars; and I need my scant but cherished pieces of what other people call folk art. How could I be who I am without art? Living with art gives me hope. It keeps me well. It affirms the miracle of human creativity. Who would I be if I forgot who I was? Would I still be alive? Or would I be nothing more than a memory that breathes, an indistinct, generic being waiting to finish?

It is a profound gift that we cannot know our futures. We can guess and worry, as I have done here, and we can also prepare, speculate, imagine, and dream. But we

cannot know. As Herb Kohl said so presciently about old age, "There is no need to resolve everything." It is possible, after all, that Sholom East may not be my final residence. I may die in my harboring condo, in my sound sleep, when I am ninety. I cannot know my future, but for now, for today, I only know that I have one. Even in an ageist society, pessimism is not a foregone element of old age; it a personal choice, just like optimism. For now, for today, I choose optimism.

A Golden Oldie

TO OPEN HER POEM OF THE LAND "RITES OF ANCIENT Ripening," proletarian poet Meridel LeSueur announces that she is "luminous with age." She has become like September corn, her stalks not as supple as June or July, no longer plump with moisture, but having matured from green to gold, she is ready at last to provide nourishment. All we need do is taste, and we will be sweetly rewarded. That is why it makes no sense that in our apathetic dominant culture we treat old people like depleted cornstalks waiting to be plowed under. We push them aside physically, socially, and intellectually, convinced that they are no longer useful or valuable. But dry cornstalks, wintering over before their burials, nourish the soil for spring planting, fulfilling their destinies until the last. They may look as though the first hard freeze has killed them, but they are quietly alive and stoically helping to preserve their kind.

No, I have not had the hardest life, but I have been through hell and high water to reach this point, and I deserve some credit. Not only do I deserve respect for my past: I deserve support for my survival. No matter what my future may hold, I intend to defend my right to it as long as possible. I have lived with inured sexism and occasional

anti-Semitism all my life, and having learned my lessons, I refuse to allow ageism to rob me of my humanity now that I am, to quote our friend Peter Laslett, a "golden oldie."

Here is a recent example of the kind of everyday condescension that most old women simply accept and try to forget about. Several weeks ago a processing error on one of my prescriptions put me in the unfortunate position of having to have a telephone conversation with a customer service representative from my mail order pharmacy. When during the course of this transactional conversation the representative called me "honey," I told her politely but straightforwardly, "Please don't call me honey. It's not professional." I have resisted condescension and patronization ever since childhood, but now that I am a prime target of ageism, I feel forced to redouble my efforts. I will resist, and I will answer forthrightly.

Therefore, I repeat: do not call me honey unless you know and love me. Do not call me dear. Do not call me sweetie. Above all, do not call me young lady. If you do, and if I answer you as I have just written, do not call me feisty. There are many forms of ageist diminishment and trivialization, ranging from the thoughtless to the downright cruel. That is because when you are old, people are much more likely to make assumptions about you without knowing you. Like racism, sexism, and anti-Semitism, these assumptions are expressions of prejudice, so it is both an exercise in futility and a waste of precious human energy to try to prove them false.

After three-quarters of a century, I have earned my place in the world. I should not have to prove anything to anyone. There is a famous career development book called *Transitions: Making Sense of Life's Changes* in which

author William Bridges suggests that during the first half of adulthood we tend to act in ways that will help us prove our competence, whether at work, in our communities, or in our family circles. Then sometime around midlife, that kind of striving starts to feel hollow and repetitive, so we begin, perhaps without realizing it, to take actions that will bring deeper meaning to our lives, whether through a change in work, lifestyle, or family circumstances.

Old age should be a time of unequivocal, naturally occurring meaning, not a time when, like sorority initiates, we must try once again to prove our worth in order to combat our culture's pervasive bias against us, including omnipresent institutional and structural bias. Nowadays I have to push and press in order to have my voice heard, my thoughts taken seriously, and my actions respected. For shame! I am all here! I have the largest, most particularized vocabulary of my life, I can think more intensely and lucidly than ever before because I have fewer distractions to diffuse my attention, and I have the wisdom and judgment that only age can bring. My actions are the most considered and insightful of my life.

Because I enjoy the wisdom conferred by old age, I sometimes feel that I should demonstrate my maturity by ignoring the fleeting resentment or momentary anger I feel when I am the victim of ageist insults, whether meted out intentionally or, more commonly, unintentionally. I have been taught to believe that I would be more peaceful if I let such feelings dissolve on their own rather than further agitating my psyche (and, importantly, that of the perpetrator) by acting on them. I would be closer to divinity, I have been told, if I distanced myself from the ordinary ageist or sexist or anti-Semitic abuses that are my lot. As an old

woman, I am now forced to turn the other cheek lest I be labeled crotchety or crabby or suffering from early signs of dementia. Or worse, lest I be physically attacked.

Still, I do not believe that standing up for oneself is by definition foolhardy, even in old age. Sometimes I do choose not to respond to an indignation in order to protect myself, but that does not mean that I am no longer entitled to feel and express a full range of emotions, including those that arise from wrongfully tolerated intimidation, prejudice, or abuse. No matter how tired we become of having to defend ourselves, we must remember that survival is our birthright, even in old age. I have a right to be righteous, I have a right to defend myself and my fellows, and I have a self-contained duty to actively but prudently resist injustice or mistreatment whenever it shows itself. Old age has not robbed me of my lifelong love of justice. No matter how long I live or how I die, I will take that love to my grave.

Part V

~

A Future

Surviving a
Death Sentence

WHEN I WAS SIXTY-FOUR YEARS OLD, I HAD SURGERY to remove scar tissue from my colon, a result of Crohn's disease. Unfortunately, as is common after abdominal surgeries, I developed an abscess. To resolve that infection, I had been prescribed Levaquin and Bactrim, two antibiotics that made me sicker and sicker the longer I took them. During two and a half days of nearly unbearable duress I complained urgently about my discomfort, to both my surgeon and gastroenterologist, but they assured me that in due course, my "side effects" would resolve. Soldier through and complete the courses, they both advised confidently, but after nearly three days of steadily worsening hell I realized that both doctors were wrong. The antibiotics were killing me.

Finally, in the roiling sleeplessness of extreme suffering, I came to a desperate decision. I decided that if I were going to die, I would rather do so from my infection than from the antibiotics to which I was obviously allergic. I needed no doctor to tell me what my tortured body already knew. The next morning I angrily threw the remaining pills in the trash. Within twenty-four hours I was feeling better. My

fever was gone, the pounding in my head was abating, and I was able to keep my food down. Within three days, I felt well, strong, and calm. I had rescued my future.

But that is not the end of the story. Five weeks and six days after my seventy-seventh birthday, I managed to rescue my future again, this time because of medicine, not in spite of it. The saga began on Thursday, August 25, 2022, in the parking lot of my condominium building. Grinning under my KN95 face mask, I settled into the passenger seat of my sister Resa's white Honda Civic. We were bound for Chamberlain, South Dakota, where the two of us would cross the Missouri River into the West. Our westernmost terminus would be Badlands National Park, located about fifty miles north of the Pine Ridge Oglala Lakota reservation and about fifty miles east of South Dakota's famed Black Hills.

For her part, patent administrator Resa was on a long-yearned-for vacation from her demanding University of Minnesota job, and I was on a long-awaited release from my pandemic-era solitary confinement. As we made our way through southern Minnesota's halcyon prairie landscapes, sighs of relief were all the conversation we needed, and as we passed the Jolly Green Giant's godlike statue, its crown of steel leaves jutting eerily skyward above the hilltop tree-tops lining the Minnesota River at Mankato, we could think only of McDonald's chicken nuggets. They, along with the obligatory French fries, were our eat-in-the-car lunch when we arrived in Worthington, a venerable farming community located at the junction of Interstate 90, the highway that would take us over the border into South Dakota.

Approaching from the east, one's first glimpse of the Missouri River is a startling, breath-stealing moment. It

is a sight I have experienced at least a dozen times over the past thirty-five years, yet to this day every crossing still feels like I am seeing this impossibly wide strip of teal water for the first time in my life. The river comes into view suddenly as you descend a broad hill that you have spent an afternoon gradually, imperceptibly climbing while driving through the eastern third of South Dakota. As if to tease the naive traveler, the landscapes surrounding the highway offer no hint whatsoever of what lies ahead. When the legendary river finally comes into view, there is just the astonishing surprise of nature.

After the glorious shock, a decision: should we exit the interstate at the eastern bank of the river in order to visit South Dakota's Lewis and Clark visitor center with its gorgeous outdoor viewing platform? Though it would have been the perfect place from which to survey the spectacular velvet hills that stretch west from the river crossing, all we wanted at that moment was to drive straight into those tantalizing rises. Westward ho, and across the river we sped.

Our destination was Oacoma, a way stop consisting of half a dozen tourist hotels, a couple of gas stations, and at its eastern edge, the venerable Al's Oasis, famous for its giant rib eye steaks, its fisherman's priced motel, its requisite but tacky trading post, and its sprawling grocery, where among the soda and canned goods one can encounter life-sized stuffed bucks, black bears, racoons, eagles, and, most imposing, a lone wall-mounted moose head, eyes wide, guarding the cash registers from on high. In the grass yard outside Al's western-movie facade stands a stout buffalo statue, just the right height and temperament for vacationing tots to mount. I felt fulfilled: it was all just as I remembered.

After checking in at the Holiday Inn Express, off we went for a comfort-food dinner in Al's ranch-like dining room. The restaurant was doing a sparse business that Thursday evening, but Resa and I, ever cautious, opted for a corner table twenty feet away from the nearest diners. As we had been for two and a half years, we were masked, removing our protective coverings only when eating. None of the other diners, nor the manager who visited our table to say hello and the two teenage girls who served as our waitresses and bussers, were wearing masks. In South Dakota the coronavirus pandemic was over, if indeed it had ever been acknowledged there. Though we did not know it until three days later, one of our waitresses had given us the viral gift, delivered when she ambled to our table as we ate, stood less than a foot from my unmasked head, and cheerily chatted with us about our taco salads.

The following day, feeling a freedom that could only be conferred by ignorance, we drove to the Badlands, ate a delicious lunch of loaded fry bread at Cedar Pass Lodge, the park's much-loved gift shop and restaurant, and spent the afternoon driving its newly blacktopped road, stopping frequently to gingerly step into the moonscapes that lined it. When seen from the park's many viewing points, the rock hoodoos, kooky spires, painted tables and cliffs, shallow gorges, miniature canyons, and riotous chimneys became infinite vistas under the absolutely clear sky that made our precious outing possible. Eventually the late afternoon sun warned us east toward our Oacoma home base, so we drove to the Golden Buffalo casino, located on the Lower Brule Sioux Tribe's riverside reservation, just thirty miles northwest of Al's Oasis.

Both Resa and I were looking forward to a relaxing

dinner in the casino's immaculate dining room, after which we planned to spend a few flirty minutes with its one-armed bandits. I was especially excited about returning to this welcoming, tolerant place where twenty-six years earlier I had attended a groundbreaking conference on Native American tourism.

We began our meal with crisp lettuce salads, and by the time the waitress served my big-boy walleye filet, I was salivating. But something was wrong. My fish did not taste like walleye. In fact, it did not taste like fish. Not only did it not taste like fish: it did not taste at all. To my chagrin, neither did my accompanying French fries. I asked for ketchup to pep them up, but even the ketchup did not taste like ketchup. Nothing tasted like anything. While I nibbled at what looked like my dinner, Resa was relishing her chicken sandwich with its delectable topping of melted cheese. At the time I thought only that I had made an unfortunate dinner choice, but when I awoke the following morning, my ignorance had morphed into fear.

Throughout that night I had awakened every hour or two with a sore, dry throat. When morning finally showed itself, I felt pretty sure that I was coming down with a cold. I asked myself whether this could be Covid, but without a diagnostic test all I could do was speculate. After all, we had been so careful: masks on except when eating, keeping to ourselves, frequent handwashes with Wet Ones. What more could we have done? How was it possible that I could have caught Covid? Somehow, somewhere I must have caught a cold. Still, I did not want to worry Resa, especially on a day when we would spend almost seven hours together driving home to St. Paul. I mentioned my sniffles to her only in passing.

Once home, I settled in for a good sleep in my own bed, a pleasure that was interrupted two or three times when I was awakened by a stuffed nose. The next morning, a Sunday, I tried to convince myself that I had caught an old-fashioned head cold. But during a coronavirus pandemic, even a garden-variety head cold is suspect, so I took a home test for Covid. Thankfully it was negative. I spent a lethargic day nursing my cold, pushing my fork around meals I could not taste, and snoozing. By bedtime that night, both my nostrils were completely plugged, my mouth was bone dry, and my throat was painfully raw. I awoke countless times to blow my nose, but when I laid down again, whichever nostril I had just blown open stung like a lightning bolt each time I inhaled. Truly, this was the cruelest cold I had had in years.

When I finally dragged myself out of bed Monday morning, I immediately tested again for Covid. Fifteen minutes later there it was: the telltale second pink line on the test plate. At seventy-seven years old, having survived a two-and-a-half-year Covid-free homestay, having been vaccinated three times against the ever-mutating virus, and having religiously masked even in the empty hallways of my condo building, I had Covid. I was scared to my shivering bones.

She who hesitates dies, I warned my momentarily paralyzed self. My first task was to deliver the woeful news to Resa, who the next morning would become a fellow victim of Covid. Then I called my healthcare clinic and requested a prescription for Paxlovid, but because that drug, which was still experimental at the time, interacts with scores of other drugs and because I take three of the medications that may be affected by it, it took several hours to obtain

permission from my specialists to begin taking this lifesaving medicine.

To my relief, by early that afternoon the needed approvals had been received, and two hours later my Covid-shy sister and brother-in-law laid the prescription at my front door and ran away down the hall. I opened my door and furtively grabbed the Paxlovid as though it were the proverbial lunch pail being pulled through a food hole by a leprous convict in a medieval dungeon. I took the first dose at dinnertime, and within about three hours my nasal congestion had completely disappeared. My temperature had returned to normal, my throat had healed, and my persistent headache seemed to have dissipated. That night I slept.

The next morning I felt drained and weak but not especially ill. "Just to be is a blessing. Just to live is holy," said renowned theologian and civil rights activist Rabbi Abraham Heschel, and that is how I felt. Somehow I knew that I would survive the virus that I had thought would kill me. Somehow I knew that I would recover my pre-Covid lung capacity, emphysema-diminished though it is. After only twenty-four hours and two doses of Paxlovid, I knew somehow that the worst of my Covid symptoms were behind me, and that I would weather whatever lay ahead without fear or pain. My body was replete with compromising diseases and conditions, but I was going to live to realize whatever the future might hold for me.

That new morning I could also feel that my body temperature had changed overnight: I felt warm and clammy, as though I were living in an Amazonian jungle. For the first time since I was a teenager, I needed nothing more than a thin cotton nightgown, and but for my inexplicable

need for a semblance of decorum, I would have gladly gone completely naked. During the five days that I took Paxlovid, I did not feel well, but I did not feel incapacitated either. For those days, and for two or three days after I completed my course, I felt what I would characterize as mild, tolerable Covid symptoms (occasional dull headaches, fatigue, muscle weakness, inability to taste) combined with what I assume were Paxlovid's side effects— elevated blood pressure and heart rate, constipation, sleigh bells ringing in my ears, and occasional insomnia.

These effects were uncomfortable, especially during the first couple of days of my illness, but they pale in comparison to the debilitating nasal congestion, fevers, painful sore throat, and chest constriction from which Resa, who did not take Paxlovid, suffered for more than three weeks. Even after four weeks resilient Resa, at the tender age of sixty-seven and as a seventeen-year ovarian cancer survivor, continued to have lingering symptoms, and it took almost three months for her to regain her pre-Covid state of robust wellness.

Twenty days after being infected I kept a doctor's appointment that I had made weeks earlier. There I learned that my vital signs were normal and that I should expect to fully recover my breath within about six weeks. The day after that I met a friend for a lovely outdoor lunch, another date I had made weeks earlier. What I did not do was put myself in harm's way, as I had done so unthinkingly in South Dakota. It is arguably unjust that we oldsters must take greater precautions than our younger neighbors in order to avoid Covid, but as the old saying goes, I am not willing to cut off my nose simply to spite my face.

These days when I wake up in the morning, I enjoy

giving myself an indulgent pat on the back for surviving something I had assumed would be a death sentence. Then I inhale my emphysema medication. Such are the contradictions of twenty-first-century old age. With each passing year, life grows more sacred, until, after long decades of what I can only call radical endurance, every day becomes a celebration.

Wishing and Hoping

ALWAYS AS I WRITE, I ASK MYSELF WHETHER THE PAST is predictive. After a lifetime I still have no answer, but I am at least laboring toward one, and that is the soul of writing. I have weathered a leap of consciousness from older to old, I have fretted and stewed over the length of my lifespan, I have conducted rescue missions into my past, I have tried not to let ageism cancel me, and I have survived Covid-19. After all that, why not look forward? "Don't get your hopes up," wiser people than I have cautioned me all my life. Why not? What is the harm in getting my hopes up? Finally I have reached a time when I am too contented with my life to let disappointment overtake me. I am old enough to let the chips fall where they may without risking injury to my ego.

Will the unexpected ever happen to me again? Will I savor the delight of a new path opening? Will my universe expand? The coronavirus pandemic has forced me to live through an extended season of sameness, and that trial has taught me that I need some novelty in order to keep my brain from withering. Let me therefore wish novelty into my future. If I were not so enamored with writing, and if I did not continue to embrace a passion for painting and

a recurring itch to knit, I would enroll in an educational program, perhaps to learn to write fiction, perhaps to further my knowledge of contemporary literature. Whatever my choice, I know that my goal would be to expand my aesthetic universe.

Activities like writing, painting, knitting, and reading are self-renewing. They are durable, automatic founts of novelty. In the last years of my mother's life, when she was physically diminished by terminal emphysema and functionally disabled by severe hearing loss, reading became the source of her survival. Without Willa Cather to capture her mind and soothe her soul, I am certain she would have left us months earlier than she actually did. Even in old age we have an enduring appetite for growth, and we ignore that hunger at our spiritual peril.

Still, in and of itself novelty is never enough to fill a future, no matter how young we are or how near to the end of our time on Earth. I cannot overemphasize the joy I take from continuing to partake in many of the everyday activities I have always loved, like listening to music, taking a walk, or watching a movie. I think now of my eighty-year-old brother, Steve, who at fifty-three had surgery to remove a cancerous kidney. As luck would have it, the tumor was completely encased in the offending kidney and posed no risk of spread, but in the weeks between his diagnosis and his surgery he understandably fretted about his life expectancy. Over a lunch of hamburgers and French fries at a now-defunct neighborhood grill on West Seventh Street in St. Paul he told me, "I thought about how I wanted to spend the rest of my time, and I ended up deciding that I just wanted to continue doing the things I've always done."

In the spring of 1998, Tom Dayton was undergoing chemotherapy for an incurable cancer of "unknown primary." Between the treatments themselves and the effects of the disease, he was utterly sapped of his human energy. At the time we may have still harbored some hope of remission, but the duress of the present had overcome him. I will never forget one particularly ominous afternoon, when after completing the simple chore of taking out the garbage, he came through the back door into the kitchen panting as though he had just run a marathon. He leaned over the kitchen counter, tears of frustration filling his eyes, and sobbed, "I just want to do what I used to do." He was fifty-one at the time.

Whether playing golf, as Steve continues to do, or plying the Minnesota River for catfish, as Tom loved to do, most of us ask little more than the chance to keep doing the things we have always enjoyed. We might take them for granted as earned pleasures, but they are also the precious building blocks of contentment. Over all the years I have lived after Tom's death, I have never been able to fully recover the ordinary contentment I felt throughout the two decades in which we shared our lives. I know that there are people who love me, but so far I have not found anyone or anything that could match the love I shared with my longtime romantic partner.

But now, having lived beyond prolonged grief, I am no longer inhibited by a broken heart. Now I have begun to wonder whether old age might finally be the time when I can find peace in the possible. I would therefore be grateful for a future that could grant me enough continuing joy so that no matter the season or weather, I would feel

happy to be alive when I meet the morning, and I would be alert enough to feel grateful for that blessing. Not withstanding the state of the world in which I will have to live, let me now write everyday joy into my future, and let me also write a continuing ability to create my own joy so that I can more easily bear whatever future is dealt me.

Thanks partly to the pandemic, I have learned to make peace with living alone and to relish, in a kind of consolation-prize way, the self-centered indulgences that accrue to those of us in that situation. I choose for myself the people with whom I would like to keep company, a habit I hope to continue for a long time to come. In order to preserve myself as a social being, I want to continue to make and keep friends. Let me therefore always have a friend who is willing to listen to me, who genuinely tries to understand me, and who thinks of me when we are not together. To that friend I will gratefully give the same, and if I can, more. There is nothing as resplendent as giving what you know is wanted and needed to someone you love.

During the years I suffered from prolonged grief disorder, I learned all too well that the line between contentment and desire can be painfully transparent. Here is what I mean. I long to relive, not merely remember now and then, my most ecstatic moments, those that popular culture might brand as "peak" experiences because they are feasts for the senses. I yearn for second and third chances to experience those rare, unforgettable moments in nature and culture, as Resa and I did during our 2022 trip to South Dakota, the one from which we returned with Covid. Covid notwithstanding, I want as much as ever to have adventures! In spite of the common cares of a lifetime I am

still myself, and in spite of my losses I still have wings. It is just that they are harder to open now, and soon they will be of no use at all if I cannot exercise them.

For more than thirty-five years, ever since Tom, Resa, and I took our first road trip to Wyoming's Big Horn Mountains in 1987, traveling in the western United States has provided the nourishment that has sustained my soul. And why not? The experiences we have while traveling confer bliss in the present, warmth in our memories, and eagerness as we anticipate our futures. Travel has lent purpose to my life, and I am afraid that the day I am no longer fit enough to travel will mark the beginning of my journey away from the world of the living. As birthday after birthday has passed with bewildering speed, I have become accustomed to the idea that my horizon is shortening, but logic and reason do not necessarily calm the heart, and rational though I may still be, I am not yet ready to resign myself to a future that leaves me place-bound. As long as I remain "druggable," I will try to roam.

* * *

Here is my dream. For several years now I have hoped to donate my collection of about two hundred works of contemporary Native American beadwork to cultural centers and museums located in and controlled by the tribal nations to which the artists who made these works belong. In addition to artworks by Ojibwe artists whose homelands fall within Minnesota, these gorgeous objects were made by Dakota, Lakota, Northern Cheyenne, Crow, Blackfeet, and Shoshone artists from South Dakota, North Dakota, Montana, and Wyoming. Having treasured these

works for three decades, I now believe the time has come for me to return them to their birthplaces. I do not want to leave my collection homeless upon my death.

If I could make this dream come true, and if all that I have inadvertently forgotten about my travels to tribal communities could fall like saturating rain into the places that gave birth to these once-unforgettable memories, I would revisit every museum, gallery, community center, roadside stand, cultural center, mission, church, gift shop, convenience store, and tribal headquarters at which I came to know the artists whose work I have collected, and during those radiant encores I would miraculously recollect every word they ever said to me, the better to honor them.

I am a grandchild of the Great Depression, and I am a child of rock and roll, so before I pass on, I wish I could to drive to Memphis, Tennessee, to visit Sun Studios, the Stax Museum of American Soul Music, and yes, even Graceland. Whether on the same or different trip, I also wish I could drive to Tulsa, Oklahoma, so that I can visit both the Bob Dylan and Woody Guthrie centers. I would especially love to see Woody's machine(s) that kills fascists. (I believe he had several.)

Before I pass on, I want to stand on the North Shore of Lake Superior at least once more so that I can soak in the soothing sounds of small splashes and shock my senses as I open my ears to the fulsome slaps of big waves. As much as I love the topography of the Great Plains and the desert Southwest, when I am on the North Shore, I want to see only water and sky on the horizon. Participants in the Split Rock Arts Program in Duluth used to ask me how it was possible "for anything to grow up here," and I

answered: power grows up here; it grows right up out of the lake. Sanity grows up here; it grows right up out of the shore's Indigenous and immigrant communities. Honesty grows up here because the weather is too bossy to allow pretense of any kind. Respect grows up here because Gichigami is too dominant to be taken lightly. Though not born to the North Shore, I am a Minnesotan, and these are my values.

For as long as I can walk, I hope to attend the Minnesota State Fair each summer, a destination that is only twenty minutes from my downtown St. Paul home. In the first place, I want to look west from the intersection of Carnes and Underwood streets and see the moving sea of about 150,000 fairgoers, each one a jovial sardine, stretching all the way down Carnes to the Mighty Midway, located in the westernmost section of the fairgrounds. It is a sight one must see to believe, and on seeing it one (almost) literally bursts with midwestern wonder and civic pride.

When I was a child, we were not allowed to attend the fair because of the polio risk, but once I grew up, I never missed it, even when I chose to go alone so that I could feel free to leave whenever fatigue got the best of me. Tom loved the fair too, and each year for the first nine or ten years of our marriage he made sure to buy me a heart-shaped pendant on which he had the vendor engrave "Tom & Andrea." Regrettably, our loving ritual came to an end because the pendant vendor stopped coming to the fair.

No matter your ethnicity, age, or political leanings, if you want to know what heaven feels like before you are called there, just sit yourself down on one of the fairgrounds' five hundred painted wood benches while holding a bucket of Fresh French Fries in one arm and a bucket

of Sweet Martha's chocolate chip cookies in the other. Then munch. Most of us senior citizens do not have the physical stamina to experience the entire state fair in one visit, so I suggest at least two outings, and three if possible. That will enable you to enjoy all your favorite exhibits, from the blue ribbon jams and pickles to the Minnesota Department of Natural Resources' giant fish pond; taste all your favorite foods, from walleye cakes to buttered corn; and enjoy music and dance, from ethnic dancing just outside the education building to the Minnesota State Fiddle Contest at Heritage Square. Believe me, the fatigue you will feel after your visits will be the most pleasurable exhaustion you have ever known.

To live in hope, to experience what is new and novel, to create my own joy, to do all that I have always loved to do, to have a friend, to travel near and far, to make my own decisions and direct my own life: these are my wishes and hopes as I ponder how my late-life future might unfurl. While I have not modified or compromised them to accommodate any exigencies that might affect my ability to help them come true, I am also a realist. If I had wished these wishes or hoped these hopes when I was twenty-five or even fifty, I might have felt that they were absolute requirements of a meaningful life. I might have plowed in and risked disappointment, or I might have chickened out and abandoned my wishes and hopes before I allowed myself to become too attached to them.

Now as I have come to relish the comforts of old age, I can accept with peace the fact that I cannot know whether my wishes and hopes will come true, but simply having expressed them I already feel a surprising sense of fulfillment. I do not feel pessimistic or silly or out of touch with

reality. Just the opposite: I feel grateful to have wishes and hopes, whether or not they are realized during my lifetime, because they are delightful companions with which to live. After all, reading a book that moves you is no miracle, but it can save your life.

Living like May Sarton

WHEN PROLIFIC TWENTIETH-CENTURY POET, NOV-elist, memoirist, and diarist May Sarton fell ill in her late seventies, she began dictating her now-classic journals rather than handwriting or typing them. There were times, this lifelong powerhouse said, when her hands were so weak that she could not lift her fingers long enough to accomplish anything. Three of these self-revelatory journals, *Endgame: A Journal of the Seventy-Ninth Year, Encore: A Journal of the Eightieth Year,* and *At Eighty-Two* (published posthumously), as well as some of her late poems and novels, made her a pioneer in exploring one woman's experience of aging without pretense or decoration. As the journals were published, critics, including her friend and literary executor Carolyn Heilbrun, deemed them of lesser quality than the several journals Sarton had written when she was younger and healthier.

Writing about *Endgame* in the *New York Times,* journalist Nancy Mairs hit the aging nail on the head: "As Ms. Sarton's health has failed, infirmity has emerged, gradually and naturally, as a major theme in her work, and in this process she communicates a harsh lesson: aging is the one disaster that, if we escape all others, will claim us in

the end." During the last two decades of her life May Sarton suffered mightily, surviving at least two strokes; midlife breast cancer followed by a recurrence several years later; cancer of the lining of her left lung that was thought to have metastasized from her breast tumor; chemotherapy and radiation that sickened and depleted her; colitis, diverticulitis, and irritable bowel syndrome, all of which gave her paralyzing cramps and kept her tethered to her bathroom; malnutrition; congestive heart failure; and a heart attack near the end of her life.

This litany stands in miraculous contrast to the fifteen poetry books, nineteen novels, and thirteen memoirs and journals that Sarton published over her lifetime. Her passion for writing overcame even her most devastating health trials: most of us would have thrown in the towel long before Sarton wrote her three late-life journals. Her expansive circle of friends and acolytes thought her indestructible, including a few who callously pronounced her a hypochondriac. After all, as a young woman she had been a professional actress who founded her own theater company. Sarton's biographer Margot Peters quotes her subject this way: "'I'm May Sarton,' she told everyone, 'and I'm taking care of a very sick old woman.'"

Sarton was part of a cohort of white second-wave feminist writers that included both Heilbrun and writer and critic Doris Grumbach, known to some Americans for her reviews and commentaries on National Public Radio. While I had known Sarton's name for many years, I had not read her work until the pandemic summer of 2020, when a progression of Google searches led me to her 1973 novel *As We Are Now*. At the risk of spoiling the book's shocking ending, here is what Peters had to say about *As*

We Are Now's protagonist and narrator, seventy-six-year-old Caroline (Caro) Spencer. Her assessment includes a quotation from the novel:

> *As We Are Now* is an old woman's testimony from "a concentration camp for the old, a place where people dump their parents or relatives as though it were an ashcan." Finally, May had included the Hell. Caroline Spencer's torments are May's imagined own: loneliness, neglect, lack of love. And for once, a Sarton heroine does not sublimate or rise above her anguish: she burns the damned nursing home to the ground. Action at last, and a fine novel.

How does Caro accomplish this ultimate act of resistance? She begins in the first sentence of the novel by assuring us that "I am not mad, only old." All too soon, however, we learn that life at Twin Elms nursing home is degrading enough to drive one mad. Caro finds herself increasingly sickened at the offhanded cruelty of the small home's small-minded staff and, as a victim herself, increasingly aware of her own psychological degradation. Subtle gestures of kindness toward her fellow inmates and satisfying, if tiny, acts of disobedience become her only means of resistance.

Needless to say, the staff thinks Caro is touched, and even the few people who occasionally visit her, including a kind-hearted local pastor and the brother and sister-in-law who had dumped her there in the first place, can see that she is gradually descending into dementia. They think nothing of indulging her frequent requests for fluid for her cigarette lighter because they assume she had misplaced the cans they had brought her on previous visits. Because it is written as Caro's journal, *As We Are Now* allows us

to follow, if we pay close attention, the growth of Caro's stockpile of lighter fluid, and along with it the gestation of her plan to end her life. In her final journal entry she makes an entreaty to herself and her reader. "Only one thing, THE important thing I must manage to do is place all the copybooks in the frigidaire. To you who may one day read this, I give them as a testament. Please try to understand."

Having read that, I thought the book had ended, but when I mindlessly turned to the next page, I found a short afterword: "This manuscript was found after the fire that destroyed the Twin Elms Nursing Home. In a letter found inside the cover, Miss Caroline Spencer requested the Reverend Thornhill to have it published if possible. This has been done with the permission of her brother, John Spencer."

In the final year of her life, having just received an advance from her publisher for *At Eighty-Two,* Sarton finally surrendered to the soul-wrenching truth: she could no longer write. As Peters says, "A May Sarton who could no longer write was not too long for this world." In accordance with her wish that she not be kept alive by extreme measures, Sarton spent the last five days of her life resting comfortably in a hospital near her Maine home. Having discontinued her many medications, she fell into a transitional sleep. All she required were supplemental oxygen and a constant drip of morphine. Finally, in the late afternoon of Sunday, July 16, 1995, she slipped away without a word.

In the final paragraph of Sarton's biography Peters writes, "May Sarton will never be considered a great writer. But she is that equally rare phenomenon, an appealing writer whose work has the power to change readers' lives."

In the future of my dreams, my writing would help change my readers' lives for the better. I do not dream of being a great writer, nor, I have concluded, did May Sarton. Whereas Sarton sought wide popularity and the admiration of her readers, I have sought to enhance the lives of the people my work might reach. Perhaps these are one and the same? I do know that all are forms of power, and I know that through her writing and the force of her personality May Sarton wielded outsized power.

I have no wish to suffer as Sarton did, but I fervently hope that in my old age I might develop the astounding resilience that allowed her to live on her own terms until she died. Though Sarton had extended periods when she was physically disabled, she never lost her ability to walk, and because she could walk and think, she never lived in a nursing home. Except for the frequent houseguests who doted on her and on whom she doted, she lived alone in her oceanfront rental home until her final five days.

Is it necessary to suffer in order to develop resilience? If that is what my future demands, I am prepared to endure my share of suffering to preserve my independence, especially my ability to keep writing. I share some of May Sarton's health issues, so even in my healthiest future I cannot imagine escaping their effects. The chips will fall, but thanks to the lesson granted by Sarton's life, I do not intend to let my symptoms get the best of me. Not only did she live independently; she traveled abroad a year before her death, a spectacular act of fortitude. I learned this only recently as I read Peters's biography, and it thrilled me to no end.

I hope to continue to write until I die. Over the past several years, I have come to believe that my most fruitful

path to both self-preservation and selflessness is through my writing. As recently as a decade ago I would have thought myself arrogant for believing this, but after a lifetime of interruption, avoidance, and self-deprecation I have finally acquired the confidence and free time needed to advance a slow but thoroughly engrossing process. I have less energy now than when I was younger, but in my future I hope to gain greater skill at making the most of whatever strength I still have. When you have the privilege of many hours each day to do what you want, it is incumbent on you to do some good, but I am no longer willing to define doing some good as self-sacrifice.

Being a writer is more than enough for me. It is hard, after all, to imagine a power greater than that of the pen. You can learn to write anytime in your life, you can get better and better at it throughout a long life; it is prodigiously satisfying, and it is a powerful tool for inspiring, educating, and serving others. I only wish that I had acted on behalf of my love of language earlier in my life rather than dismissing my own acts of creativity as unimportant and unworthy. Thankfully that behavior, which lasted for at least four decades of my adult life, is now behind me: I have banished it. May Sarton was stronger and more intellectually adventurous than I, but had she been in my shoes as she entered old age, I am sure that she would have done the same.

I now feel entirely free to claim as my vocation any purpose to which I am actively dedicating my best efforts. Untethered from employment, relieved of expectations, and excused by virtue of age from "doing my part," I am finally able to exercise my power of choice without internal or external repercussions. Imagine how difficult it is

for most of us to reach this point! Such a fraught question: What do you do? Or the younger version: What is your work? My plain answer is this: I do whatever I want within the blissful boundaries of my internal sense of decency and duty. This is my present; this is my future.

A Path toward Atonement

FORGIVE ME, EVERYONE, FOR I HAVE SINNED. WHILE I know that the future is the time when we reap what we sow, I still dare to hope that I can elude some of what I deserve. Admitting such a thing is probably as black-hearted as the deeds I have done to warrant this plea, but now that I am in my time of last chances, I would be grateful for a future that includes forgiveness. I hereby apologize for everything I have done and said that has hurt someone, and for everything, over eight long decades, that I have said and done out of cruelty or selfishness, especially during the first few years of my life after Tom's death, when I was no longer wed to someone whose needs and wishes blessedly came before mine, and when my pathological grief would not allow me to behave as a decent, caring human being toward people I loved and respected.

I have pledged never to use words like *everyone* and *everything* to compensate for writerly laziness, but the truth is that over the course of my lifetime I have not only forgotten many of my sins, I have also forgotten whom I may have sinned against. This sounds callously caustic, but it is the innocent, inescapable truth. Recently I connected with two of my high school friends, women whom I

saw almost every day as a teenager but with whom I have not had contact in nearly sixty years. I was astounded at how much they remembered of our times together, both in high school and afterward, until in their early twenties they got married and I did not, and we lost touch.

Incidents like this bolster my growing belief that sometime during my life, my memory was seriously, even fatally injured, because these days many of my recollections seem to be partial, momentary, and decontextualized. In fact, intensely unsatisfying attempts to access my past have become my new normal. Imagine that one rainy afternoon, in a restful reverie, you think of an old friend. Her name is on the tip of your tongue, but it remains frustratingly out of reach no matter how hard you concentrate. Think, too, of the intense tension you feel when a miniscule snatch of a forty-year-old memory flits through your mind, but before you can retrieve it, your mind goes blank. Your precious chance has vanished. Too many of my long-ago yesterdays are now beyond my grasp, and straining to remember them feels so difficult, so much like an uphill battle, that I usually let my frustration dissipate before my forgetfulness preoccupies and depresses me.

Rather than a slow fade over many years, as we might expect during a long journey into old age, I think my memory was acutely damaged when I was middle-aged, and I think this damage was precipitated by Tom's death. For nearly ten long years after he died I lived pinched between my desire never to forget him and my inability to access my memories of him because they caused me such excruciating pain. I am now convinced that by the time I was able to heal from prolonged grief, my long-term memory had diminished beyond my ability to resuscitate it.

For example, my memories of the program in 1992 at which David Beaulieu spoke about the seven stolen rights of American Indians are vague at best, and were it not for the indelible impression that day made on me, I doubt that I would recall anything more than the skeletal fact that I was there. I can no longer visualize the man who counseled me that haters hate broadly, and I remember only fragments of our conversation. The essence of this unforgettable encounter remains intact in my mind, as do some of the most memorable words the man I call Anthony spoke, but I no longer remember which of us said what during much of the conversation. How eternally sad, how full of everlasting regret I remain because I can no longer conjure that splendid, wise young man.

It is within this indefinite moral state, and with the knowledge that I can no longer afford to languish until the time is "right," that I have set myself on a path toward atonement by reembracing my Jewish religious heritage. My personal understanding of Eastern European and American Judaism is still superficial, but here is what attracts me. First and foremost, Judaism offers abundant formal and informal opportunities for atonement; after all, the holiest day of the Jewish year is Yom Kippur, the Day of Atonement. Crucially, Judaism does not demand sacrifice in order to earn forgiveness, even for sins we have forgotten or are too ashamed to disclose, even to ourselves. It encourages us to think of ourselves as inherently virtuous and asks only that we live ethically and honestly, that we honor family and treasure friends, that we demonstrate compassion and empathy, and that we defend people everywhere who have been victimized or sinned against.

Judaism also asks that we accept as true the concept of

one, and only one, infinitely good deity who exists apart from humanity rather than within it and has no visible form but nevertheless has a particular affinity for the welfare of human beings, especially the descendants of ancient Israel: in other words, a supreme being who is "the cause and preserver of all existence." At the same time, one need not accept this concept, or any concept of god for that matter, in order to claim one's Jewish birthright and, if one chooses, to live Jewishly, including joining a synagogue. Mainstream Judaism thrives on debate, discussion, and diversity of thought among its people. It invites us to question, doubt, pray or not, and develop our own beliefs while committing ourselves to the broad humanistic values in which most mainstream Jews as well as members of other mainstream religions believe.

Throughout my childhood I was steeped in the religious and cultural practices that were brought to the United States by my Russian and Lithuanian grandparents, customs that they learned from their parents and grandparents, who in turn learned them from their own parents and grandparents dating back to a time when birthdays and anniversaries were not marked by a secular calendar but by the Jewish holiday closest to one's date of birth or marriage or death. Once here, American Jews began taking steps toward modernizing some of these practices by allowing men and women to sit alongside each other in synagogue rather than segregating them on opposite sides of a center aisle or relegating women to the temple's balcony, and by allowing worshippers to drive to services on Shabbat rather than having to walk in the dead of a Minnesota winter to a synagogue that was several miles from home.

For the first decade of my life my mother kept kosher, but as her family grew and her busy, independently minded children refused to pay attention to which dishes were for foods containing dairy products and which were for non-dairy, she finally received rabbinical permission to stop using two separate sets of dishes. So much for traditions that were sacrosanct for hundreds of years in the Jewish shtetls of Eastern Europe. My mother, I think, regretted what she felt were betrayals as these customs gave way; my father could not have cared less. Neither of them attended Shabbat or holiday services regularly, but their older children participated fully, if not fully enthusiastically, in our local Jewish community so as not to break the hearts of our grandparents. I attended Hebrew school, Sunday school, Friday evening and Saturday morning Shabbat services; I joined Young Judea when I was eight years old; I joined B'nai Brith Girls as a freshman in high school; and when I graduated from high school, it all abruptly ended.

I never stopped conceiving of myself as a Jew: I cannot imagine being otherwise, but for most of my adult life I did not attend services regularly and I prayed—to whom or what I was not sure—only when I felt desperate. I was not an agnostic nor was I an atheist, and if asked, I answered to Jewish, even at the risk of religious discrimination. Though Tom grew up in a Jewish neighborhood, and though he felt himself wholly part of a Jewish family, it never occurred to us to join a synagogue, mostly I think because we did not have children. And frankly, even when Tom became terminally ill, I gave little thought to the idea that my religion might offer harbor or consolation as I struggled through the common kinds of hard times so many of us have endured over the course of our lives.

But over the past few years my attitude toward my religion has evolved in two life-altering ways. First, I have grown old. Even though I have always taken my Jewish identity for granted, the fact that I am coming closer to death has led me to confront the deepest questions of identity I have ever asked. I have answered this way: I was born a Jew, I have lived as a Jew, and I want to die as a Jew. I need to know that there will be a kind-hearted rabbi to preside over my burial, and that my funeral will be conducted in accordance with Jewish bereavement practices.

Equally important, for the first time in my entire adult life I feel a need to belong to a progressive Jewish congregation that formally acknowledges the anniversary of my death each year through the Jewish custom of *yahrzheit,* a Yiddish word whose literal translation is "season" or "time of year." On that occasion one's name is read aloud to the congregation. *Yahrzheit* is an acknowledgment that one deserves to be remembered, and I want that. This is not merely a preference, nor is it an ego-driven need: it is an abiding statement of personal identity and an act of deep regard toward my parents, grandparents, siblings, and friends.

Second, I am now more afraid of anti-Semitism than ever before in my life. Having been born at the end of World War II, I was taught to expect it, and as a young woman in her earliest jobs, I experienced it in both isolated and ongoing ways. In the middle 1960s, it was legal and common to require job applicants to specify their religion on employment applications, so my employers always knew that I was Jewish. Unsurprisingly, during my several workplace experiences of outright anti-Semitism, the perpetrators never spoke their hatred out loud. Instead, it was displayed in other awkward, poorly concealed ways.

Here are two examples, the first from 1965, and the second from 1966:

> *"Your attire is not appropriate for a stationery saleswoman; we do not allow red shoes; you are fired."* This after I had bought a new pair of what I thought were work-proper shoes to start a new job at a department store in St. Paul. I was on the job for only two hours. Shortly after this incident I learned from an unimpeachable source (my wise-eyed grandmother who had worked at that store for twenty years) that the firing supervisor was a well-known anti-Semite.

> *"Surely, you, more than any other employee, should know the value of a dollar and not waste paper; you are fired."* This after the manager happened to observe that I had mistakenly duplicated a blank page as I was trying to teach myself how to operate the copy machine at an insurance company in Los Angeles. I grabbed my handbag and left the building immediately. I had worked there for only three hours.

Partly because of these experiences, and partly because of my evolving values and interests, I eventually sought a career at the University of Minnesota. I felt that a public university would offer greater religious and racial tolerance, and, indeed, throughout my long tenure there I never felt any sense of religious discrimination, whether from individuals or institutionally. In retrospect, I think that the university's humane environment must have left me inattentive even after I retired, because until Donald Trump ran for president, I did not fully recognize just how much acts of hatred had intensified in our country.

In a racist backlash to the election of President Barack Obama and as a knee-jerk reaction to our country's

growing racial and cultural diversity, America's political right wing and its come-lately, morally empty leaders began moving further and further to the right, both rhetorically and in deed. Violent antisocial acts became commonplace as a significant minority of Americans began expressing their hatred loudly, publicly, and viciously, often without consequence. Acts like murdering Jewish worshippers in their temples, desecrating Jewish graves, and widely disseminating inciteful anti-Semitic images and hate speech have permeated our culture, harkening and actually outperforming earlier periods of intense American prejudice against Jews. Even worse, the same is true for members of other religious minority groups.

This appalling state of affairs could have eaten me up had I continued to do no more than wordlessly watch it, feeling ever more powerless and fearful each time an incident occurred and having no antidote for that fear. Then, in the late summer of 2021, when my sister Nancy and brother-in-law Allen joined Mount Zion Temple, a liberal Jewish congregation in St. Paul, I decided to follow suit. There I found a community of people who shared my political beliefs and moral values and acted on them in courageous, affirmative, and unified ways. Suddenly I felt protected. Suddenly I felt part of a community that was actively resisting hate by doing good. Suddenly I felt as though I had arrived at the right place.

When we joined Mount Zion, Nancy and Allen's musician daughter-in-law, Tami, had just taken a job as the synagogue's accompanist, which meant that their two granddaughters—my great-nieces—began attending Hebrew school there, singing in the children's choir, and socializing with the children of other members. Suddenly,

here was a new way to connect with my family. I could stay free from Covid by attending services via Zoom, I could listen to my parents' and Tom's names being read aloud on their *yahrzheits,* and I could watch my adorable nieces as they stood on the steps of the sanctuary's stage and sang the Hebrew songs of my childhood, rendered with new but equally lovely melodies.

A few months after we joined Mount Zion I was part of an event at which I read from *After Effects,* my memoir about my struggle with prolonged grief disorder, and I contributed to a conversation about grief and healing moderated by the congregation's senior co-rabbi, Adam Stock Spilker. I loved listening to Rabbi Spilker's inspiring sermons: I found him a superb thinker, a dedicated religious leader, and a deeply ethical person who was crowned, to our delight, with a droll sense of humor. It was a pleasure to sit beside him as he spoke about the ways in which our congregation might help members who have suffered a loss. Then as the event was coming to a close I suddenly and unexpectedly felt myself surrounded—actually inculcated—by the collective empathy that filled the room. Twenty-three years after my own significant loss I felt newly repaired.

After our event, I finally found the courage to do what had been on my mind for months: I approached Rabbi Spilker and asked if he would preside over my funeral. For a split second he was taken aback, but very quickly he pressed his palms together and drew his hands to his sternum in the traditional Hindu namaste greeting of respect. He bowed his head slightly and said, "I would be honored to preside at your funeral, of course!" I confessed then that I had been wanting to ask this of him for months and

offered my relieved, heartfelt gratitude. It was a short conversation, but it ecstatically exemplified physicist David Bohm's definition of dialogue: "meaning flowing through." These are the acts of goodness that allow us to hold our fears at bay and sleep soundly, even when we are alone.

I wonder if there is an unnamed but distinct attribute of old age that calls us back to faith, even those of us who have spent too much time commiserating over all that is rotten in our world and not enough time cleaning things up. I wonder if old age grants us a newly awakened charitability, one that permits someone like me to take pleasure in being part of a community in which acts of kindness and movements toward justice are everyday occurrences springing from a shared set of beliefs and values that revere goodness. This kind of community, simply by virtue of being itself, gently invites us to acknowledge a divine power, or maybe as we move closer to death we awaken a spiritual impulse that gradually moves us closer to that power without our knowing.

An Afterlife

AS A MAINSTREAM AMERICAN JEW BORN TO LEFT-leaning parents who came of age during the Great Depression, I was not brought up to believe in an afterlife. I could not imagine resurrection or reincarnation. We begin scientifically as biological morsels, and we end environmentally as dust in the earth. That is the north and south of it. Nevertheless, when I was a child, I always imagined a monotheistic, formless male god who resided somewhere beyond the sky. In my outsized imagination it was possible to speculate that our dead loved ones decamped to that place, a heaven where they would never have to work or suffer, and they would always be surrounded by their predeceased loved ones.

Jewish though I was, my vision of perpetual heaven was actually a secular fantasy made possible by movies and novels, and as I think back on it, I probably only imagined that perfect place when I watched a movie or read a novel, something I did to excess since we lived within walking distance of a public library. The dreary truth is that for the first half of my adult life I never bothered to consider whether the human soul could separate from its body, ascend to a better place, and live on into eternity. I was

too invested in my dependable material existence to give much thought to dimensions of consciousness that were unfamiliar to me.

All that hooey went down the drain when Tom died. Suddenly I found it impossible to believe that once his body was interred, all trace of him vanished as though he had never existed. How could he be underground at the cemetery when I could still hear him pouring a glass of milk at night or singing "Like a Rolling Stone" in the basement shower after work? I could sense strongly that he was still with me, a sensation that engulfed me, body and soul, for good and for awful, for many years after his death.

Today his presence feels more like memory and less like flesh, but after a quarter-century of physical separation, a sense that his spirit has never left me seems to have survived, albeit in a quiet, mild form. This persistent feeling of an angel on my shoulder is one reason why I know that no matter how old we are, we remain capable of experiencing profound evolutionary changes in our deepest beliefs. Now in old age my beliefs about death are shifting: I find that I am more willing to free myself of some of the binds of rationality, and that release is opening new avenues of thought to me. Now I feel ready to accept what once seemed irrational as perfectly natural and therefore easy to live with.

Now that I have a lifetime of learning behind me, I am more aware than ever that my liberal arts education remains far from complete. My knowledge of literature is shamefully thin, and my knowledge of philosophy consists of two undergraduate courses and the Collier–Macmillan *Encyclopedia of Philosophy*. My education in the Hebrew language and Jewish studies ended in sixth grade when I

could no longer bear being bullied on the Hebrew school bus. Growing up, I saw Hasidic Jewish men and boys walking every day in our neighborhood wearing their *kepahs* (skull caps), *payot* (sidelocks), and *tefillin* (phylacteries), but I never felt curious enough about them to conduct even a cursory inquiry. Only now in my late life have I begun to learn, through film and literature, more about the Haredim, a sect of strictly Orthodox traditional Jews originally from Eastern Europe. This learning has allowed me to discover that my Hasidic neighbors were part of that sect.

Artistic works of the imagination, especially those that are highly indebted to the artist's personal history and beliefs, inspire and provoke. Having first moved us, works of art then get us thinking. That is what happened to me when I read and saw modern works of art about the Haredim. These books and films offered vivid renderings of seemingly rational people, some of whom looked and spoke like my grandparents, others of whom looked and spoke like my Hasidic neighbors, talking about irrational beliefs as though they made logical sense. These exchanges so moved me that I solemnly opened my mind to the idea that spiritual death may not be rational.

Even in contemporary Jewish spirituality, which seems to hold that there is no afterlife, there may also be no such thing as death. Are the dead really our departed ones? Indeed, is it logical that our dead should leave us? Is it reasonable? After all, the universe is not limited to the relatively few elements our senses can perceive. There are infinite realities we cannot see, hear, touch, smell, or taste, and of which we cannot conceive. No human being can know it all, and spiritual death may be nothing more

than an efficacious rationalization based on our partial knowledge.

Though Haredi beliefs about spiritual death long pre-date the Holocaust, it seems entirely reasonable to me that European Jews who outlived Hitler would hold the belief that the spirits of our dead loved ones never leave us and that we are always in their company, able to feel their love. For these survivors a belief became an entitlement. How otherwise could they have kept their sanity? How could they have gone on after the war to emigrate to other coun-tries, start new families, and restore their dignity? Between 1933, when Hitler took power, and 1945, when the Second World War ended, two out of every three European Jews were murdered. The Jewish population in Europe went from nine and half million in 1933 to three and a half mil-lion by 1945.

As a child I was told repeatedly that but for fortune our entire family would have been annihilated in the Holo-caust. We now know that my great-grandmother, Risia Beevna Vinarskaia, was killed in the September 1941 mas-sacre of thirty-three thousand Jews at Babi Yar, a ravine outside Kiev, a city that was then part of Russia. My mater-nal ancestors were Russian: they spoke Russian, they felt themselves to be Russian, and they did not identify with Ukrainian culture. (My grandmother was vehement—and prejudicial—about this cultural difference.)

As I write, I look again at a black-and-white photograph of Risia that was probably taken five or ten years before she was murdered. She appears to me as a self-aware woman wearing a dark-colored tailored blouse adorned with two sunburst brooches, her dark, wiry hair neatly combed in a contemporary style, and wearing fashionable glasses

over her wise eyes. The photograph looks so modern that my heart flutters. How could she have died so brutally, so inhumanely? What must it have felt like to be barbarically debased before dying? I cross the bridge of time and feel unnervingly close to her. In her I see my grandmother, Reva; my mother, Lee (Ilyena before she emigrated); and my sisters, including Resa, who was named after her.

This photograph kept finding its way to the front of my mind as I read *Shosha,* Polish American writer Isaac Bashevis Singer's 1978 novel of Hasidic Jews before and after World War II. As the story unfolds, we follow its narrator, writer Aaron Greidinger, through his childhood in 1930s Warsaw, getting to know his motley assortment of family, friends, and neighbors during the years leading up to the war. Among them are tiny, frail Shosha, whom Aaron eventually marries; neighbors Haiml, a dreamer with a penchant for mysticism; and Haiml's wife, Celia, a would-be atheist who does not approve of Haiml or Hasidism. As Hitler consolidates power and prepares for war, the situation for Warsaw's Jews worsens significantly. Those few who have any influence at all are being imprisoned and executed, and the powerless, meaning everyone else, are being systematically sent to "work" camps.

By the late 1930s, Poland's Jews, having no safe haven, were abandoning their homes and walking east, hoping to reach Russia, the very country from which two million Jews had fled between 1880 and 1920. Aaron, Shosha, and Shosha's mother set out for the northeastern Polish city of Bialystok, but on their second morning out Shosha abruptly collapses and dies within minutes. Most of the others in their party of neighbors, including Aaron, made it through to Russia and were able to survive the war.

The war ends; years pass. Now a renowned writer, Aaron travels from New York City to the new Jewish state of Israel in 1951 to lecture and attend meetings in Tel Aviv. Between engagements he stops at an outdoor café for a cup of coffee, and there in a miraculous coincidence he encounters his old friend Haiml. Over coffee overlooking the Mediterranean, the friends bring each other up to date, Aaron telling Haiml about Shosha's death and Haiml telling Aaron about the long-ago deaths of Celia and another friend, Morris, with whom they spent many winter evenings discussing philosophy and notions of God. Listening to Haiml, Aaron could tell that his friend "was growing ever more inclined toward mysticism and occultism," yet he could not help but feel the truth of Haiml's words:

> But somewhere inside me I have the feeling that Celia is here, that Morris is here, that my father—may he rest in peace—is here. Your Shosha is here, too. How is it possible, after all, that someone should simply vanish? How can someone who lived, loved, hoped, and wrangled with God and with himself just disappear? I don't know how and in what sense, but they're here. Since time is an illusion, why shouldn't everything remain? I once heard you say—or quote someone—that time is a book whose pages you can turn forward, not back. Maybe *we* can't, but some forces can. . . . How can it be that all the generations are dead and only we *shlmiels* are allegedly living? You turn the page and can't turn it back again, but on page so-and-so they're all right there in an archive of spirits.

What a magnificent image in which to wrap myself! To walk arm in arm with Tom in a place where we might meet everyone we have ever missed is a dream worth dying

for. What makes Haiml's argument so believable is that he admits that he does not know "how and in what form" his loved ones are with him. He only knows that it is inconceivable that they could have left. As our lives grow longer, our archive grows larger, but that only means that our spiritual community will be that much merrier when we ourselves become part of it.

I also suspect that Haiml's philosophy is a marvel that holds especially strong resonance for those of us in old age. For the first time in my life I feel comfortable believing something that I cannot understand. As I age through my seventies, earthly endeavors still attract me, but they are not everything and they are not as precious as they once seemed. The veil between life and death is thin to begin with, and, like our skin, it becomes thinner as we age. As it thins, it becomes more transparent, and ultimately it is permeable, either by virtue of the death of a significant other or by virtue of our own deaths.

Throughout human history, spiritualists have sought eternal life, and more modestly, scientists have sought longer lifetimes, but I do not want to outlive my era. I do not want to be treated as a relic, nor do I want to behave as one. I fervently hope that no matter my age at the time, I will know when I am ready to move on. Once there is no hope of helping me, I do not want to be kept alive by a machine that can pump oxygen to my lungs but cannot recognize that my brain is dead. I do not want to be a dead person who breathes, nor do I want to be a respirating, enervated person whose stubborn body insists on functioning after it has no reason to do so.

* * *

When my grandfather died, I began to understand that no one you love is ever old enough to die. I can stand by that even though I believe that death is the only merciful end to suffering when nothing else is possible. It is better to die than to suffer without hope. At the same time, I no longer think of old age as an era during which infirmity or loss of self is inevitable. The truth that bears repeating is that most old people are not sick, they are just old. Each time I have vacationed in Santa Fe, I have been struck by the number of people who seem to be well into their eighties but who are still confidently doing the two-step as country singer Bill Hearne, in his seventies, performs in the La Fiesta lounge at the La Fonda hotel. I am stirred when I watch the city's oldest residents stroll on the plaza, work and play in an easygoing way, and enjoy a glass of sangria with their evening meals. They inspire me to protect my health.

Unfortunately, that is only one side of the lifespan coin. There is another. As geriatrician Louise Aronson says in her clear-eyed, lovingly written book *Elderhood*:

> There is old and there is ancient. Live long enough and eventually the body fails. It betrays us. Our flesh wrinkles, sags, and sinks. Strength wanes. We lose speed, agility, and balance. Abilities once taken for granted are accessed only verbally, using the past tense. Sometimes the mind follows the body's descent, words, logic, insight, and memories dropping away. We fall ill more often and more gravely. We become frail. The smallest, most ordinary tasks—eating, showering, walking—become time consuming, difficult, dangerous, or impossible. Absent purpose or agency, frustration, boredom, and discomfort provide the landscape of our days. In the end, we are

defined more by what we are no longer than by what we are. We fight and flirt with death.

I am now a person who does not want to fight death. I know that I do not want to live long enough to become ancient, and I imagine that my chronic diseases and conditions will conspire to keep that from happening. Like most of us, I would like to travel swiftly and smoothly from life to death. If I can preserve my health long enough, perhaps I can earn the blessing of an easy transition. I now believe, however irrationally, that even though I spend almost all my time alone, I will not die alone. Even if I am without company in my bedroom or hospital room or hospice room when I pass on, Tom will find his way to me and, with his remembered touch, accompany me to our archive of spirits.

There we will shed tears of joy as we join my parents and grandparents and great-grandparents, and after sharing a heavenly meal of lean beef brisket and creamy potato knishes, we will amble through timelessness to reacquaint ourselves with Dr. Jane Hodgson and Rabbi Bernard Raskas, and pay our respects to Dr. Robert Butler, Dr. Gene Cohen, Barbara Ehrenreich, kind-hearted Verne Gagne, open-hearted Helmut Gutmann, Carolyn Heilbrun, Little Crow, Arthur C. Parker, John Prine, May Sarton, and Isaac Bashevis Singer. May we all rest in peace.

Acknowledgments

I BEGIN BY THANKING MY SISTERS, NANCY LEVINE, Judy Gilats, and Resa Gilats, and my brother-in-law, Allen Levine, for their unwavering support in everything I do. Thank you, Nan, for your abiding interest in all my undertakings, including being the first reader of *Radical Endurance* from its conception to its finish, and for bearing with me through the long evolution of the manuscript. Thank you for reading everything I write.

Thank you, Judy, gifted artist and book designer, for both your sisterly love and your professional support, especially your exquisite, sensitive design of *Radical Endurance*'s interior pages. Thank you, too, for all the personal design work you've done in support of my myriad whimsies, and thank you for refusing to take money for any of it. Thank you for your amazing photographs.

Thank you, Resa, for inviting me to ride with you on that fateful August 2022 trip to Badlands National Park. Crossing the Missouri River was a dream come true for me. Please accept my heartfelt apology for giving you Covid at Al's Oasis in Oacoma. May we travel together again and again.

I thank my longtime colleague and friend, visual artist

Joyce Lyon, for her deeply thoughtful reading of an early version of the manuscript and for her brilliantly articulated feedback, which proved so crucial as I searched for clarity and focus in my writing. Thank you, Joyce, for your help and for the nourishment I have received from your stunning art over these many years.

I thank Mary Nichols, my friend, former colleague, and dean emerita of the University of Minnesota's College of Continuing and Professional Studies, who offered the clear-headed reading of *Radical Endurance* that convinced me, as Grace Paley once said, to "take out all the lies." After a spirited conversation with Mary over a patio lunch, I sped home and ensconced myself at my computer. One by one, I simply and straightforwardly made all the changes she suggested. I never hesitated or disagreed. Twenty years ago Mary offered me the opportunity to help develop lifelong learning programs aimed at serving people in the second half of life. She wisely saw that as our college's longtime audience members were aging, their learning needs and interests were changing, and it was important for our university to respond to those changes with newly relevant programs. Her confidence in me brought about what I can only call a revivification of my work life, a rebirth that was instrumental in my recovery from prolonged grief disorder after Tom's death. Thank you, Mary.

I want to thank my friend Bill Spinelli, the family physician who partnered with me to develop Encore Transitions: Preparing for Post-Career Life. Bill's perspective on physician burnout, his knowledge of our human life course, and his contagious intellectual curiosity were instrumental in creating the learning experiences that

made Encore Transitions so meaningful to our partici-
pants. As a physician who used his skills as a volunteer
in places of emergency need, he inspired me to train to
become a yoga teacher serving older people in community
settings. Thank you, Bill.

I also thank Phyllis Moen, professor emerita and the
McKnight Presidential Chair in Sociology at the Univer-
sity of Minnesota, for her pioneering work as a scholar
of the human life course. Her groundbreaking concept of
an "encore life" characterized by meaningful engagement
through post-career work, volunteerism, and social con-
nection has powerfully influenced the field of healthy aging
for an entire generation and has kept many of us vigorous
after feeling used up or dismissed. I could never have writ-
ten *Radical Endurance* without Phyllis's ideas to guide me.
Thank you, Phyllis.

I thank my lucky stars that University of Minnesota
Press senior acquisitions editor Erik Anderson did not
see my manuscript when it was called "Intimations of
My Mortality" and later but equally morbidly "After the
Apogee." When Erik did see an early version of "Radical
Endurance," it was a book that did not know itself. His
constructive interrogation of that unfocused manuscript,
along with his generosity, patience, and faith, allowed us
to arrive at the book you just read. When I say "generous,"
I mean it wholeheartedly: our editorial journey spanned
the better part of a year, a remarkable commitment for a
deeply gifted, highly respected, sought-after editor. *Radi-
cal Endurance* is Erik's book as much as mine, and I have
no doubt that I am not the only author he works with who
feels this way. Thank you, Erik.

I send heartfelt thanks to sensitive, brilliant graphic

designer Amanda Weiss, who designed *Radical Endur-ance*'s spectacular cover. It is a cover, as Press staff have said, that one cannot look away from. And thank you to copy editor Louisa Castner, whose thoughtful, thorough editing was instrumental to the book's readability, fluidity, and grace. I had no idea how many insidious, stubborn errors remained in what I thought was my best effort at a clean manuscript!

I also send heartfelt thanks to the dedicated, talented people at the University of Minnesota Press who have supported this book, especially editorial assistant Emma Saks, who answered my questions patiently, thoughtfully, and promptly no matter how silly or overreactive. Thank you, Emma. Thank you to Heather Skinner, publicity director for the Press, who has guided me at every turn with her deep knowledge, sage advice, and unfailing support of my books. And thank you to managing editor Laura Westlund, whose suggestions helped make *Radical Endurance* more readable and, importantly, more meaningful.

I express my gratitude to the University of Minnesota Press for publishing this book, but beyond that and from deep in my heart, I also want to thank the University of Minnesota Press for its existence. Independent presses, including university presses, are foundational to preserving democracy. They publish significant books that cannot turn a profit; they publish books that serve small and marginalized audiences; they publish books in translation so that we can learn from authors who write in languages we do not understand; they publish books that bring to light little-known places, people, and ideas; they publish books that enable us to better appreciate the physical and cultural geographies of the diverse places we call home;

they publish books that liberate us and take us over the rainbow. They stand in long-lived, tenacious resistance to censorship and the fatuous flights of small-minded, near-sighted extremists. Thank you to independent and university presses.

Finally, a note about the spelling of Kiev in *Radical Endurance*. Out of respect for my maternal grandparents, I have chosen to use the Russian-derived spelling Kiev (pronounced KEE-ev in two syllables) rather than the Ukrainian-derived spelling Kyiv (usually pronounced KEEV in one syllable by Americans). As I mention in the book, my maternal grandparents were Russian. Along with Yiddish, the language of choice in their Jewish community, they spoke Russian as their primary language, not Ukrainian. KEE-ev was the pronunciation I heard throughout my life, and the one I now carry in my personal history.

References

"2,000 Protest War by Forming a Ring around the Capitol." *New York Times,* June 23, 1972. https://www.ny times.com/1972/06/23/archives/2000-protest-war-by -forming-a-ring-around-the-capitol.html

"Alzheimer's Disease Fact Sheet." National Institute on Aging. https://www.nia.nih.gov/health/alzheimers-dis ease-fact-sheet

"Alzheimer's Treatments: What's on the Horizon?" Mayo Clinic. October 12, 2022. https://www.mayoclinic.org /diseases-conditions/alzheimers-disease/in-depth/alz heimers-treatments/art-20047780

Aronson, Louise. *Elderhood: Redefining Aging, Transforming Medicine, Reimagining Life.* New York: Bloomsbury, 2019.

Bonner, Brian. "Champion for a Woman's Right to Choose." *St. Paul Pioneer Press.* October 29, 2006, 1A.

Boorstein, Michelle, and Scott Clement. "Survey Finds 'Classical Fascist' Antisemitic Views Widespread in U.S." *Washington Post.* January 12, 2023. https://www .washingtonpost.com/dc-md-va/2023/01/12/antisemi tism-anti-defamation-league-survey/

Bridges, William. *Transitions: Making Sense of Life's Changes.* Cambridge, Mass.: Da Capo Press, 2004.

Brody, Jane E. "Are Mammograms Worthwhile for Older Women?" *New York Times.* August 17, 2020. https://www.nytimes.com/2020/08/17/well/live/mammograms-older-women.html

Butler, Robert N. "The Life Review: An Interpretation of Reminiscence in the Aged." In *New Thoughts on Old Age,* ed. Robert Kastenbaum. New York: Springer, 1964: 265–78.

Butler, Robert N. *The Longevity Revolution: The Benefits and Challenges of Living a Long Life.* New York: Public Affairs, 2008.

Carstensen, Laura. *A Long Bright Future: Happiness, Health, and Financial Security in an Age of Increased Longevity.* New York: Public Affairs, 2011.

Cohen, Gene D. *The Creative Age: Awakening the Human Potential in the Second Half of Life.* New York: Harper Collins, 2000.

Cohen, Gene D. *The Mature Mind: The Positive Power of the Aging Brain.* New York: Basic Books, 2005.

Douglas, Susan J. *In Our Prime: How Older Women Are Reinventing the Road Ahead.* New York: W. W. Norton, 2020.

"Dr. Jane E. Hodgson." National Institutes of Health National Library of Medicine. June 3, 2015. https://cfmedicine.nlm.nih.gov/physicians/biography_150.html

Ehrenreich, Barbara. *Natural Causes: An Epidemic of Wellness, the Certainty of Dying, and Killing Ourselves to Live Longer.* New York: Hachette, 2018.

Feuchtwanger, Lion. *The Oppermanns.* New York: McNally Editions, 2022 [1933].

Frankl, Viktor E. *Man's Search for Meaning.* Boston: Beacon Press, 1959.

Freedman, Marc. *Prime Time: How Baby Boomers Will Revolutionize Retirement and Transform America.* New York: Public Affairs, 1999.

Gawande, Atul. *Being Mortal: Medicine and What Matters in the End.* New York: Metropolitan Books, 2014.

Gilleard, Chris, and P. Higgs. "Aging without Agency: Theorizing the Fourth Age." *Aging and Mental Health* 14 no. 2 (March 2010): 121–28.

Gornick, Vivian. *The Situation and the Story: The Art of Personal Narrative.* New York: Farrar, Straus and Giroux, 2001.

Greenberger, Marcia D., and Rachel K. Laser. "Human Rights Hero: Jane Hodgson, M.D." American Bar Association. *Human Rights Magazine.* January 1, 2003. https://www .americanbar.org/groups/crsj/publications/human _rights_magazine_home/human_rights_vol30_2003 /spring2003/hr_spring03_humanrightshero/

Grigoriadis, Vanessa. "A Death of One's Own." *New York Magazine.* November 30, 2003. https://nymag.com/ny metro/news/people/n_9589/

Gullette, Margaret Morganroth. "The Mystery of Carolyn Heilbrun's Suicide: Fear of Aging, Ageism, and the 'Duty to Die.'" In *Agewise: Fighting the New Ageism in America.* Chicago: University of Chicago Press, 2011.

"Hair Loss in Women." Cleveland Clinic Health Library. https://my.clevelandclinic.org/health/diseases/16921 -hair-loss-in-women

Heckman, Don. "Joan Baez: 'I Was in a State of Guilt.'" *New York Times.* June 18, 1972. https://www.nytimes

.com/1972/06/18/archives/joan-baez-i-was-in-a-state
-of-guilt-joan-baez-i-was-in-a-state-of.html

Hedegaard, Holly, Sally Curtin, and Margaret Warner. "Increase in Suicide Mortality in the United States, 1999–2018." National Center for Health Statistics. NCHS Data Brief No. 362, April 2020.

Heilbrun, Carolyn G. *The Last Gift of Time: Life beyond Sixty.* New York: Ballantine Books, 1997.

Heilbrun, Carolyn G. *Writing a Woman's Life.* New York: Ballantine Books, 1988.

Kaplan, Daniel B., and Barbara J. Berkman. "Older Adults Living Alone." *Merck Manual* (professional version). April 2021.

Kohl, Herbert. *Painting Chinese: A Lifelong Teacher Gains the Wisdom of Youth.* New York: Bloomsbury, 2007.

Kohl, Herbert. *36 Children.* New York: New American Library, 1967.

Kohl, Judith, and Herbert Kohl. *View from the Oak: The Private Worlds of Other Creatures.* San Francisco: Sierra Club Books, 1977.

Kohn, Nina A. "The Pandemic Exposed a Painful Truth: America Doesn't Care about Old People." *Washington Post.* May 8, 2020. https://www.washingtonpost.com/outlook/nursing-home-coronavirus-discrimination-elderly-deaths/2020/05/07/751fc464-8fb7-11ea-9e23-6914ee410a5f_story.html

Laslett, Peter. *A Fresh Map of Life: The Emergence of the Third Age.* Cambridge, Mass.: Harvard University Press, 1989.

Lee, Lewina O., et al. "Optimism Is Associated with Exceptional Longevity in 2 Epidemiologic Cohorts of Men and Women." *Proceedings of the National Academy*

of Sciences 116 no. 37 (September 10, 2019): 18357–362. https://www.pnas.org/doi/10.1073/pnas.1900712116

LeSueur, Meridel. *Ripening: Selected Work 1927–1980.* Old Westbury, N.Y.: Feminist Press, 1982.

Macmillan, Carrie. "Lecanemab, the New Alzheimer's Treatment: 3 Things to Know." Yale Medicine. July 24, 2023. https://www.yalemedicine.org/news/lecanemab -leqembi-new-alzheimers-drug

Mairs, Nancy. "When Bad Things Happen to Good Writers." *New York Times.* February 21, 1993.

McFadden, Robert D. "Carolyn Heilbrun, Pioneering Feminist Scholar, Dies at 77." *New York Times.* October 11, 2003. https://www.nytimes.com/2003/10/11/arts /carolyn-heilbrun-pioneering-feminist-scholar-dies-at -77.html

Moen, Phyllis. *Encore Adulthood: Boomers on the Edge of Risk, Renewal, and Purpose.* New York: Oxford University Press, 2016.

Nabokov, Vladimir. *Speak, Memory: An Autobiography Revisited.* New York: Vintage Books, 1951.

Nathan, Neera. "How Extreme Stress Causes Hair Loss." *Forbes.* June 30, 2020. https://www.forbes.com/sites /neeranathan/2020/06/30/why-extreme-stress-causes -hair-loss/?sh=3cdd069f4e6f

Paley, Grace. *Just as I Thought.* New York: Farrar, Straus and Giroux, 1998.

Parker, Arthur C. "The Social Elements of the Indian Problem." *American Journal of Sociology* 22: 22 (September 1916): 252–67.

Peters, Margot. *May Sarton: A Biography.* New York: Knopf, 1997.

"Provisional COVID-19 Deaths by Sex and Age." Centers

for Disease Control and Prevention. National Center for Health Statistics. May 4, 2022.

Qian-Li Xue. "The Frailty Syndrome: Definition and Natural History." NIH Public Access Author Manuscript, 2010. https://www.ncbi.nlm.nih.gov/pmc/articles/PMC 3028599/

"Remaining Jewish Population of Europe in 1945." Washington, D.C.: United States Holocaust Memorial Museum, Holocaust Encyclopedia. Accessed June 13, 2021. https://encyclopedia.ushmm.org/content/en/article /remaining-jewish-population-of-europe-in-1945.

Rock, Lucy. "Interview: When Do You Know You're Old Enough to Die? Barbara Ehrenreich Has Some Answers." *The Guardian*. April 7, 2018. https://www .theguardian.com/lifeandstyle/2018/apr/07/barbara -ehrenreich-natural-causes-book-old-enough-to-die

Sarton, May. *As We Are Now*. New York: W. W. Norton, 1973.

Sarton, May. *Journal of a Solitude*. New York: W. W. Norton, 1992.

Savett, Laurence A. *The Human Side of Medicine: Learning What It's Like to Be a Patient and What It's Like to Be a Physician*. Westport, Conn.: Auburn House, 2002.

Schonberg, Mara, et al. "Should I Continue Having Mammograms? For Women Age 75 to 84 Years." Beth Israel Deaconess Medical Center. 2022. https://eprognosis .ucsf.edu/decision_aids/Mammography_75-84.pdf

Silberner, Joanne. "The Reason There's Been No Cure for Alzheimer's." *The Free Press*. January 10, 2023. https:// www.thefp.com/p/where-is-the-cure-for-alzheimers

Singer, Isaac Bashevis. *Shosha*. London: Penguin Classics, 1978.

"Social Isolation, Loneliness in Older People Pose Health
Risks." National Institute on Aging Featured Research.
April 23, 2019. https://www.nia.nih.gov/news/social
-isolation-loneliness-older-people-pose-health-risks

Walsh, Paul, and Patrick Reusse. "Famed Wrestler Gagne
Linked to Death of Man, 97." *Minneapolis Star Tribune.*
February 20, 2009. https://www.startribune.com/feb-20
-2009-famed-wrestler-gagne-linked-to-death-of-man
-97/39839282/

"WHO Remains Firmly Committed to the Principles Set
Out in the Preamble to the Constitution." World Health
Organization. https://www.who.int/about/governance
/constitution

ANDREA GILATS is a writer, educator, artist, and former yoga teacher. Her previous books are *After Effects: A Memoir of Complicated Grief* (Minnesota, 2022), winner of a Foreword INDIES 2023 Book of the Year Honorable Mention, and *Restoring Flexibility: A Gentle Yoga-Based Practice to Increase Mobility at Any Age.* After twenty years as the founding director of the University of Minnesota's legendary Split Rock Arts Program, she created and directed two University of Minnesota lifelong learning programs for older adults, LearningLife and Encore Transitions, which received national recognition for its holistic approach to envisioning life after work. That work inspired her to create Third Age Yoga, her community-based teaching practice for older adults.